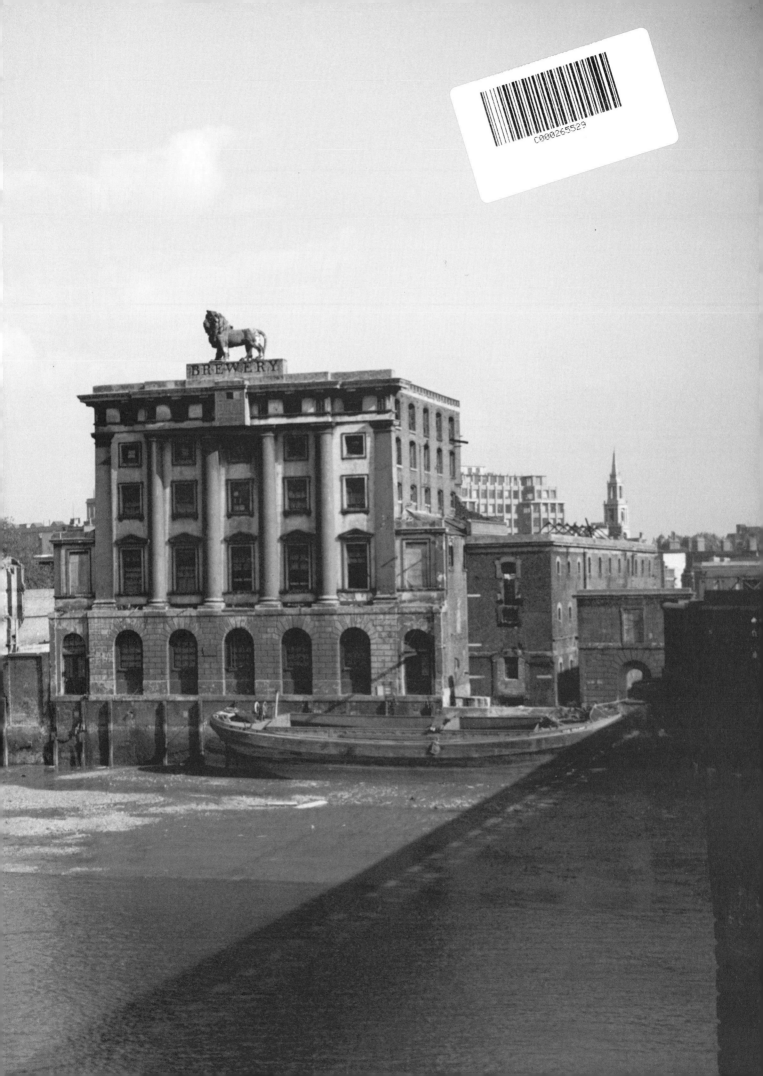

BRITAIN'S LOST CITIES

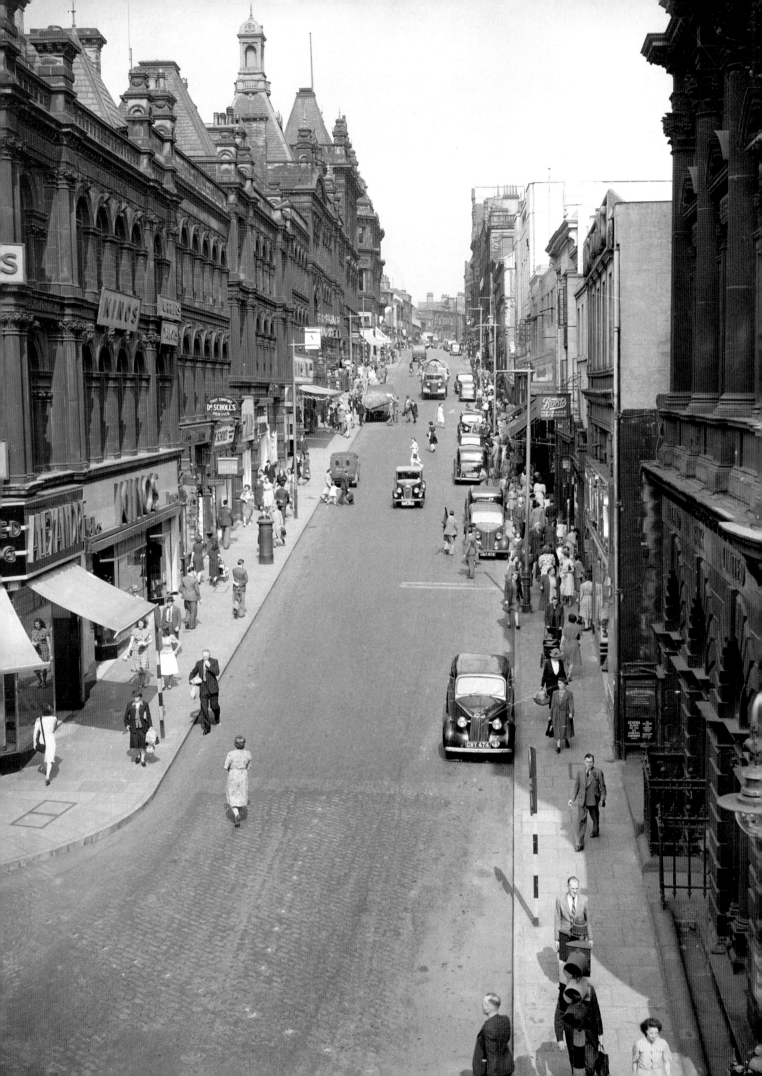

BRITAIN'S LOST CITIES

GAVIN STAMP

First published in Great Britain
2007 by Aurum Press Ltd
7 Greenland Street, London NW1 0ND
www.aurumpress.co.uk

A catalogue record for this book is available from the British Library.

ISBN-10 1 84513 264 5
ISBN-13 978 1 84513 264 4

10 9 8 7 6 5 4 3 2 1
2011 2010 2009 2008 2007

Designed by Peter Ward
Printed by MKT Print, Slovenia

◀◀ Bradford, Darley Street, looking uphill from Kirkgate in the 1950s. The Bradford Banking Company building of 1858 immediately on the right survives, but all the buildings on the left hand side of the street fronting the Kirkgate Market gave way to the Arndale Centre in the 1970s.

CONTENTS

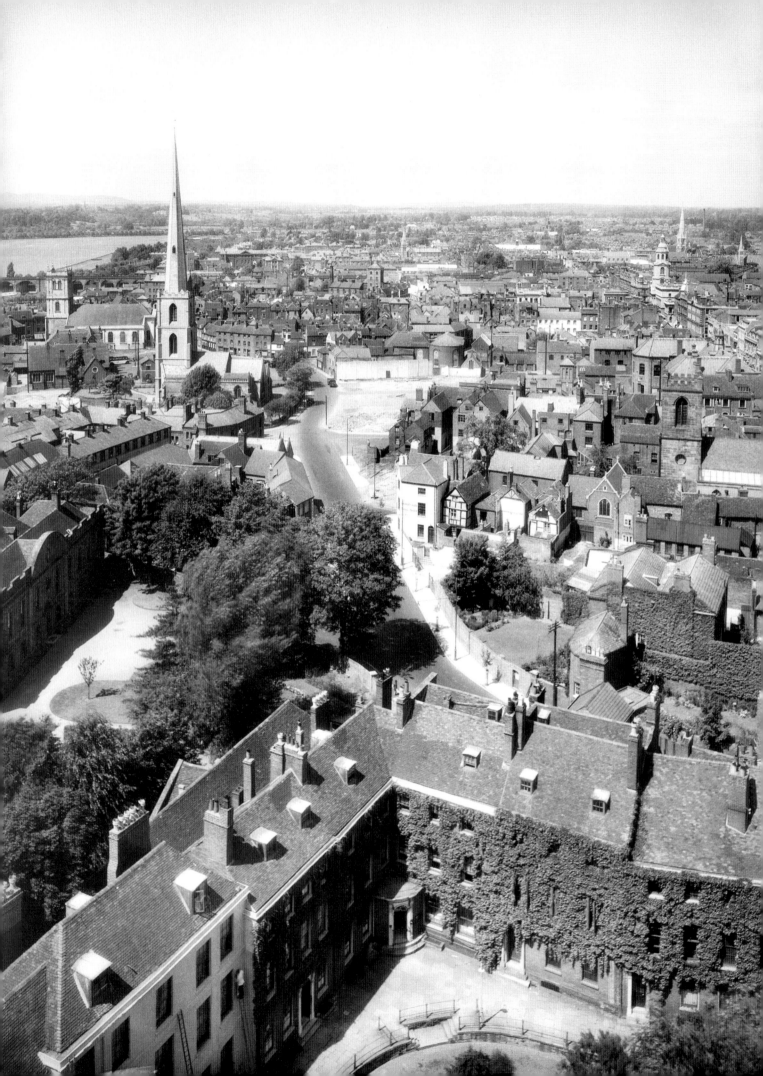

INTRODUCTION

Change is inevitable. Cities cannot stand still; they grow, are adapted, modified, modernised, or they can decline and decay. Streets are widened; buildings are replaced because they are run-down, or inadequate, or can give way to larger structures. Sometimes catastrophic disasters can occur, such as fires or aerial bombardment. All these processes acting over centuries have made the histories of our cities interesting and given them character, variety and richness. In the 20th century, however, not only did the pace of change accelerate but the scale of rebuilding increased. Owing to both war and the political possibility of town planning on a large scale, the whole centres of many cities were radically transformed. This book illustrates the monuments and streets of these cities as they looked before the transformations. Whether the subsequent changes have been for the better or worse must be for the reader to judge, but the visual evidence is compelling.

Change is inevitable, but before the 20th century it tended to be piecemeal, occasional and organic. Cities had been re-planned before, of course, but the new straight streets and open squares were usually laid out on undeveloped land outside the existing built-up area. That was the case with Georgian Bath, Edinburgh and London, but even in Newcastle-upon-Tyne, where Richard Grainger had to buy up and demolish property to create Grey Street, the old city centre was left largely intact. Comprehensive plans for rebuilding whole cities had certainly been proposed in the past, but they tended to remain unrealised. Despite the several ideal and impractical plans prepared by Wren and others, after the Great Fire of 1666 London was rebuilt on the same Mediaeval street pattern as before, with but a few improvements. Only with powers of compulsory purchase could property rights be ignored and devastated cities rebuilt to a different plan.

Later, in the 19th century, the improvements could be more substantial. In the cause of slum-clearance, the Metropolitan Board of Works cut new thoroughfares like Victoria Street and Shaftesbury Avenue through densely built-up parts of London. Corporation Street in Birmingham was similar. Nor should the ruthlessness and destructiveness of the Victorian railway companies be underestimated. Sanctioned by Acts of Parliament, they

1

◄◄ Worcester: the view from the tower of the Cathedral looking north-west before the Second World War and before Deansway was made into a dual-carriageway.

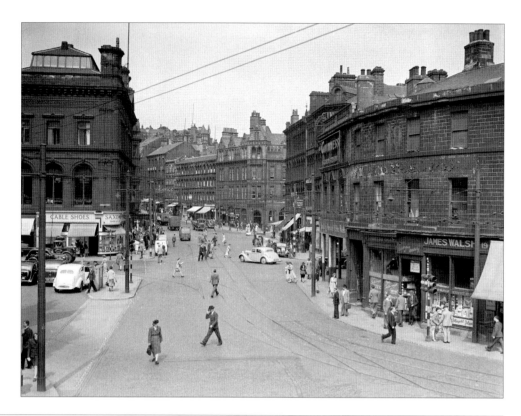

▶ Town Hall Square looking north-west up Bridge Street; one of many views of Bradford taken after the Second World War by the local postcard publishing firm of Walter Scott. All the buildings in the foreground have since disappeared.

2

smashed their way into the hearts of London, Birmingham, Glasgow and elsewhere. Nor were ancient monuments sacrosanct; in Newcastle the castle narrowly escaped destruction when the railway first crossed the Tyne while in Berwick the castle was actually destroyed when the rails came across the Tweed. Meanwhile, there was little to prevent speculators and landlords building and rebuilding wherever they chose and could afford.

In the 20th century, however, the changes came more quickly and the scale of the interventions increased. In the space of a few years, whole cities were transformed and made almost unrecognisable to their inhabitants. This was partly due to new and stronger pressures demanding change and partly because of the destruction resulting from war. Military conflict had not occurred in Britain for centuries, our island fortress having escaped such campaigns as brought devastation to, say, Moscow in 1812 or Atlanta in 1864. But with the conquest of the air, Britain's cities became defenceless against aerial bombardment. Even so, there was no ostensible reason why a bombed city – especially those historic cities targeted in the Baedeker Raids of 1942 – should not have been rebuilt largely as it was before – just as Ypres was in the 1920s having been shelled into mounds of rubble during the Great War. In 20th-century Britain, however, other forces came into play.

One of these was the invention of the internal combustion engine and the advent of the motor-car. The Highways and Locomotive (Amendment) Act of 1896 freed the motorist from inhibiting restrictions. That same year came the first fatal casualty caused by a motor car, and over the following century over half a million Britons would be killed on the roads. That is almost the same number as were killed in the Second World War (while the victims of railway accidents over the same period would merely fill a cemetery), but this did not prevent the rapid growth of road traffic nor the desire of national and local authorities to accommodate it. The boon of private mechanised travel ensured the atrophy of the railway system and the mutilation of villages, towns and cities with road widenings and relief roads. In 1910, John A. Brodie, City Engineer for Liverpool, announced that 'We have recently been spending a large amount of

money on the widening and straightening of main thoroughfares . . . I venture to think that for main lines of communication wide roads will become of greater and greater importance in the future'.[1]

Cars were the future and few dared to oppose the importunate and ever growing demands of motorists. In 1922 there were one million motorised vehicles on Britain's roads; forty years later there were ten times that number and it was assumed that the demand for cars would go on and on increasing. In 1963, the report of the study chaired by Colin Buchanan called *Traffic in Towns* warned that even if only a third of the likely demand for car-commuter travel was met it would require the demolition of half the fabric of the inner city: 'If we are to have any chance of living at peace with the motor car, we shall need a different sort of city'.[2] This was a warning rather than a recommendation but, unfortunately, many local authorities were keen to create that different sort of city, with its urban landscape of flyovers, roundabouts, pedestrian decks and multi-storey car parks. Only towards the end of the 20th century was there an acceptance not only that roads were much more wasteful of land than railways but also that accommodating the car is inimical to urban life.

Intimately connected with the growth of motor traffic was the rise in stature of the town planner, for the first priority of so many town plans was to deal with the intractable problems of congestion and movement. 'The street systems of nearly all our great towns are the street systems which were deemed sufficient fifty, a hundred, two hundred years ago,' argued the planner Thomas Sharp in 1932.

> They remain practically the same as they did then. New growths and extensions upwards and outwards have been added to the cities, new habits of intensified travel have been acquired by their populations. An entirely new set of conditions exists. But the old street systems remain. Every five years the traffic on the streets is doubled, but the same streets serve it . . . It is obvious that great schemes for the reconditioning of existing towns will have to be made and executed.[3]

And these would have to be carried out regardless of cost, as 'congestion results in personal discomfort and inconvenience to vast numbers of people, and in monetary loss on a gigantic scale to all sections of the community'.

Town planning was, of course, not new but the profession of the planner was. In his preface to the published transactions of the great international conference on Town Planning organised by the Royal Institute of British Architects in 1910, the President noted that

> 'town planning' has different meanings in different mouths. To the medical officer of health it means sanitation and healthy houses; to the engineer, trams and bridges and straight roads, with houses drilled to toe a line like soldiers. To some it means open spaces; to the policemen regulation of traffic; to others a garden plot to every house, and so on. To the architect it means *all* these things, collected, considered, and welded into a beautiful whole. It is his work, the work of the trained *planner*, to satisfy all the requirements of a town plan, and to create in doing so a work of art.[4]

However, whatever the merits of garden cities like Welwyn or of some of the post-war New Towns, it cannot really be claimed that any of the rebuilt cities of Britain are works of art. This may reflect the fact that the principal instigators of change were politicians and engineers. Some well-known and influential planners, like Sir Raymond Unwin and Sir Patrick Abercrombie (who would be responsible for many wartime rebuilding plans) were architects, but it is surely significant that the town planners in most cities were surveyors or engineers – men with little interest in aesthetics who were primarily concerned with traffic issues. In Norwich, indeed, the City Engineer publicly

dissented from the 1945 plan prepared by two experienced architects and advocated much more, and destructive, road widening and building in the ancient city.

As early as 1910, G. Baldwin Brown felt obliged to warn the Town Planning Conference against the 'clean slate' approach,

> which has a fascination for many people, especially for the capable administrator dominated by a theory . . . For cities are not only made, but grow. Their growth is organic . . . Furthermore, the growth is conditioned not only by physical but by human environment, and is closely dependent on history. The character of the inhabitants of a city, their relations with their neighbours, their occupations, their achievements, their reverses of fortune, have all left their impress on streets and places and mansions, till these have become through successive ages monumental records of an historic past.[5]

But such concern became increasingly rare, especially after the human, moral and cultural catastrophe of the Great War discredited the old ways of doing things and encouraged so many to yearn for a brave new world in which the problems created by the legacy of the past – substandard housing, traffic congestion, industrial pollution – would all be solved by research and the application of science and reason. Planning therefore demanded a *tabula rasa*, while the building industry and the speculators endorsed the lie that old buildings had a limited life and had to be replaced rather than reconditioned and converted.

In 1938, in pleading for the preservation of the best of Georgian London – which he thought could only be achieved by planning which involved the systematic assessment of what was worth keeping on aesthetic and historical grounds – John Summerson said that,

> To my mind, a town with no old streets is like a man who has lost his sense of past and future, who just exists, idiotically and pathetically exists, from second to second . . . After all, the beauty of a city isn't just the sum total of the beauties of its buildings. The time-factor comes into it . . . In fact, I believe that the more ambitious, the more revolutionary we become in our attitude to present-day town-planning, and architecture, the more we shall be inclined to value those fragments of building history that we can reasonably preserve.[6]

But in an age obsessed by speed and modernity, with the glamour of the United States and Hollywood, an age that found the past – especially the Victorian past – as distant, oppressive, ugly and incomprehensible, such an attitude was rare.

The *tabula rasa* approach was further encouraged by the growing influence of the Continental Modern Movement, of architects and theorists like Le Corbusier and Walter Gropius, with their apparent rejection of history, commitment to scientific analysis, and belief in the desirability of mass-production, standardisation and the frank use new materials – steel and reinforced concrete. 'A breach has been made with the past, which allows us to envisage a new aspect of architecture corresponding to the technical civilization of the age we live in; the morphology of dead styles has been destroyed; and we are returning to honesty of thought and feeling', wrote Gropius.[7] As for Town Planning, 'at once the most burning and baffling problem of all', the goal was a very different city. 'A critical examination of existing urban conditions began to throw new light on their causes. It was realized that the present plight of our cities was due to an alarmingly rapid increase of the kind of functional maladies to which it is only in the natural order of things for all ageing bodies to be subject; and that these disorders urgently called for drastic surgical treatment'.

So, in the exhibition mounted by the MARS (Modern Architectural Research Group) in London in 1938, the 20th-century scene was illustrated by a photograph of Oxford Street, lined with discordant, eclectic buildings and clogged with buses and

◀ Princes Street, Edinburgh, with the New Club, designed by William Burn in 1834, and the Life Association of Scotland building of 1855 by David Rhind shortly before both were demolished in the 1960s.

INTRODUCTION

5

taxis. 'This is what we, our fathers and grandfathers, have done to England. This is the product of a century of progress. The mischief is done. The monstrous town enmeshes our life and wealth. We regret, we condemn. But what can we do?'[8] The answer was start again; rebuild. The most extreme statement in this vein was surely that made in the 1930s by Le Corbusier – who would have such a baleful influence on British planners – in his visual celebration of the aeroplane (published in English) called *Aircraft*. 'L'avion accuse . . .', he wrote. 'Cities must be extricated from their misery, come what may. Whole quarters of them must be destroyed and new cities built'.[9]

This was, in fact, the view of the bomber pilot, and just a few years later the Luftwaffe would obligingly facilitate Le Corbusier's 'New Vision'. During the Second World War, almost every city in England and Wales was attacked from the air. Economic historians have long debated the military effectiveness of strategic bombing but contemporaries had no doubt that future wars would bring terror from the air. The experience of the First World War – during which London was attacked by both airships and aircraft – encouraged the military orthodoxy that cities could not be defended as 'the bomber will always

get through'. What was less certain was the morality of killing civilians and of attacking city centres rather than specific installations of industrial or military importance.

The story of the bombing of cities in both Britain and Germany is profoundly unedifying and not at all simple. Although Nazi Germany had already demonstrated its ruthlessness by the razing of Warsaw and Rotterdam, the unfortunate fact is that the attacks on British cities resulted from the decision by Winston Churchill, when he became Prime Minister in May 1940, to bomb Germany. 'After that', as Sven Lindqvist has written, 'through its own inner logic, the bombing war produced the most efficient methods to cause the greatest possible damage'. Later that year, the Royal Air Force was ordered to attack German cities with incendiary bombs followed by attacks with high-explosive bombs to prevent the defenders fighting the fires. 'Thus', as the official history of the air war recorded, 'the fiction that the bombers were attacking "military objectives" in towns was officially abandoned. This was the technique which was to become known as "area bombing".'[10]

A British raid on Berlin provoked the massive attack on the East End of London and the docks in September 1940. In November, an incendiary raid on Munich was followed by the devastating assault by the Luftwaffe on the centre of Coventry. And so the level of destruction, of barbarism, was ratcheted remorselessly upwards. Like Coventry, the British cities attacked by the Germans over the following year were undoubtedly of military or industrial importance: ports or naval bases such as Liverpool, Portsmouth, Southampton, Plymouth, Bristol, Clydebank; or major conurbations like Manchester, Birmingham and Sheffield. But matters were made worse in 1942 when the head of Bomber Command, Arthur Harris – that repellent figure who had begun his career by bombing rebellious tribesmen in Iraq – decided to attack the ancient, beautiful cities of Lübeck and Rostock because they were full of old timber houses which would burn well. They did, and the outraged Germans then launched the so-called Baedeker raids on historic English cities in revenge. These cities – like the earlier targets – were easy victims: Britain had invested in bombers rather than in defence. As the historian Charles Whiting has written, 'three years after the war had commenced, a whole row of historic cities – Canterbury, Exeter, Bath, Norwich, York – were subjected to repeated bombing raids *with not one single shot being fired in their defence*'. Two years later, in 1944, came the psychologically terrifying attacks in 1944 by the pilotless V1 flying bombs, followed by the final, dreadful assault of the V2 rockets.

The damage, trauma and misery created by the German bombing of British cities should be neither underestimated nor overestimated. What should never be forgotten is the loss of life sustained by civilians: Some 80,000 men, women and children were killed on the Home Front during the Second World War while millions were rendered homeless, refugees in their own country. On the other hand, both the casualties and the scale of destruction would be greatly exceeded in Germany as a result of the repeated attacks made by Bomber Command, at a huge cost in lives, on Hamburg, Cologne, Berlin, Munich, Dresden and so many other cities. Some raids, like that on Würzburg, burned by the RAF in March 1945, were pointless. 'Würzburg was a city very like Exeter, only even more beautiful. It had no military or industrial importance', wrote W.G. Hoskins, a native of that victim of the Baedeker Raids. 'There could not be a more powerful illustration of the utter folly of war, of the fact that as any war goes on the barbarians always get the upper hand and the voice of reason and magnanimity is gradually shouted down by those warped beings who have the lust to destroy'.[11]

At first, the devastation meted out to Coventry, Plymouth and other cities seemed overwhelming, but, as the rubble was cleared, it emerged that the 'damage was lighter than had been at first imagined . . . As a result, it was not long before anger and sorrow gave way to hope and enthusiasm, together with a sudden surge of interest in town

planning'.[12] And the sad truth is that many damaged or gutted buildings which could have been repaired or restored were rapidly demolished as unsafe after the raids to create vast cleared areas – an urban landscape of bombsites, ready for the comprehensive rebuilding. For many, indeed, the bombing was not so much a disaster as an opportunity, as it enabled the realisation of ambitious town planning schemes already prepared. This was the case in Coventry and several other cities (and in Coventry, contrary to popular belief, the physical destruction actually began before the war). Britain could now be rebuilt and modernised. As far as the zoologist and philosopher Julian Huxley was concerned, 'The blitz has been a planner's windfall . . . Not only did it do a certain amount of much-needed demolition for us, but – more important – it made people in all walks of life realise that reconstruction was necessary, and what it might mean if it were properly planned. After long negative years of frustration, the whole temper of Britain has become positive and forward-looking'.[13]

Belief in Planning (with a capital 'P') was an expression of the *zeitgeist*, the spirit of the age. Every city now had to have its plan – even those, like Edinburgh, which had not been bombed. It was all part of pursuing planning on a national level. In October 1940, Lord Reith, the former director-general of the BBC, was appointed Minister of Works and Buildings with responsibility for reconstructing the bombed cities. He selected Bristol, Birmingham, Coventry and Southampton as test-cases and encouraged their city councils to plan boldly and comprehensively. With the support of central government and with powers of compulsory purchase given by the Town and Country Planning Act of 1943, the bombed cities could make a declaratory order for the amount of land they considered necessary to realise the comprehensive rebuilding of their centres. There was talk of democracy in all this, but, as Alison Ravetz has remarked, what was conspicuous about the wartime years was 'an almost boundless professional self-confidence among architects and others involved with town planning'.[14] The type of town plan that often emerged would be satirised by Osbert Lancaster in his cartoon history of an imaginary typical town, *Drayneflete Revealed*, in which 'The Drayneflete of Tomorrow' consists of wide dual-carriageways between scattered multi-storey blocks of modern flats with the odd 'Cultural Monument scheduled under National Trust' isolated on a roundabout.[15]

In fact, one positive result of the bombing was an enhanced appreciation of the nation's historic buildings. The National Buildings Record was established to record them and the requirement to make statutory lists of them was eventually confirmed under the 1944 and 1947 Town & Country Planning Acts. 'These lists would no doubt be useful for planning the country after the war.'[16] But historic buildings were of little concern to most wartime planners. The mood of the time was at first optimistic and a large popular literature on the desirability, indeed inevitability of planning was produced – often reproducing images of Le Corbusier's ideal schemes of twenty years earlier. 'The New Britain must be Planned', insisted the architect Maxwell Fry in *Picture Post* in 1941. 'That some of our bigger towns are inefficient and untidy to a degree which no woman would tolerate in her kitchen and no man in his workshop, may be news to many . . . But bad towns are an invisible burden on every citizen – damaging his health, his pocket, his enjoyment of life. And bad towns are unnecessary. It is a question of thought, of *planning*'.[17] Two years later RIBA organised an exhibition on *Rebuilding Britain*: 'Britain is always being rebuilt . . . Rebuilding is inevitable; it is not a dream. We have lost millions of cubic feet of shelter, in one form or another, and in addition to this we shall find ourselves at the end of the war with a great deal of leeway to make up on our normal pre-war rate of replacement and rehousing'.

'Our great unlovely cities . . . thwart the life of the spirit as brutally as they thwart efficiency'. And they were often unhealthy, so that improving the nation's health would go hand in hand with new clean and efficient buildings – an architecture of sun,

light and air. There is no doubt that much was wrong and dispiriting about Britain's cities. There were huge areas of run-down, poor-quality housing that deserved replacement. Polluting industries were sited next to residential areas; urban air was full of smoke, buildings were blackened by soot. As the architect Lionel Brett was right to recall,

> even the preservationists of the forties saw the great mass of our Victorian "twilight areas" as expendable. Six years of war had reduced these parts of London and the great provincial cities to a sinister squalor that recalled the darkest passages of *Bleak House*. Where the dingy terraces still stood, rotting sandbags oozed on to the pavements, rats infested the cellars, summers of uncut grass choked the back gardens, and black tape or dirty plastic blinded the windows. Britain could take it, but on the clear understanding that all this mess would be swept away.[18]

But nothing could be done until the war was over, and when it was the authorities in the blitzed cities found that the mood in government had changed. There was now less enthusiasm to get on with rebuilding as the nation's economic prospects were bleak. Britain was bankrupt and exhausted, so that the Treasury now began to demand the postponement or scaling down of ambitious rebuilding plans, while the plans themselves sometimes encountered the opposition of traders and businesses. Housing and schools had higher priority. The wartime vision dissipated. 'There was no coherent national planning policy in the 1940s', one historian has concluded. 'City centre re-planning proceeded largely independently of other considerations in reconstruction work. The decision-making process involved a three-way negotiation between local authorities, local vested interests and central government. Generally, the public at large played little part in the planning process, while the advice of outside experts was often not adhered to'.[19] Only in Plymouth was the wartime plan for rebuilding carried out rapidly and almost in its entirety. Even in symbolic Coventry, the much vaunted plan for a new and better city took two decades to achieve. Elsewhere, bomb sites survived well into the 1960s.

The rebuilding of Britain's cities had not been abandoned, however, only postponed. The original vision was to have been achieved by central planning and by Socialism; this time it would be effected with the help of capitalism. In the 1950s, wartime and post-war restrictions on building began to be lifted and under Harold Macmillan's Conservative government a property boom began. In London this was led by developers who had cannily bought up bomb sites at low prices when few others were interested in them. In the provincial blitzed cities, building was at first largely carried out by but one company, Ravenseft, established by Louis Freedman and Fred Maynard, which specialised in shops. As Oliver Marriott has written in his study of the post-war property boom, 'This was from necessity, not choice. Building licenses were only granted for replacing bombed shops or shops on housing estates'. In the first half of the 1950s, Ravenseft built in Plymouth, Exeter, Coventry, Bristol and other cities. 'In these crucial years Freedman and Maynard had virtually no opposition. One reason was that they were opening up a type of development which had previously been unknown. This was large-scale co-operation between municipal authorities and private enterprise'.[20]

Such co-operation became the model for local authorities unable to finance their ambitious plans themselves. 'Partnership', as recommended in official circulars, harnessed the increasing speculation in property. A plan would be ready, and land would have been purchased by the council and then offered for lease to developers by competitive bidding. 'The result', as Brett, by now Lord Esher, later wrote, 'would normally be a brand-new inner relief road feeding multi-storey car parks, a pedestrian shopping mall and lettable office slabs that paid for it all, and the trick was to gain all this without squeezing developers' profits out of existence. At its best the technique could finance a vital road improvement . . . At its worst it could wreck a cathedral city

like Worcester, or exchange decent low-rented houses for unlettable shops . . .' By such means were so many of Britain's cities transformed after the Second World War.

The process was encouraged, or exacerbated, by other considerations. There was the enthusiasm for new roads displayed by so many city planners – roads which could be partly paid for by the Ministry of Transport. There was the fact that the commanding heights of the architectural profession were being taken over by the partisans of the Modern Movement – and that developers found that the architecture that resulted not only secured critical acclaim but was also cheap. There was also increasing enthusiasm for multi-storey buildings, while the modernist planning theories espoused by the leaders of the profession – ideas often derived from Le Corbusier in particular – were utterly hostile to the traditional urban street. And behind all this, particularly in the large cities of the North of England and Scotland, there was a sense of shame about the industrial past, a visceral and blinkered rejection of the dark but substantial legacy of the Victorians – fuelled in part by a crude Socialist vision – that could amount to little more than civic self-hatred and which resulted in relentless destruction. Over and over again it was remarked of particular cities that more of its historical buildings had been knowingly demolished in the 1950s and 1960s than had been destroyed by German bombs in the Second World War. As Colin Amery and Dan Cruickshank put it in 1975, 'it is fair to say that the damage to our towns since 1945 has been done by ourselves. The damage has been colossal and it has been carried out knowingly and effectively – almost as if there were an officially-sponsored competition to see how much of Britain's architectural heritage could be destroyed in thirty years'.[21]

The process of change, of rebuilding, of comprehensive redevelopment accelerated in the 1960s, particularly under Harold Wilson's Labour government. It was encouraged by the extensive use of system building operated by large contractors, a method encouraged by the need to meet government targets for new housing. By the end of the decade, comprehensive redevelopment had become a form of *Terror*, with city after city subjected to huge clearances – for new housing in the inner suburbs and for commercial developments and new road systems in the centre. There seemed no stopping the juggernaut of urban renewal – until the partial demolition of a tower block in East London called Ronan Point by a gas explosion in that *annus mirabilis* 1968 began a process of questioning both the architecture of the Modern Movement and the social desirability of comprehensive redevelopment. Not long afterwards came the Poulson affair, and the exposure of the cosy relationship existing between that corrupt architect and local and national politicians.

At long last, Britain began to wake up to what had been happening and what was being lost. 'Building and rebuilding cities has always been a pretty brutal business since new construction is only possible on the ruins of something else', observed a beleaguered Lionel Esher. 'For centuries it never occurred to the constructors that they were not necessarily improvers'. But it began to occur to others, and opposition grew at a local level – usually to the fury of the elected city councillors – with local civic societies and other action groups assisted by the national amenity societies: the Society for the Protection of Ancient Buildings founded by in 1877 by William Morris, the Georgian Group which dated from 1937 and the Victorian Society founded in 1958. But more was needed to fight the continuing erosion of the decent, ordinary (unlisted) buildings which constitute the fabric of most towns and cities (although declaring conservation areas had been possible since the 1967 Civic Amenities Act) and in 1975 another pressure group, SAVE Britain's Heritage, was established.

1975 happened to be European Architectural Heritage Year, yet the large-scale destruction was still going on. In that year, the clearances and unnecessary demolitions in some thirty towns and cities were surveyed in the book by Colin Amery and Dan Cruickshank called *The Rape of Britain* (polemical titles were a response to the level of

destruction: *The Sack of Bath* by Adam Fergusson had been published two years earlier). It had an introduction by Sir John Betjeman who had allowed himself to become a selfless talisman for so many who were fighting for old buildings and historic places. 'This is a devastating book', he wrote. 'In my mind's ear I can hear the smooth tones of the committee man explaining why the roads must go where they do regardless of the humble old town they bisect. In my mind's eye I can see the swish perspective tricked up by the architect's firm to dazzle the local councillors.'[22]

'Who are the villains?' asked Keith Waterhouse in a review of the book which is worth quoting to give a sense of the tenor of that time, and the change in popular attitudes from naïve utopianism to cultural conservatism and pessimism.

> The development thugs, of course, with their disregard for anything but rent per square foot. The planning officers who are always so pathetically behind the times, like faded society belles wearing last season's gown. The architects, who make up in arrogance what they lack in talent. For my part, I would put most of the blame on the councillors who invite and encourage the laying-waste of their own townships. The trouble is that many of them are not very bright. They have neither the intelligence nor the know-how to realise how they are being manipulated by the property gangs. Yet somehow the destruction must be stopped. When a well-loved building has been pulled down it stays pulled down – the mistake can never be put right . . . There is more to life than living in the present.[23]

Over the two decades following 1975, the scale of destruction diminished and a new appreciation of the small scale, the varied and the piecemeal superseded the modernist vision. Refurbishment began to be favoured by local authorities over replacement and recognition of the suicidal consequences of allowing the motor car to dominate is gaining ground. Destructive road schemes once deemed essential, like the 'Motorway Box' in London and the tunnel under Bath proposed by Colin Buchanan, were abandoned. That so many of the post-war rebuildings are themselves now being replaced by better and more sensitive structures suggests that the mid-20th-century planners' dream, if not misconceived, was certainly cheaply and crudely realised. Bombed cities had to be rebuilt, but not necessarily as carried out in the 1950s and 1960s when the arrogant utopianism of the modernist vision was encouraged both by the selfishness of the road lobby and the barely controlled avarice of commercial developers.

It may seem strange that the naïve utopian dream, that human society can be transformed through architecture and the urban environment, should have outlived the collapse or discrediting of idealist political systems – fascism and communism – but it was central to Modern Movement theory. The notion that a vibrant, humane city can be created all at once by research, reason and design alone rather than being dependent upon evolution over time persisted, while the belief in progress, in novelty, in the unquestionable value of the modern, remained rooted in the British psyche. Architects and planners are possibly not much given to introspection, or doubt, but perhaps members of the planning profession could have taken more heed of Baldwin Brown's warning back in 1910, that 'the historic past has the very strongest claims on the reverent attention of the present; but . . . the danger is that considerations recognised in principle may in practice be crowded out through the clamorous insistence of hygienic, artistic and economic claims'. They might then have been able to acknowledge the crucial, humane consideration that, as Sir John Summerson wrote towards the end of his long life, 'no building touches the heart until one century at least has passed over its roof; a shallow view, perhaps, but one which proceeds from deep and as yet barely recognized truths about man and his buildings'.[24]

The photographs that illustrate the case studies that follow all show Britain's cities before (or during) the major changes inflicted upon them in the last century. They were

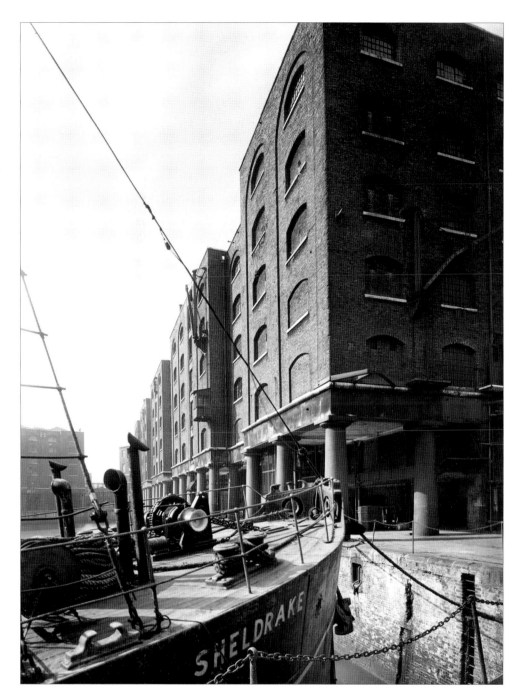

◁ St Katharine's Dock, London, engineered by Thomas Telford in the 1820s with warehouses on cast-iron Doric columns by Philip Hardwick. The dock closed in 1968 and almost all of the warehouses have since disappeared.

not all taken at the same time. There was, of course, no ideal moment as change is constant and the history of these transformations varied: in London the process really began immediately after the Great War, while in Scottish cities there was little widespread change until the 1960s. Whichever, the buildings and streets that they show had a character that may not seem to be evident in their replacements. These lost buildings may not be acknowledged masterpieces, nor the urban spaces formal set pieces of distinction, but both had charm and interest, positive qualities and value to those who had eyes to see. Britain's cities were usually messy and confused, organic creations that had evolved over time, which is why they were of interest and why so much of the destruction now seems lamentable – whether it was caused by enemy bombs or, worse, by our own native road engineers, town planners, developers and politicians.

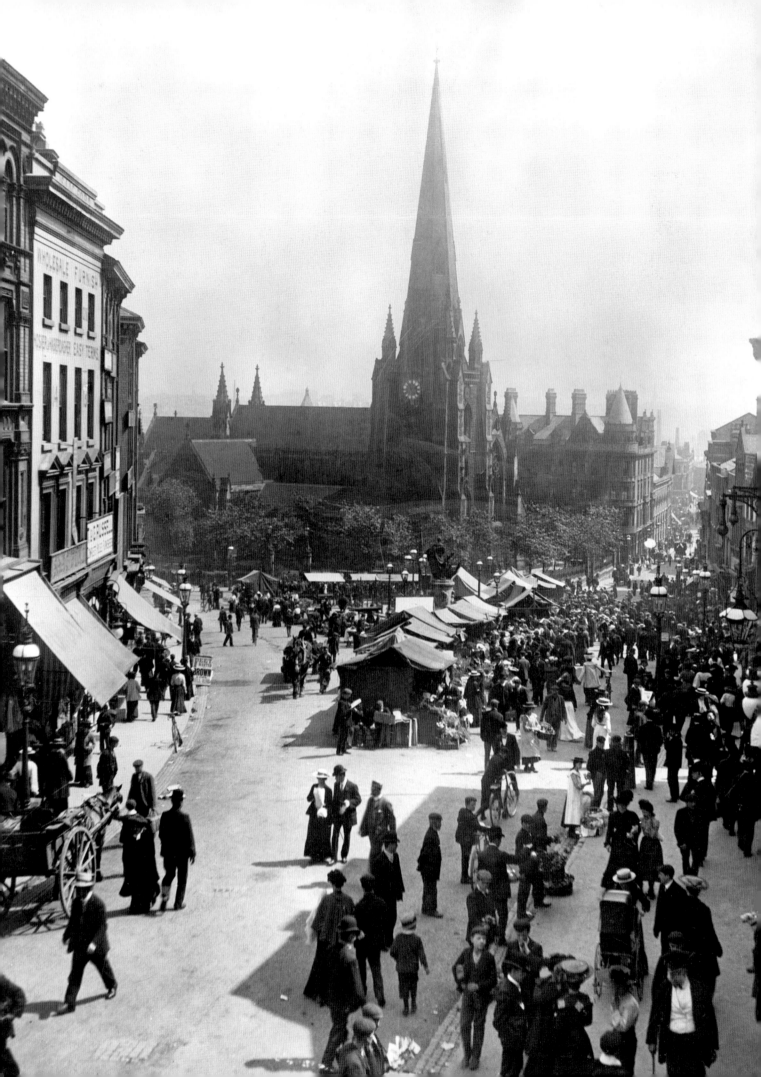

1: BIRMINGHAM

'Birmingham is almost a new city', wrote Ian Nairn after revisiting the place in 1967. 'No other town in Britain except Croydon has changed its looks so radically.'[25] With its enthusiasm for ring roads, motorways and for comprehensive redevelopment, Birmingham actively entered into the spirit of the 1960s more than any other city – apart from Glasgow perhaps. Victorian civic buildings and much else perished as Birmingham surrendered to the motor car and the city centre was divided from the inner suburbs with a ring of wide roads, roundabouts and underpasses that obliged the mere pedestrian to cross either by dank passages or on bridges. But Birmingham's transformation was not born so much of the self-hatred and disgust with the past that afflicted most of the great Victorian cities of Britain; rather from optimism and vigour. As it had been in the past, Birmingham was to be the city of the future. In easy retrospect, it seems sad that so much of that optimism was misguided.

Birmingham was never a grand Victorian city, like Liverpool or Newcastle – although its Town Hall, conceived as a Roman Corinthian temple by J.A. Hansom (inventor of the Hansom cab), suggests such an aspiration. Its development was more confused and piecemeal, and its prosperity was based on a number of craft industries in small workshops rather than on large-scale industrial concerns. Birmingham's metal-working – knives and guns – can be traced back to the Middle Ages. By the beginning of the 19th century it had become an important centre of intellectual and political life as well as an industrial city. However, because so many of the Georgian buildings have disappeared, as Tudor Edwards wrote, 'It is difficult to realise that Birmingham was once a model town, well-planned and even elegant according to Georgian criteria'.[26] And in the early 18th century it acquired a grand English Baroque parish church by Thomas Archer which is now St Philip's Cathedral.

The city the motorways cut up was, however, largely a Victorian creation. Having first encouraged the development of the canal system, Birmingham became an important centre of the railway network. It was the destination of the first great trunk railway line in the world – Robert Stephenson's London & Birmingham – and, by some miracle, the

◀◀ The Bull Ring in 1905; all the buildings other than St Martin's Church, rebuilt by J.A. Chatwin in 1873-75, have since disappeared.

The Great Western Hotel in front of Snow Hill Station in Colmore Row in the 1920s; designed by J.A. Chatwin in 1875 and once the finest hotel in the city, it was demolished in 1971.

Corporation Street shortly before the First World War; most of the original Late Victorian buildings in this new street laid out after 1875 have now disappeared.

original terminus in Curzon Street designed by Philip Hardwick survives while the same architect's Euston 'Arch' at the other end of the line has notoriously perished. Later the railways burrowed beneath the streets and gave the city two big stations, in New Street and by Snow Hill. At the same time, the principal streets were lined with exuberant commercial buildings. The city remained proudly self-confident and was soon being transformed by that philosophy known as 'the civic gospel'. This was very much due to the reforming Liberal council led by a politician who would soon strut on a national stage: Joseph Chamberlain, who was Lord Mayor in 1873-76. Much was achieved under

Chamberlain's Improvement Scheme of 1875; water and gas supply was acquired and run by the municipality, and Birmingham was given a great civic centre around the Town Hall, with a Council House, museum, art gallery, library, post office and other institutions, as well as a fine new boulevard: Corporation Street. As Asa Briggs has written, 'Birmingham acquired the international reputation during the 1870s and early 1880s of being 'the best-governed city in the world'.[27]

By the beginning of the 20th century, Birmingham was the second largest city in England (and by 1951 it had overtaken Glasgow in size). 'Here in Colmore Row you could imagine yourself in the second city of England,' recorded J.B. Priestley in 1933 when on the tour he published as his *English Journey*.

> There is a really fine view at the end, where the huge Council House turns into Victoria Square. You see Hill Street mistily falling away beneath the bridge that the Post Office has thrown high across the road. If there is any better view in Birmingham than this, I never saw it. For a moment, as you stand there, you believe that at last you have found an English provincial city that has the air and dignity that a great city should have, that at last you have escaped from the sad dingy muddle of factories and dormitories that have been allowed to pass for cities in this island, that at last a few citizens who have eyes to see and minds to plan have set to work to bring comeliness into the stony hotch-potch, that Birmingham has had the sense to design itself as well as its screws, steam cocks, and pressure gauges. This is an illusion . . .[28]

By that date, change was in the air and fine buildings from the previous century (and earlier) were beginning to disappear. 'One can do no other than laud the old City Fathers for their civic enterprise', wrote Tudor Edwards in 1950,

> and taken by and large Colmore Row and Corporation Street have a dignified Victorian solidity unsurpassed elsewhere in the provinces. But the more recent destruction of the Old Square, the Bluecoat School and Barry's Grammar School was wanton and ill-done, and there was little excuse for cracking the old bottle to let in the new wine . . . We are living in an age which prefers an Odeon or a multiple store to a moderately good building by Barry, and a mammoth office block to a sedate Georgian school. Certainly the planners have their problems in this city which was never intended to grow so large and certainly not so quickly, and while the suburbs grew the town-centre did not. The opprobrium which all motorists cast upon it is thus richly deserved, though we cannot regard civilisation merely from a motorist's point of view.

Unfortunately, Birmingham increasingly did see it from that blinkered point of view – especially since the Austin motor works had been established in the south of the city in 1910 and became important to its economy.

Making Birmingham fit for the motor car really began at the end of the First World War when, in 1917, the city's Public Works Committee approved plans for a network of arterial roads. The following year the architect William Haywood published *The Development of Birmingham*, which envisaged rebuilding New Street Station like Grand Central in New York and proposed a large new civic centre on American Beaux-Arts lines around Broad Street west of Victoria Square and the Central Library. This idea lingered, although only part of the concept was realised, with the building of the Hall of Memory and a few other grand Classical buildings around what is now Centenary Square, before the Second World War halted work.

Birmingham suffered very badly during the war with its many factories naturally being targeted, but although many buildings were damaged no major architectural monuments were entirely lost. The first of the German air raids came on 9 August 1940, and by the time they ceased in the summer of 1942 some 2,000 tons of bombs had been

The King Edward VI Grammar School in New Street by Charles Barry (with help from A.W.N. Pugin) 1833-37, demolished in 1936.

16

The Central Library, an enlargement by Martin & Chamberlain in 1864-65 of the Midland Institute by E.M. Barry of 1855-57, shortly before its demolition in 1974; the new replacement building, by the John Madin Design Group of 1969-74, is visible on the right.

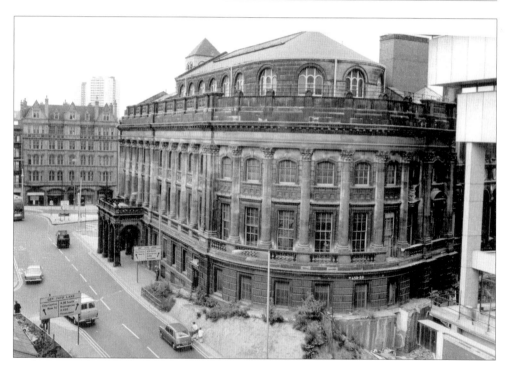

dropped on Birmingham, making it the most blitzed city after London. The last heavy attack came on 9-10 April 1941 when the Bull Ring area (around the old village green where cattle were once tethered), New Street and the High Street were badly hit.

Even so, the plans to rebuild Birmingham pre-dated the war. Herbert Manzoni became City Engineer & Surveyor in 1935, and until he retired in 1963 he encouraged both the comprehensive redevelopment of run-down residential areas and the revival of the city centre, with the rebuilding of New Street Station and the construction of a new civic centre. Manzoni began planning the proposed Inner Ring Road during the war in

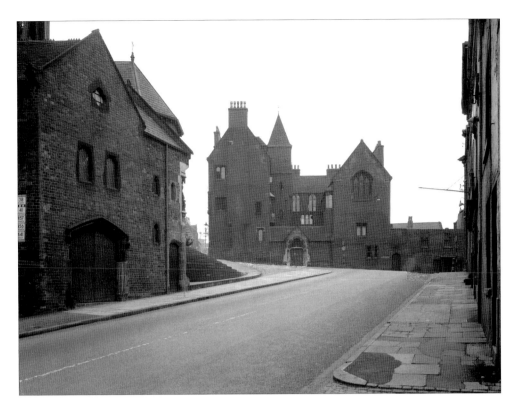

1943. He had little interest in the old fabric of Birmingham. 'I have never been very certain as to the value of tangible links with the past,' he said in 1957. 'As to Birmingham's buildings, there is little of real worth in our architecture. Its replacement should be an improvement, provided we keep a few monuments as museum pieces to past ages . . .'[29] The nature of his original vision of new roads and blocks of new (and nondescript) buildings can be seen in a naïvely confident book entitled *Birmingham: Fifty Years On* published in 1952: 'In fifty years the twelve arterial roads and the inner, outer and middle ring roads now on the drawing board will all be completed . . . If we plan wisely the streets of Birmingham also may become works of art'.[30] The first part of the proposed road system to be built – the Smallbrook Ringway, in 1957-60 – was indeed conceived as a wide boulevard lined with shops. But any hope of art was negated when the remaining planned roads were changed into urban motorways, owing to the baleful influence of the United States, government policy and the criticisms of the Professor of Planning at Birmingham University, Leslie Ginsburg.

The complete Inner Ring Road was opened in 1971. Large areas of the inner city were razed to create it, and the urban motorways cut the emerging civic centre in half and separated the Bull Ring from the city centre – 'fearful risks', as Ian Nairn admitted in 1960, despite his enthusiasm for what was happening. Prominent casualties included the war-damaged but restorable Market Hall of 1831-35, Pugin's Bishop's House opposite St Chad's Roman Catholic Cathedral – perhaps the most remarkable urban domestic design of the 19th century – and the Central Library by E.M. Barry – whose opening, in 1866, was, as Asa Briggs wrote, 'a great landmark in the history of the civic gospel'. The demolition of the last was particularly deplorable is it faced the Council House across Chamberlain Square and helped make that urban space, filled with monuments, a real square. Even Nairn admitted that here was 'a little masterpiece of Victorian urbanity. There is one spot under the portico of the library where all the buildings crowd together like a bit of orchestration by Bruckner or Mahler, and the whole of the nineteenth century can be apprehended like a revelation'.

17

Aerial view of the city centre in c.1948; in the foreground is Victoria Square and the Council House and Town Hall, with New Street stretching eastward towards Moor Street Station and the Bull Ring.

No more. And much more could have gone, but by the 1970s conservation was fighting back. The West Midlands Group of the Victorian Society was founded in 1967 and was instrumental in halting the planned demolition of the General Post Office in Victoria Square. Incredibly, a large area in the heart of the city bounded by St Philip's churchyard, Waterloo Street and Colmore Row, containing a number of distinguished Late Georgian and later buildings, was still proposed for redevelopment as part of the road scheme. As the Victorian Society complained with justice in 1969, 'All this and a chunk of the churchyard are to go for a wider road, a bus stop and an empty space. The plan is ultimately 50 years old . . .'[31] Mercifully, it was eventually abandoned.

Seduced by the vigour and optimism, Nairn could write in 1967 that 'the city's spirit is now equal to that of a century ago, in Joe Chamberlain's heyday'. But the 1960s has left behind few monuments as distinguished as those of the preceding century. Perhaps one of the few of any merit is the new Central Library by John Madin; others – like the rebuilt New Street Station with a shopping centre on top – have proved so mediocre and inadequate that they themselves have been proposed for rebuilding. As for the vaunted Inner Ring Road, not only did it make life grim for pedestrians but it was also found that it constricted the development of the city centre. In consequence, under-passes have now been filled in and sections of it made into normal roads on the level, where pedestrians now enjoy parity with cars. Today, Birmingham is recovering, but photographs sadly confirm how much was unnecessarily sacrificed in the most doubtful cause of reducing traffic congestion.

◁ Bull Street looking west photographed by George Washington Wilson in the late 19th century. Every building in this photograph has since disappeared.

◁ St George's Church, a Commissioners' Church of 1819-22 by Thomas Rickman, the antiquary who classified the phases of Mediaeval architecture as 'EE', 'Dec' and 'Perp'; enlarged with a longer chancel in 1883-84, it was demolished in 1960, but Rickman's much-vandalised tomb survives in the now desolate churchyard.

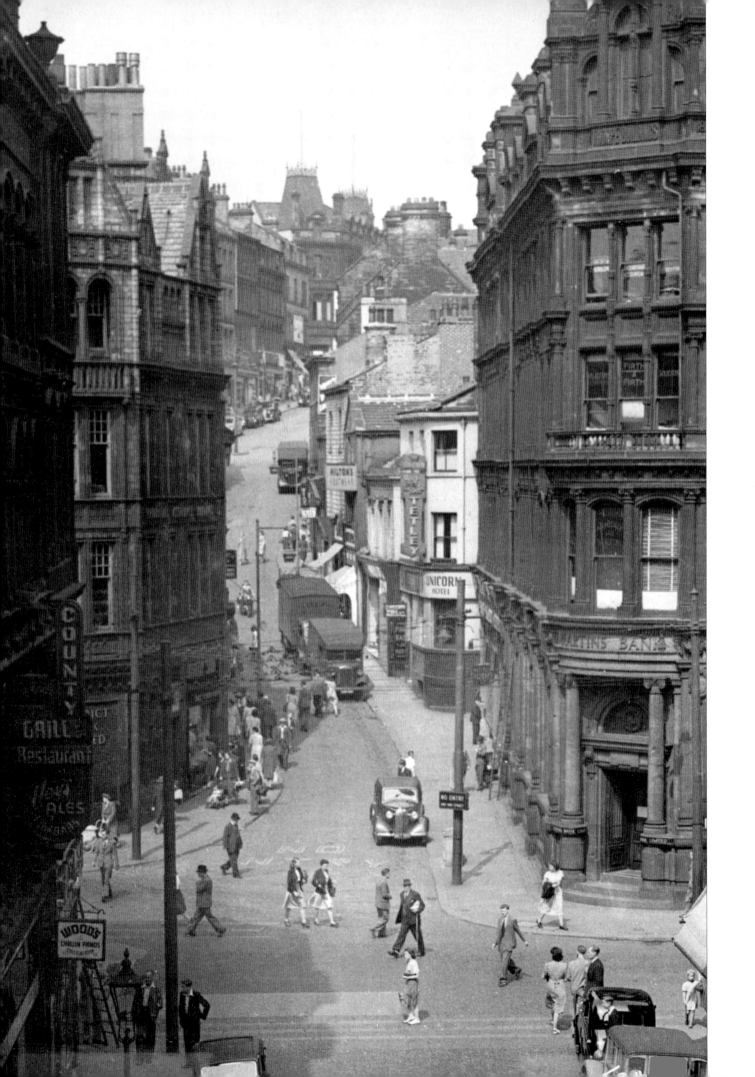

2: BRADFORD

Bradford was once a Victorian city. Although its origins can be traced back much further – and the core of what is now Bradford Cathedral is a 15th-century Perpendicular Gothic church – it was in the first half of the 19th century that the town grew with amazing speed into the worsted textile capital of the world. Wool made Bradford, and by 1850 it was the seventh largest and the fastest growing urban centre in England. Such rapid growth and industrialisation came at a cost, and while the inevitable problems of disease, overcrowding and inadequate sanitation began to be tackled by the reforming Victorians, the town was left with a muddled plan and incoherent open spaces – a defect which would ruthlessly be seized on by the utopian planners of the mid-20th century.

Like other Northern cities on either side of the Pennines, Bradford had a distinct character of its own. It was certainly very different from its nearby rival Leeds. This was partly due to a large influx of German and German-Jewish merchants and manufacturers who created a remarkable philanthropic and artistic local culture; the composer Frederick Delius was a product of one of these families. J.B. Priestley – Bradford-born – wrote that 'The results of this friendly invasion were very curious. Bradford became . . . at once one of the most provincial and yet one of the most cosmopolitan of English provincial cities. Its provincialism was largely due to its geographical situation. It is really in a back-water'. Nikolaus Pevsner, who made his survey in the 1950s, considered that 'Bradford is essentially a Victorian city . . . a city of sombre and sober office and warehouse buildings, revealing riches but no temptation to display. Compared with for instance Sheffield, the centre of Bradford is not without dignity. There is hardly anything strident. An interesting feature is the extent to which in High Victorian days a local firm of architects could still dominate the scene'.[32]

That firm was Lockwood & Mawson, which was responsible for the principal public buildings raised in the city centre in the mid-Victorian decades: St George's Hall, a concert hall intended to meet 'the cultural needs of a business metropolis' but which Pevsner thought 'a poor relation of the Liverpool St George's Hall and the Birmingham Town Hall'; the grand Kirkgate Market, 'in a free Cinquecento style'; and their two

◀ Ivegate, seen from the Market Street in the 1950s.

masterpieces in High Victorian Gothic: the Wool Exchange and the Town Hall with its Italianate landmark campanile. It was in connection with the Wool Exchange that John Ruskin famously was invited to Bradford in 1864 and bemused his audience with a lecture, later published in *The Crown of Wild Olive*, on the social morality of architecture: '. . . I do *not* care about this Exchange – because *you* don't; and because you know perfectly well that I cannot make you . . . But you think you may as well have the right thing for your money. You know there are a great many odd styles of architecture about; you don't want to do anything ridiculous; you hear of me, among others, as a respectable architectural man-milliner; and you send for me that I may tell you the leading fashion . . .'[33]

Almost as impressive as the public buildings were the commercial structures – also all built of stone – in particular those built by the North German merchants in the area north of the Leeds Road known as Little Germany. For Asa Briggs, 'Many of the German warehouses were of greater architectural interest than any of the other buildings of Bradford . . .' Some of the mills are of considerable architectural pretension as well as scale. Samuel Cunliffe Lister built a huge silk mill north of the city centre at Manningham, while in 1850 Titus Salt moved his alpaca and mohair mills out of Bradford further to the north to the model planned settlement known as Saltaire, all designed by Lockwood & Mawson. Today, both of these great stone mill buildings survive and have been restored for new uses while so many of the warehouses in the centre of Bradford have been discarded.

Although its great days ended with the collapse of the German piece goods trade in 1875, Bradford remained an important and culturally vibrant city well into the 20th century. The years before 1914 were, thought Priestley, Bradford's Indian Summer which saw the 'last majestic flowering of nineteenth-century provincial life . . . What came to an end during the First War – at least in my experience – was a kind of regional self sufficiency, not defying London but genuinely indifferent to it'.[34] Between the world wars the city centre was enlivened with fine cinemas and new Art Deco commercial buildings and a new street, Broadway, was laid out; during the Second World War Bradford was bombed but there were no serious architectural losses. Victorian Bradford emerged into the bleak and austere post-war years largely intact. And that was now the problem. With the inexorable decline of the textile industry, and with civic pride undermined by the increasing ascendancy of London and the South-East, the neglected, smoke-blackened 19th-century buildings of the city became a reproach, something to be ashamed of – an attitude exacerbated by conventional prejudice against the Victorian.

In 1946 Stanley Wardley came from Wakefield to be Bradford Corporation's City Engineer and Surveyor, and found 'A very serious traffic problem . . . to be faced; there was a lack of adequate public and civic buildings, and much of the shopping, business and warehouse premises were ill-suited to modern requirements'.[35] In 1953, he unveiled a 20-year development plan to make Bradford a city of the future. This envisaged a ring road connected to the national motorway system, new wide roads cut through the city centre and the replacement of almost the entire Victorian built fabric. Work began in the late 1950s. Forster Square – admittedly never a coherent urban space – was not only largely rebuilt but also changed in shape, while to its south a new shopping area was laid out around Broadway. Bradford's two railway termini – both Forster Square and Exchange, with its fine twin iron train sheds – were both demolished and their tawdry replacements built further out, for worshippers of the motor-car hate railways. And many fine and solid buildings were replaced by mediocre, vaguely modern structures, with most of the new work being cleaned up by Bernard Engel and Clyde Young, two architects with rather less talent than the local firms of a century earlier. In 1962, John Betjeman rightly described the emerging new Bradford as 'international nothingness'.[36]

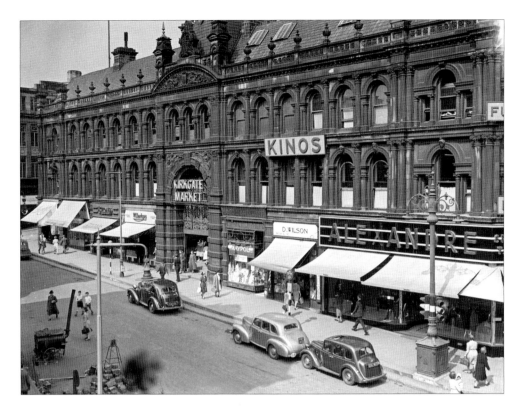

Many distinguished buildings were swept away. One particularly sad loss was the Swan Arcade, a large block of the 1870s next to the Wool Exchange containing four linked arcades with glazed iron roofs. Demolished in 1962, it was replaced by Arndale House designed by the criminal architect John Poulson. At least when the same developers proposed the demolition of the Wool Exchange, the building was bought by Bradford City Council to save it. Other casualties included the Mechanics' Institute, Doric, of 1839-40, and the Court House of 1834, according to Pevsner 'The best Grecian building in Bradford'. By the 1970s, the scale and pace of demolition was beginning to elicit considerable opposition. When the Kirkgate Market was proposed for demolition in 1973 by Town & City Properties, not only the Victorian Society but also famous sons of Bradford like Priestley and David Hockney protested. In vain; the market was replaced by an Arndale Centre, 'wholly without merit, massive concrete facing slabs and mean badly arranged entrances obliterate the streetscape of Westgate and Kirkgate'.[37] Even the architects, John Brunton & Partners, admitted in retrospect that it was a pity the market building was not retained as part of the development.

Three decades on, the City Engineer's brave new world is being systematically replaced. Bradford's post-war buildings have proved to have been as inadequate as they were dreary, while the wide roads, roundabouts and pedestrian underpasses were inimical to civilised urban life. Concrete structures of the 1960s are being replaced and the Broadway is being rebuilt again. 'What was intended by Stanley Wardley to be a modern aristocracy of buildings is heading for the chop', wrote a local observer in 2005. 'How cheap and tawdry those designs seem to us – the through-city road system drastically altering the sight lines of how Bradford had evolved – yet in the early 1950s they must have looked impressive on paper and in model form'.[38] Today, they certainly seem less human and interesting than the dense, complex and lively pre-war city recorded in old photographs – especially those taken by the Bradford firm of Walter Scott for their postcards. As in other cities, the inadequate and unnecessary post-war rebuilding of Bradford now seems a criminal waste of money, energy and materials.

Forster Square seen from the west before the Second World War; the Cathedral and the General Post Office in front survive today but otherwise every building has gone and the square has been completely rebuilt – twice – and changed in shape.

Market Street looking south-west towards the campanile of Lockwood & Mawson's Town Hall; almost all the buildings on the left hand side, including the Swan Arcade, would disappear in the 1960s.

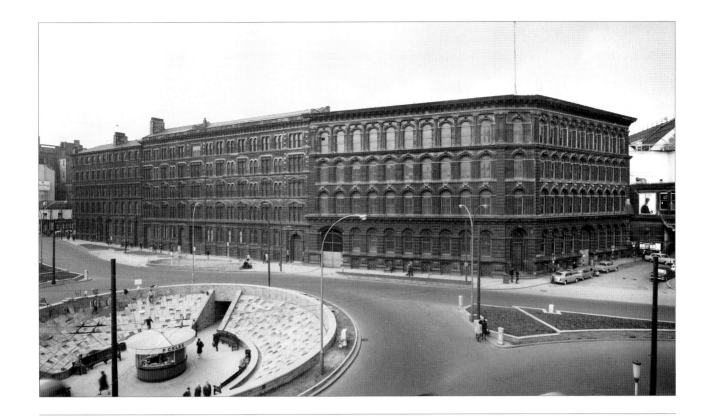

▲ Henry's and Kassapian's
Warehouses designed
by Eli Milnes and other
warehouses on the south
side of Leeds Road in
c.1961; one warehouse has
already been demolished,
exposing the train shed of
Exchange Station behind,
and all the rest would be
cleared away over the
following decade.

'But will this also be the judgement of our descendants in, say, fifty years time, when the contributions of Bernard Engle and Partners and S.G. Wardley to mid-twentieth century architecture and town planning are being re-assessed . . . ?' sensibly asks Christopher Hammond. 'Will our descendants, in turn, poring over the photographs and architects' gleaming perspectives of Central House, as we now pore over the photographs of Swan Arcade, condemn the planning decisions which led alike to their destruction?'[39] We shall see. For while the recent creation of Centenary Square next to the Town Hall seems admirable, the proposal by the architect Will Alsop to create a large lake in the city centre suggests that modern Bradfordians have again taken leave of their legendary hard-headed common sense. But the Victorian city in which Priestley grew up has gone for ever.

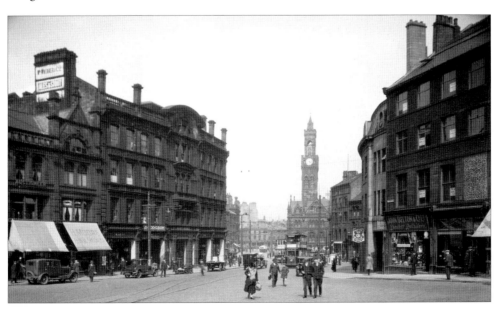

◀ Victoria Square before
the Second World War.
Every building – apart
from the Town Hall in the
distance – has since been
demolished.

3: BRISTOL

Bristol is an ancient city, but one that has constantly grown and changed. It still has exceptional buildings dating from almost every century since Mediaeval times – even from the 20th. And yet Bristol is representative and typical. 'If I had to show a foreigner one English city and one only to give him a balanced idea of English architecture (the balance tilted, however, a little in our favour)', John Summerson once wrote,

> I should take him not to Oxford or Cambridge, which have developed in one special direction, nor to cathedral cities where nothing much has happened since Henry VIII quarrelled with the Pope, but to Bristol, which has developed in all directions and where nearly everything has happened; and where every great historic happening from the Dissolution to the Blitz has left its mark.[40]

Unfortunately, this means that the city also bears the mark of every planning and architectural orthodoxy of the post-war decades.

As a port on the river Avon, Bristol was very prosperous by the 11th century and by the 14th it was an important as London in terms of ships and crews. Until the Second World War, Bristol retained much of the character of the Mediaeval city it once was. There had been a castle and it had a dense concentration of churches within the old city walls. Around the beginning of the 14th century, as Nikolaus Pevsner stated, 'Bristol suddenly jumped into the front rank of English and indeed European architecture'.[41] This can be seen in two of the great Mediaeval buildings which survive: the original parts of the church that became Bristol Cathedral, and the large and elaborate parish church of St Mary Redcliffe, 'the fairest, goodliest, and most famous parish church in England', as Queen Elizabeth described it.

Bristol continued to prosper after the Reformation. Its narrow streets were once filled with 16th- and 17th-century timber houses – just a few of which survive, like the Llandoger Trow inn in King Street – and the 18th century added solid and elegant stone terraces and squares, notably Queen Square, laid out in 1699. In the early 19th century, in Clifton, to the north, terraces and villas were built which are, as Summerson wrote,

◄◄ St Mary Redcliffe and Redcliffe Street photographed by Reece Winstone in 1935; other than this great Mediaeval church, all the buildings have since disappeared – victims both of the Blitz and road-widening.

▶ Looking north across the Floating Harbour and Bristol Bridge to the High Street in 1901; all the buildings to the right of St Nicholas's and Christ Church were destroyed in 1941 but not replaced.

'architecturally, as faultless as anything of their kind in Britain'. By that time, however, despite the best efforts of Bristol's merchants and their inspired engineer, I.K. Brunel, the designer of the Great Western Railway and of some of the first Atlantic steamships, the city was being superseded as the Atlantic port of England by Liverpool. Even so, Bristol continued to flourish, as the extravagant brick warehouses and commercial buildings designed by local architects in the so-called 'Bristol Byzantine' style still testify.

However, none of these later developments overwhelmed Bristol's Mediaeval character or undermined its proud and vigorous independence. When J.B. Priestley visited in 1933 he found

> something that would not have astonished me at all in Germany, France or Italy, and
> ought not to have astonished me in England: I saw a real old city, an ancient capital in
> miniature. What is especially admirable about Bristol is that it is both old and alive,
> and not one of your museum pieces, living on tourists and the sale of bogus antiques.
> It can show you all the crypts and gables and half-timbering you want to see; offers you
> fantastic little old thoroughfares like Mary-Le-Port Street and Narrow Wine Street; has a
> fine display of the antique, the historical, the picturesque; but yet has not gone 'quaint'
> but is a real lively bustling city, earning its living and spending its own money.

Nevertheless, by the time Priestley was in Bristol, the city was responding to the usual pressures and beginning to take the sort of insensitive, utilitarian decisions which, after the Second World War, would have disastrous consequences for the surviving urban fabric. Accommodating the motor car led to the laying out of Redcliffe Way after 1936 as the new route from the city centre towards Temple Meads Station. Unfortunately, this would not only sweep past St Mary Redcliffe, spoiling the church's context, but was run across Queen Square – with one councillor insisting, 'Gentlemen, there is no "architecture" in the square and you know it'.[42] 'It was a pity', wrote Summerson, 'that Redcliffe Way had to be slashed diagonally across the Square and an even greater pity that it had to destroy the Merchants Hall and disfigure the approach to King Street on the way'. Then there was the decision to

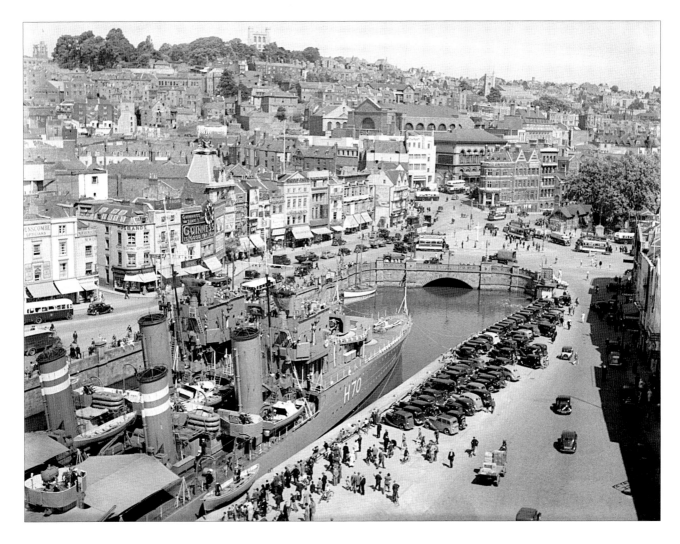

cover over more of the Quay, or the redirected arm of the river Frome, to enlarge the Tramway Centre. Summerson again: 'The Centre is an opportunity missed. It is the place where once the sea flowed right into the City and where, as little as twenty years ago, you would see masts and rigging silhouetted against the street fronts.' 'The civic authorities of Bristol have not managed with imagination this vital open space', complained Pevsner after the war. 'Could not the water have been re-introduced?' There was also the decision to make College Green look boringly municipal by lowering and tidying it up in connection with the building of Vincent Harris's Council House, begun in 1938.

But these changes seem minor compared with the immense destruction inflicted by the Luftwaffe over the next few years. Bristol was bombed heavily and repeatedly. The first raid came in June 1940, the last in May 1944. Five heavy raids came in November and December 1940. On 3 January 1941 the night-time attack lasted for twelve hours, and by the end of that month over a thousand Bristolians had been killed. The worst raid of all came on 16 March and the following month, the day after another heavy raid, the Prime Minister visited the shattered city, his secretary recording that 'There was devastation such as I had never thought possible'.[43] The last major raid on Bristol was on 15 May 1941. Many of the raids were directed against such military targets as the docks at Avonmouth and the Bristol Aeroplane Works at Filton, but it was the ancient centre that bore the brunt of the attacks: a quarter of the Mediaeval city was destroyed.

The heart of Bristol, the vital shopping and commercial area around Wine Street and Castle Street just north of the Avon near Bristol Bridge was the worst hit, but streets all over the city centre were badly damaged. Casualties included four of the Mediaeval

▲ *H.M.S. Fortune* and *H.M.S. Firedrake*, the last ships to be moored in the Centre before this section of the River Frome was covered over, photographed by Reece Winstone in 1937.

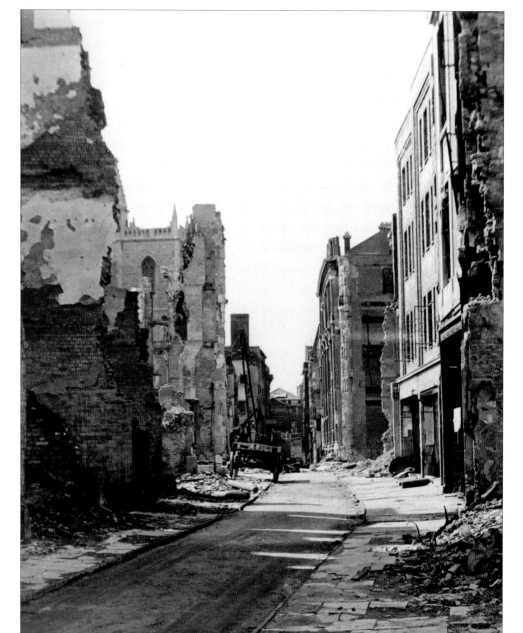

▶ St Mary-le-Port Street looking towards the Flower Market in 1941 after the bombing; the tower of the bombed eponymous Mediaeval church is visible on the left.

churches, which were left as gutted ruins, and St Peter's Hospital, a Mediaeval mansion reconstructed in 1612. But, as in other cities, many damaged structures were rapidly cleared away which could well have been restored. A particularly sad loss was the celebrated Dutch House in the High Street, 'the finest of the C17 timber houses of Bristol', which was cleared away by the Army two days after the heavy raid of 24 November 1940, despite the fact that it was held up by a modern steel frame. The Mediaeval tower of the Temple Church narrowly escaped demolition when its pronounced and ancient lean from the vertical was mistakenly assumed to be the result of bombing.

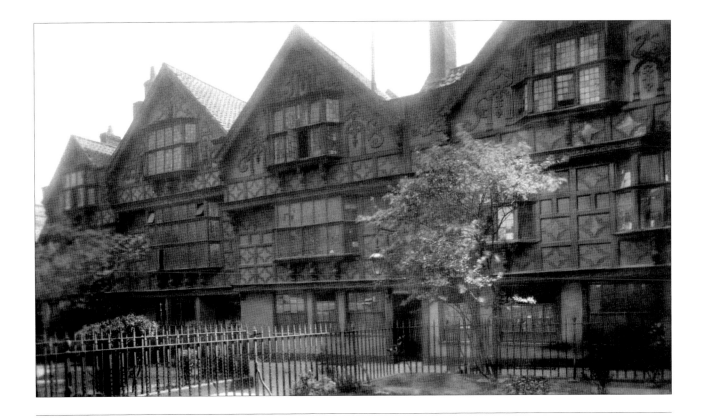

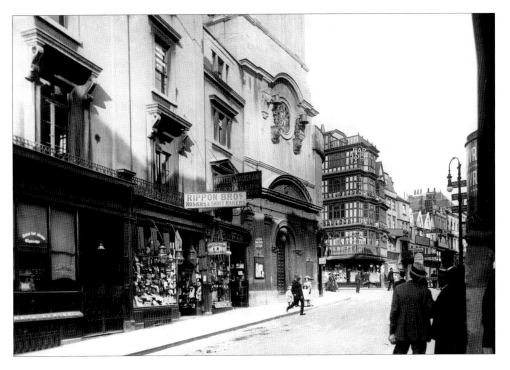

Some damaged buildings were restored, however. Park Street, 'the handsomest shopping-street in England' (Summerson), rising up to Sir George Oatley's astonishing 20th-century Gothic tower for the University, had lost a third of its uniform stone buildings but – after plans to widen it had been abandoned – J. Nelson Meredith, the City Architect, insisted that it was rebuilt with replica facades. Meredith also restored the Lower Arcade off Broadmead in 1948 (the similar Upper Arcade was blitzed). 'Bristol has been bombed', wrote John Betjeman in 1958; 'much lace-like carved stone of those Somerset towers and arcades has been smashed; the delicate plasterwork (some of the

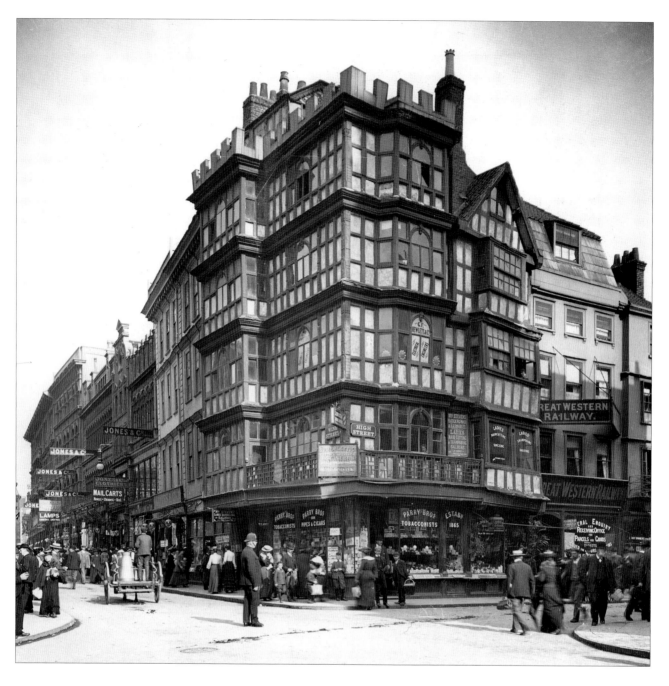

The celebrated 17th-century Dutch House on the corner of Broad Street and High Street in c.1902; badly damaged in the raid of 24 November 1940, it could have been saved, but was instead demolished two days later by the Army.

best in Europe) in Georgian houses has gone for ever: yet Bristol seems much the same as when I last saw it. The strong character is not destroyed nor have all its best buildings and its narrow steep alleyways disappeared'.[44]).

Like other bomb-damaged cities, Bristol soon prepared a plan for rebuilding. This was not remarkable in its design (compared, say, with Coventry's) but it was radical and controversial in its overall application and led to conflict between the chamber of commerce and the City Council. As one trader would complain, 'The people who devised it are the judges of their own work – the plaintiffs are their own judge and jury'.[45] The City Architect had come up with a reconstruction plan in 1941 soon after the worst of the bombing, and in 1943 the City Engineer (who doubled up as Planning Officer) submitted his proposals for roads. There was to be an outer and an inner ring road, while an 'inner circuit' two miles long was to be continued from Redcliffe and Temple Way. As far as he was concerned, 'neither efficiency nor amenity can be obtained unless very adequate arrangements are made to deal with the control of traffic'.

⊲ The Upper Arcade between Broadmead and the Horsefair in 1939, two years before it was destroyed in the Blitz. Demolition of the continuing Lower Arcade, also by James & Thomas Foster, 1824-25, after the war was only prevented by public protest.

The following year the City Engineer submitted his report on his Master Policy Plan for the re-planning and reconstruction of the city centre. The principal and radical proposal was to move Bristol's main shopping centre a little to the north, to Broadmead and The Horsefair, leaving the devastated and cleared area around Wine Street and Castle Street as a public open space containing civic buildings. The area around Broadmead, although damaged in the war, was still largely standing, so this proposal involved the demolition of many buildings which had survived the blitz. In other words, the part of the city that had been destroyed was not going to be rebuilt, while a part which had not been destroyed was going to be rebuilt instead. 'Some of the proposals are new and possibly rather revolutionary', wrote the author of the plan, tuning into the *Zeitgeist*, 'but your Engineer feels that the spirit of adventure is abroad in connection with post war developments, and that Bristol would not wish to be behind in this direction'.

These proposals met with the opposition from traders who wanted to rebuild their premises in the old shopping centre as soon as possible, and the Bristol Retail Traders'

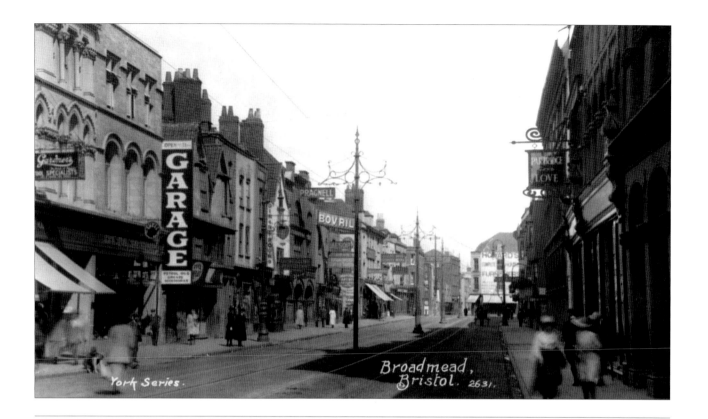

Broadmead, Bristol. 2631.
York Series.

▲ Broadmead in the early
1920s; largely undamaged
in the Blitz, this area was
almost completely rebuilt
after the war.

▶ Castle Street in *c.* 1914;
once the city's busiest
street, this is now an open
space following wartime
destruction and clearance.

Federation was formed to oppose them. The Council, however, argued that the Wine
Street and Castle Street area could not be rebuilt as it was because the streets had been
too narrow and the plots too small. The victory of the Labour Party in the local
elections in 1945 gave added impetus to the proposals, although a public inquiry had
to be held and the Minister of Town and Country Planning, Lewis Silkin, only allowed
245 out of the 771 acres requested under Bristol's declaratory order, the Treasury was

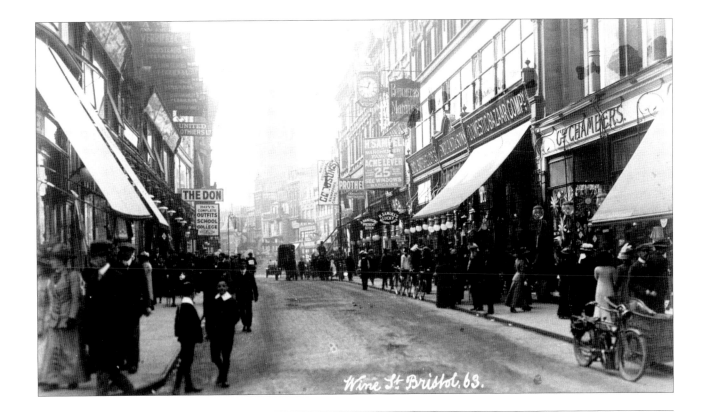

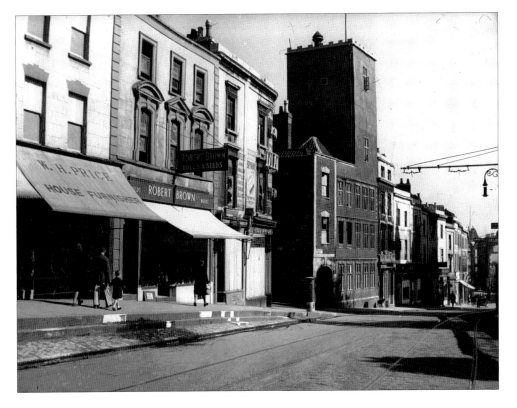

▲ Wine Street in 1914 looking west from Narrow Wine Street; like Castle Street, this is now a barren open space.

◀ Redcliffe Hill in 1941; William Watt's shot tower of 1782 and the other buildings were cleared in the mid-1960s for road widening.

increasingly reluctant to finance ambitious schemes (in the post-war climate of worsening austerity). Meanwhile, both traders and architects felt excluded from the Council's deliberations. In 1947, the Retail Traders' Federation organised a poll which found that while some 13,000 Bristolians wanted the shopping centre to be rebuilt on the site of the old, only 400 wished to have the proposed new centre at Broadmead. The findings of this tentative exercise in local democracy infuriated the Labour Council,

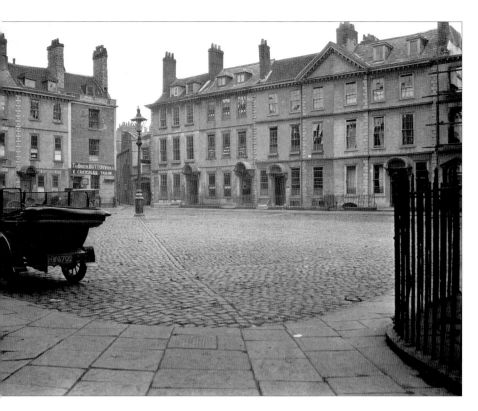

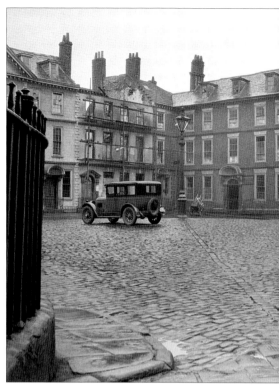

▲ St James's Square, the north and east sides of this early 18th-century development, cleared away in the mid-1960s for the Inner Circuit road.

▶▶ St James's Square, the east and south sides, destroyed in the Second World War.

which announced that, 'The so-called poll is without any official sanction and can carry no weight. The slipshod, inefficient and utterly undemocratic methods by which it is being conducted are reminiscent of Hitler's early efforts in political demagogy'.[46]

So work began regardless on the Broadmead scheme in 1949. The result was not impressive: 'The planning as unimaginative . . . The shop facades are generally dull . . .'[47] The principal building was a new store for Lewis's designed by Percy Thomas & Son and built in 1955-57. As the Bristol Civic Society later complained, although the rebuilding involved several conservation schemes,

> it also required the wholesale clearance of a down-at-heel, but virtually undamaged Georgian and 17th-century area of considerable architectural quality. At least, the protection and re-use of the Greyhound Inn, Quakers' Friars, Lloyds Bank in Merchant Street, John Wesley's New Room and the Lower Arcade, mean that it remains an important place in Bristol's architectural heritage, albeit much reduced since the planners and developers started.[48]

Meanwhile, the proposals for a civic centre in the Wine Street area were quietly dropped, although when part of the site (where the Dutch House had stood) was leased instead to the Bank of England and an insurance company there was public protest. The rest of what had been a vital part of the city remained as a car park. Today, this crucial area by the Avon is laid out as an open space, a sterile riverside void, leaving Bristol without the vital urban centre of gravity that it once had.

And the destruction continued. Bristol may have been advanced in producing a list of historic buildings in the early 1940s – compiled by the Council for the Preservation of Ancient Bristol – but, as Andrew Foyle has noted, 'this offered little protection for historic buildings in the redevelopments of c.1950-75, when demolition losses probably equalled those from bombing'. In the 1960s, the principal threat to historic buildings came from road engineers. What remained of the Georgian terraces of St James's Square were swept away for the Inner Circuit road, and the area around St Mary Redcliffe was

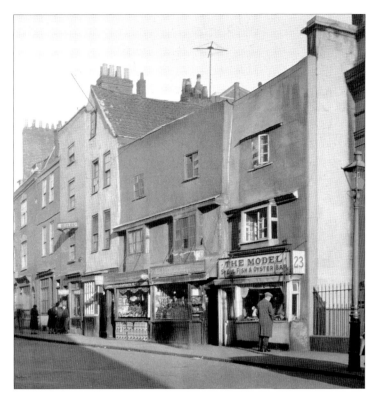

The south side of the
Horsefair in 1931; most of
this old street survived the
Second World War, only to
be demolished afterwards.

BRISTOL

37

cleared for road widening, with casualties including the 17th-century shot tower in Redcliffe Hill. In 1962 the damaged 15th-century church of St Augustine-the-Less by College Green was demolished and the following year the significant ruins of the Bishop's Palace – burnt out during the Reform Bill riots of 1831 – were cleared away. In 1969 and 1970 timber-framed houses at the bottom of Christmas Steps and in Narrow Lewins Mead were also swept away for the wretched Inner Circuit road, 'thus wiping out the last area in the centre of Bristol where one could stand entirely out of sight of any but 18th-century or earlier buildings.' Three years later, ancient gabled warehouses in Broad Quay were demolished. 'Much of what has gone was destroyed needlessly; all is irreplaceable', commented the Bristol Civic Society. 'No amenity society should demand preservation at all costs but, with a civic record like Bristol's, it is not surprising that the city's societies seem more than usually sensitive to threats to old buildings'.

Fortunately, by the 1970s, local protest against this continuing vandalism was growing and the ambitious schemes for the 'vertical segregation' of traffic and pedestrians proposed in the City Centre Policy Report of 1966 remained largely unexecuted. Since then, the attitude of the city's authorities to development has been forced to change and conservation schemes rather than demolition have revitalised much of the city centre. It was happily symbolic of this new attitude that, in 2000, the wide road that slashed across Queen Square was removed and the 18th-century layout of the gardens reinstated. Bristol today retains many historic buildings of high quality and remains a most interesting city which, as Priestley found, is both 'old and alive'. But terrible scars remain from both the Second World War and from the destructive planning decisions made soon afterwards. It is impossible not to regret the loss of the ancient city centre. Fortunately, however, it is possible to recapture what the buildings and streets of Bristol were like before 1940 because of the wealth of old photographs collected and – crucially – published by the late Reece Winstone. In consequence, Bristol must be visually one of the best documented cities in Britain, although a photograph can never be an adequate substitute for a lost building.

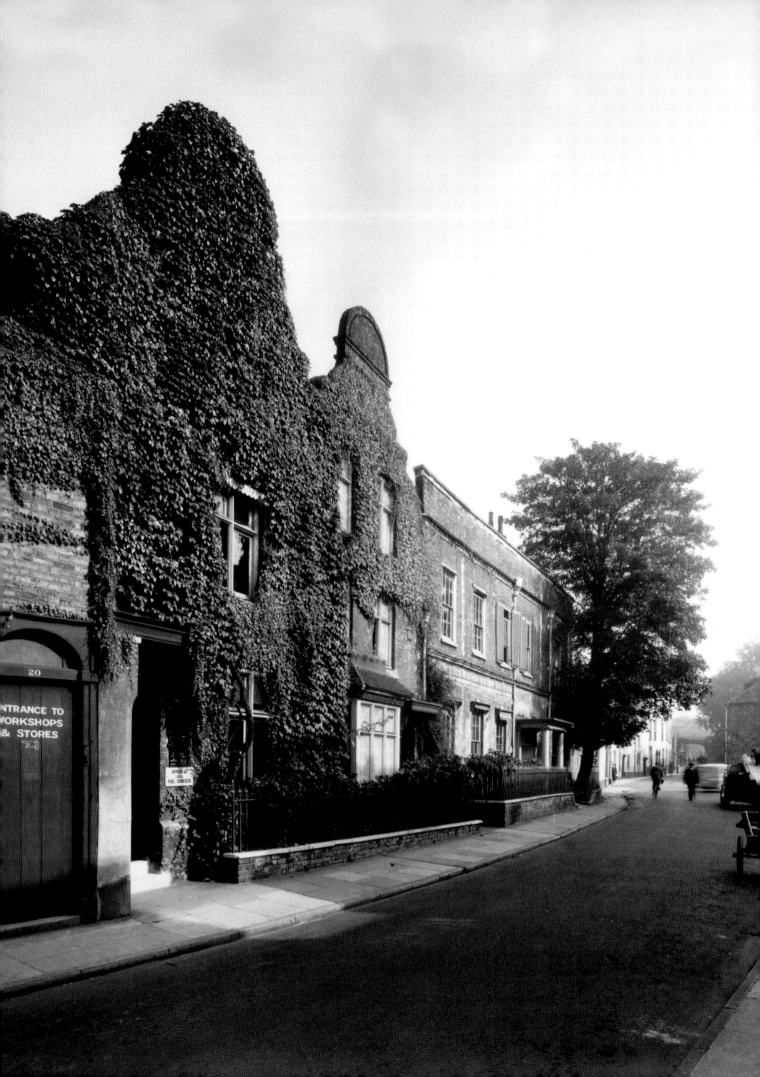

4: CANTERBURY

In Baedeker's *Handbook for Travellers to Great Britain* (the 1890 English edition), Canterbury was described as 'the ecclesiastical metropolis of England . . . It is an ancient city, with numerous quaint old houses, and has been the seat of an archbishop since the 6th century'. Dominating the city and the surrounding countryside was, of course, the Cathedral, rebuilt after the murder of Thomas à Becket, whose subsequent cult brought pilgrims and prosperity to Canterbury until it was brought to an end with the Reformation. Though the abbey dedicated to that first Archbishop of Canterbury, St Augustine, was suppressed, the Cathedral was desecrated a century later by Cromwell's forces and during the 18th century five of the old city gates were demolished, still the ancient city remained largely intact and continued to prosper as both a market town and, later, a garrison town. New buildings mingled with the old and, in 1830, Canterbury became the southern terminus of the first passenger railway in the south of England – the other end being at Whitstable on the Thames Estuary.

At the outbreak of the Second World War, Canterbury remained largely 'an ancient city', but its geographical situation close to the English Channel which had attracted St Augustine there now put it in the front line and at great risk from German bombers flying above towards London. In 1940 the Battle of Britain raged overhead and some houses were damaged by jettisoned bombs. Nevertheless, at the beginning of 1942, Canterbury was the only town in Kent not damaged by the war – but not for much longer. As an historic and beautiful city, it was to become one of the victims of the second wave of retaliatory cultural bombing raids that the Germans so cruelly named after that admirable 19th-century compiler of guide books, Karl Baedeker. At the end of May, as the level of destruction and barbarism was ratcheted remorselessly upwards by both sides, 'Bomber' Harris launched the first of the RAF's thousand-bomber raids against the ancient cathedral city of Cologne, to appalling and devastating effect. Two nights later, on 1 June 1942, the Luftwaffe targeted Canterbury in revenge.

For two and a half hours, incendiary and high-explosive bombs rained down on the city. The Cathedral was hit, but the most devastated area was the Whitefriars area to the

◀◀ Watling Street shortly before the Second World War; today the five-bay house with the straight parapet survives but the gabled 17th-century brick house next door and much else perished in the 1942 Baedeker Raid and the subsequent clearances.

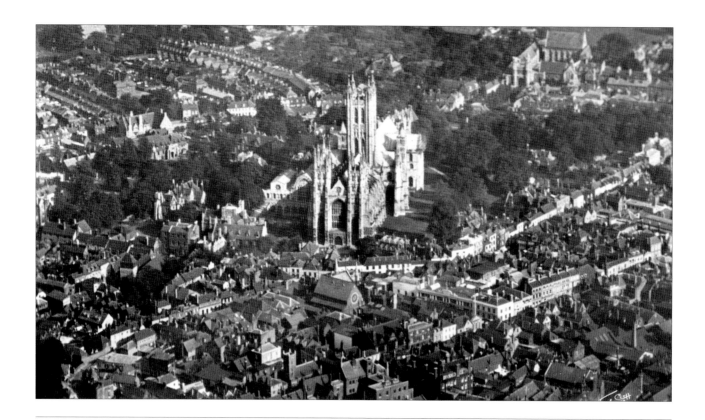

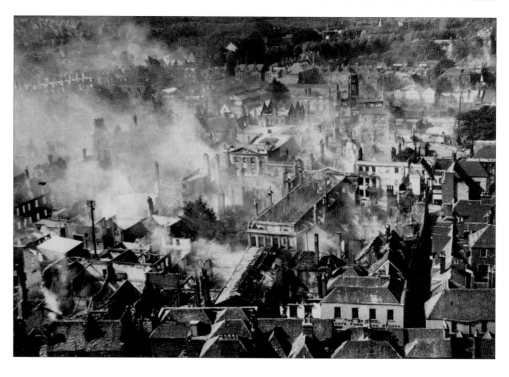

▲ Aerial view of the city from the west before the Second World War.

▶ The area to the south of the Cathedral photographed the morning after the Baedeker Raid on 1 June 1941 by Anthony Swaine from the Bell Harry Tower.

south-east around the High Street and St George's Street, bounded by the city walls. 'By God's mercy the cathedral still stood four square . . . ,' recalled one observer. 'But the eastern half of the High Street was in a condition only comparable to that of Ypres during the last war. It presented an almost unbroken vista of desolation, and among the buildings battered into shapeless rubble heaps or irreparably damaged were many hallowed by antiquity'.[49] Badly damaged buildings included the Cathedral Library, the King's School, St Augustine's College and the houses in front of Lady Wotton's Green, St George's Church and the old Corn Exchange, a Regency building described by John

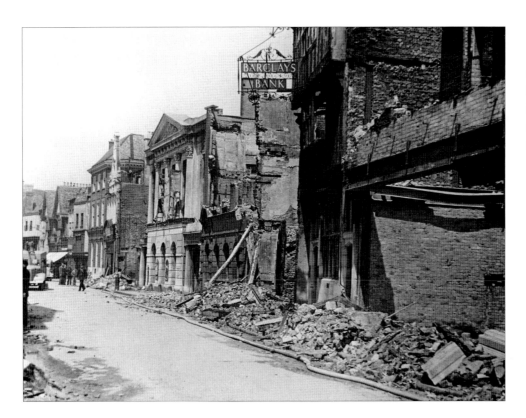

Summerson as 'perhaps the best piece of classical architecture in Canterbury'.[50] For as Pennethorne Hughes later explained in his *Shell Guide*, 'it was not a mediaeval city that was bombed: it was a cross-section of urban architecture around a treasured mediaeval centre'.[51]

What then occurred in Canterbury after the Baedeker raid is little known and seldom recounted in histories of the Second World War, but was all too typical of what took place in almost every bomb-damaged city in Britain. On the following day, after a night of fire-watching on the Cathedral roof, the architect Anthony Swaine climbed up Bell Harry Tower again to photograph the smoking and gutted ruins to the south east. As he later recalled, "Many buildings, although damaged, were left standing and capable of repair; however, whilst the ashes and cinders were still warm, the evil act of matricide was about to begin".[52] As elsewhere, the city authorities welcomed the destruction as an opportunity to carry out long-mooted town-planning improvements. Under wartime special powers, the Town Clerk, John Boyle, and the City Architect and Engineer, H.M. Enderby, rapidly set about clearing most of the damaged buildings. As many as seven hundred houses were then razed, along with the Mediaeval Whitefriars, the Corn Exchange, the Longmarket of 1822, and even churches: St Mary Bredin and St George's – whose tower alone survives today (without its spire) thanks to the intervention of Sir Albert Richardson. The result was a vast cleared site around Burgate and St George's Street – the scene of desolation around Rose Lane recorded by Michael Powell and Emeric Pressburger in their 1944 film *A Canterbury Tale*.

The question then was: what to build there instead? In 1944, the architect Charles Holden – soon to be busy with his plan for the City of London – was invited to work with the City Architect and Engineer on re-planning the city centre. Their *Canterbury Town Planning Scheme* was published the following year. It envisaged new roads, a ring road and a new Civic Way running from the cathedral to a new civic centre, the compulsory purchase of seventy-five acres and the demolition of many surviving buildings which might have been noticed in a new edition of *Baedeker*. But – for once –

▶ St George's Street
looking west in 1937; all
these buildings would be
cleared after the 1942
bombing except for the
tower of St George's
Church (without its spire).

42

the opposition to this gratuitous destruction was successful. A Canterbury Citizens Defence Association was formed which, in the November 1945 local elections, won all eighteen seats on the Council. The Holden-Enderby plan was soon abandoned.

A new plan was then prepared by the new City Architect, Hugh Wilson, and approved in 1949. This retained the ring road and East-West relief road proposed by Holden and Enderby but involved much less compulsory purchase. 'The detailed planning of the city will be very considerably affected by the presence of its ancient monuments and buildings', noted *The Architects' Journal*. 'The implication of the plan is that it will not be possible to preserve a large part of the mediaeval centre as it exists today'.[53] This plan continued to provoke 'bitter controversy' and it was only partially realised by Wilson and by his successor, J.L. Berbiers, over the following two decades. Only part of the proposed ring road was built, creating a *cordon sanitaire* to the south and east of the old city walls. When John Newman surveyed Canterbury for his *Buildings of England* volumes on Kent, published in 1969, he concluded that 'The chances offered by the bombing of Canterbury were not adequately taken; indeed, the fate of the whole city centre is in balance as this is being written'.[54]

While the principal pre-war streets were retained, the complexity and density of the old Mediaeval street pattern were ruthlessly simplified. Some of the new buildings were feebly neo-Georgian while others attempted to be vaguely Modern; most were lacking in character and bore no relation to what had existed on the site before 1942. Surprisingly, when Ian Nairn visited Canterbury for the BBC in 1960 he was impressed, finding it 'a cathedral city without sanctimoniousness, and a rebuilt city without inhumanity' and considering that the rebuilt St George's Street 'is a real attempt to match old and new honestly and sensitively'. But when he came back seven years later, he considered the rebuilding only a 'fifty-fifty' success and thought that the new Longmarket 'has turned out to be a disaster'. As far as John Newman was concerned, he found that "the hesitant rebuilding that has gone on over the last twenty years has left this area peculiarly bitty, in places to good effect, usually disastrously". All that deserved

The south side of the New Dover Road in 1941; the whole of this Georgian terrace, called St George's Place, was demolished in 1942.

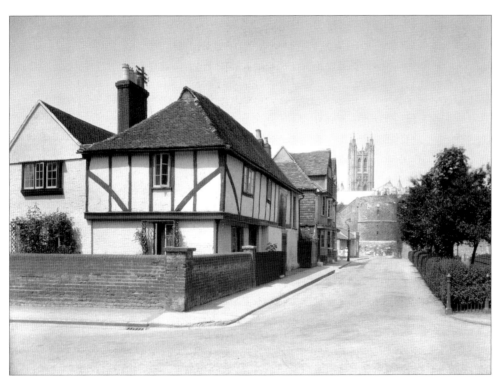

Lady Wotton's Green in front of St Augustine's College with a bastion of the city walls and the Cathedral to the west. These timber-framed buildings were blasted to bits in 1942 and then a ring road was driven through in front of the Mediaeval city walls.

praise were 'two imaginative shops' by Robert Paine & Partners, one of them in St George's Street, David Greig's, which was otherwise 'almost totally without character'.

Since then, several of the post-war rebuildings have themselves been replaced. Faced with the mediocrity of most of the replacement architecture which resulted from enemy action during the Second World War, it has become a *cliché* to observe that in so many cities wartime plans and post-war rebuilding did more damage than the Luftwaffe. In Canterbury that truth is particularly difficult to deny.

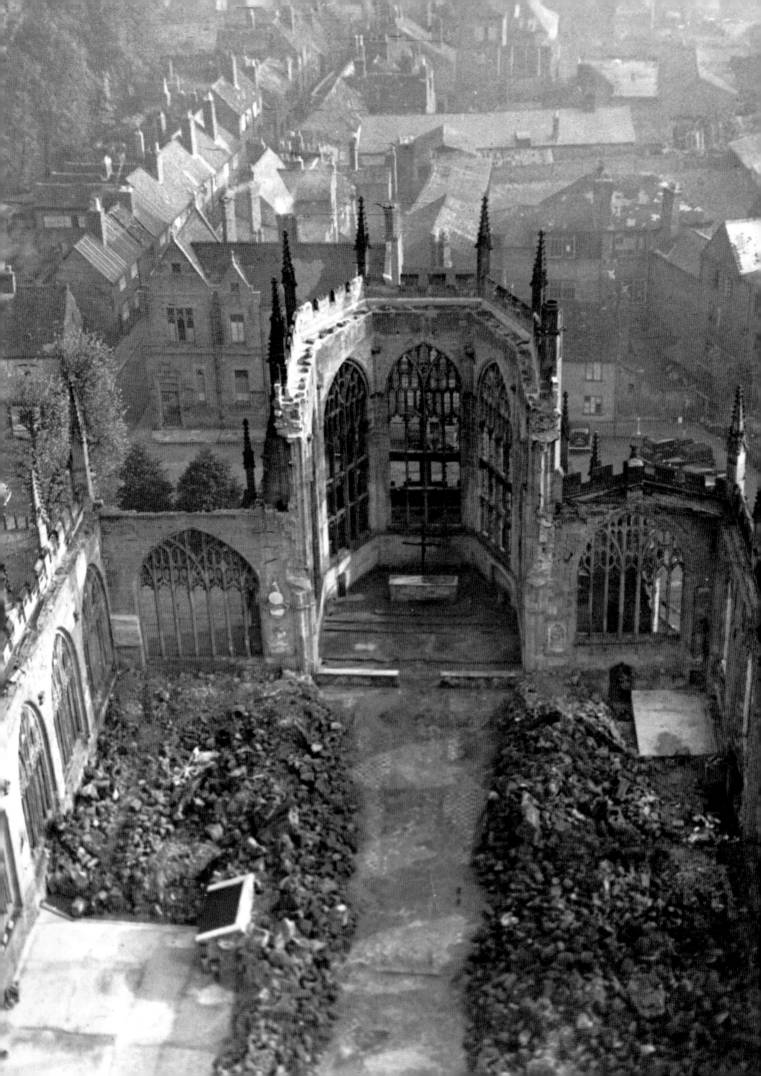

5: COVENTRY

During the night of 14 November 1940, in the first 'major raid' suffered by Britain, the centre of the ancient city of Coventry was destroyed. Guided by the '*X*'-*Gerät* navigation beam system, over four hundred German bombers dropped some 30,000 incendiary bombs and over 500 tons of high explosives on the city. Communications and services completely collapsed as the city burned. Almost six hundred people were killed that night and some 60,000 houses destroyed or damaged. The principal architectural casualty was the Cathedral, the former Late Mediaeval parish church of St Michael, which was entirely gutted by fire. Although the Royal Air Force would later inflict much greater loss of life and destruction on Cologne, Hamburg and other German cities, sudden devastation on this scale was unprecedented. German radio broadcasts coined a new verb to describe it: *Koventrieren* – 'to Coventry'.

British propaganda was quick to exploit this catastrophe to emphasise German ruthlessness and barbarism and to make Coventry into a symbol of British resilience. 'For English people, at least, the word Coventry has had a special sound ever since that night', wrote W.G. Hoskins after the war, 'though so many other English towns suffered a like fate afterwards: but it marked the beginning for us of a new form of human warfare, more violent and more indiscriminate than had been known for over a thousand years . . .'[55] Photographs of the ruins of the ancient Cathedral were published around the world, and it was insisted that it would rise again, just as the city itself would be re-planned and rebuilt, better than before.

But the story of the destruction of Coventry is not so simple or straightforward. If any aerial bombardment can be justified in war, then Coventry was a legitimate target. It may have had a Mediaeval centre, but the city had greatly expanded and was full of bicycle, car and engineering works which had been turned over to armaments manufacture. Furthermore, severe as the damage was, a large number of ancient buildings survived the war – only to be destroyed in the cause of re-planning the city. But what is most shocking is that the finest streets of old Coventry, filled with picturesque half-timbered houses, had already been swept away just a few years before the outbreak

45

◄◄ The gutted shell of St Michael's Cathedral soon after its destruction during the night of 14 November 1940; the surviving houses to the east were all subsequently demolished.

▸ St Michael's Cathedral before the Second World War.

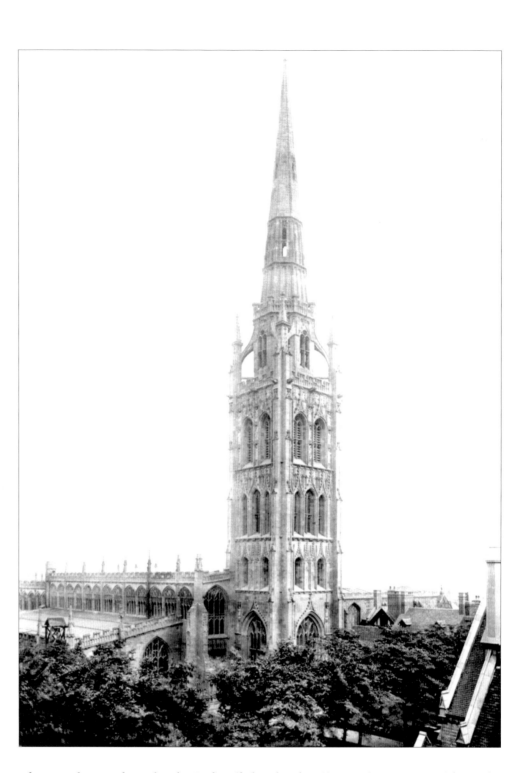

of war – destroyed not by the Luftwaffe but by the City Engineer. Even without the Second World War, old Coventry would probably have been planned out of existence anyway.

With its three tall and magnificent church spires and wealth of old gabled houses, Coventry had been a real Mediaeval city, sometimes described as an 'English Nuremberg'. J.B. Priestley visited on his *English Journey* in 1933 and found that

> It is genuinely old and picturesque: the cathedral of St Michael's, St Mary's Hall, Ford's and Bablake Hospitals, Butcher Row, and the old Palace Yard. You peep round a corner and see half-timbered and gabled houses that would do for the second act of the *Meistersinger*. In fact, you could stage the *Meistersinger* – or film it – in Coventry. I knew

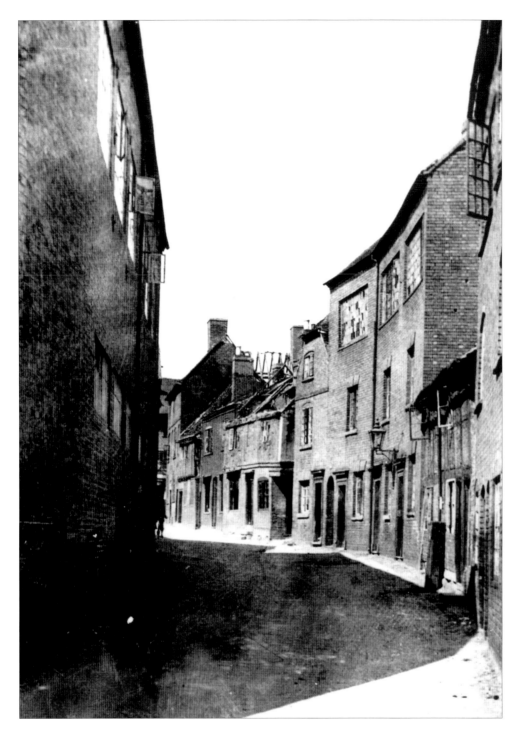

◀ St Agnes Lane during
its demolition in 1936; the
New Hippodrome was
built on the site.

it was an old place – for wasn't there Lady Godiva? – but I was surprised to find how much of the past, in soaring stone and carved wood, still remained in the city.

But, in fact, by this date, picturesque Coventry was already being systematically eliminated.

The problem was industry, which was changing the character of the city. The Daimler motor car factory – the first in Britain – had been established here in 1896 and others followed. As Priestley put it, 'These picturesque remains of the old Coventry are besieged by an army of nuts, bolts, hammers, spanners, gauges, drills, and machine lathes, for in a thick ring around this ancient centre are the motor-car and cycle factories, the machine tool makers, the magneto manufacturers, and the electrical

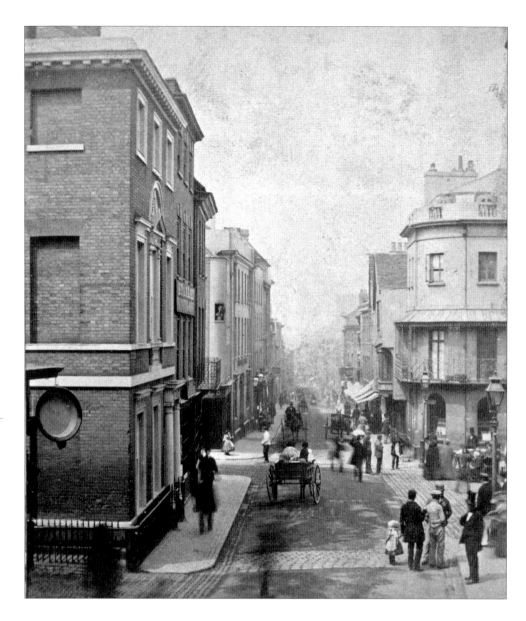

▶ Smithford Street seen from the High Street in the 1860s; the Georgian buildings had all been replaced by the 1930s and the street has since been replaced by the post-war shopping precinct.

companies'. The old and the new were increasingly in conflict, especially as the population of the city had tripled since the beginning of the century to reach a quarter of a million before the Second World War. For John Summerson, Coventry was the principal example of

> the collision of different ways of life, and different kinds of architecture. Before the war, one would meet the bedesmen of Bablake Hospital going to church in Tudor gowns. Many streets were still largely sixteenth and seventeenth century, built for men who made and sold woollen caps to the world outside their Gothic walls or fed or armed the makers and sellers of woollen caps. All this fitted the spired skyline and the mediaeval picture. But going further down the street one came to the Coventry of the ribbon-weavers and watchmakers – dirty red streets of grim little three-storey houses with long workroom windows under the eaves . . . Farther still, one came to the houses built in living memory, built for the cycle trade, the small-arms trade, the sewing-machine trade. But the real present-day Coventry was elusive until one realized that it was writhing – a huge invisible entity – through the whole city . . . until one realised that the cappers' houses and the ribbon-weavers' houses were teeming with factory-hands from Triumph, Singer, Rudge and Armstrong-Siddeley . . .[56]

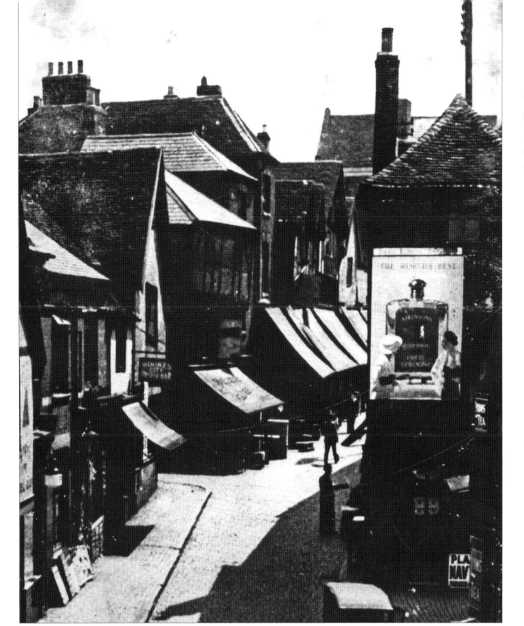

◁ Butcher Row, looking south in the 1930s; this ancient street, full of Elizabethan houses, was entirely wiped out in 1936 to create Trinity Street.

◁ The south end of Butcher Row, close to Holy Trinity Church, in c.1935.

▲ The Bull Ring and Butcher Row looking south from Ironmonger Row in 1935 shortly before demolition.

And cars and motor-cycles required wide new roads to drive along; narrow, winding Mediaeval streets would not do. In consequence, many were swept away by the city council on the west side of the city centre, from Fleet Street to Chapel Street – roughly the area later to be covered by the post-war shopping precinct – for the laying out of Corporation Street in 1929-31. Worse was to follow. Cross Cheaping north of Broadgate – the commercial centre – was widened, while the old buildings to the east in front of Holy Trinity Church were razed in 1936-37 to create another new street, Trinity Street. These included the best of the ancient lanes: Great Butcher Row and the Bull Ring. Other old streets like St Agnes Lane were removed at the same time. All this was carried out by Ernest Ford, the City Engineer. The city authorities seem to have had no regrets about this destruction; in opening Trinity Street in 1937, the Lord Mayor referred to the old Butcher Row as 'a blot on the city'.[57]

In view of the concentration of factories near the centre of the city, it was scarcely surprising that Coventry was a target for the Luftwaffe. The first raid took place in mid-August and several followed, although the scale and the ferocity of the attack on 14 November – launched in retaliation for the first British raid on Berlin – took Coventry and the nation by surprise. Many factories were damaged (although production soon resumed) but the area most devastated was the city centre around Broadgate, which had already been much rebuilt in the 20th century. Further raids followed, and a severe raid

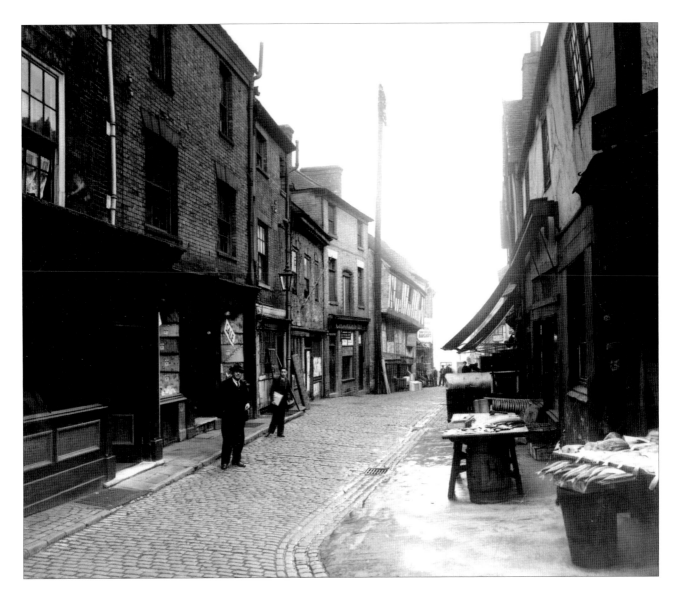

in April 1941 destroyed the early 19th-century nave of Christ Church which had been added to the old Greyfriars steeple.

▲ Butcher Row, looking north from Trinity churchyard, in 1935.

In one respect, however, Coventry had been ready for the attacks. Well before the outbreak of war the city council already had the City Engineer's department, together with a new town planning section, eager to continue improving the existing city. And in 1938, following Labour taking control of the council, Donald Gibson was appointed the first City Architect and soon assembled a team to prepare radical plans for Coventry. Their vision of 'Coventry of Tomorrow' was exhibited in May 1940 – before the bombing started. The two departments proved unable to collaborate, and after the 14 November blitz the city was offered two rival plans. For Gibson, the bombing was 'a blessing in disguise. The jerries cleared out the core of the city, a chaotic mess, and now we can start anew'.[58] He later recalled that, 'We used to watch from the roof to see which buildings were blazing and then dash downstairs to check how much easier it would be to put our plans into action'.[59]

Gibson's plan was soon adopted by the city council, in February 1941. It envisaged a new civic centre and a partly pedestrianised shopping precinct all within a ring road. A local paper reported that 'The City Architect has tolerated no barriers, has refused to concern himself unduly with the preservation of ancient features, has disregarded the lines of ancient streets insofar as they complicate his scheme, and has certainly not

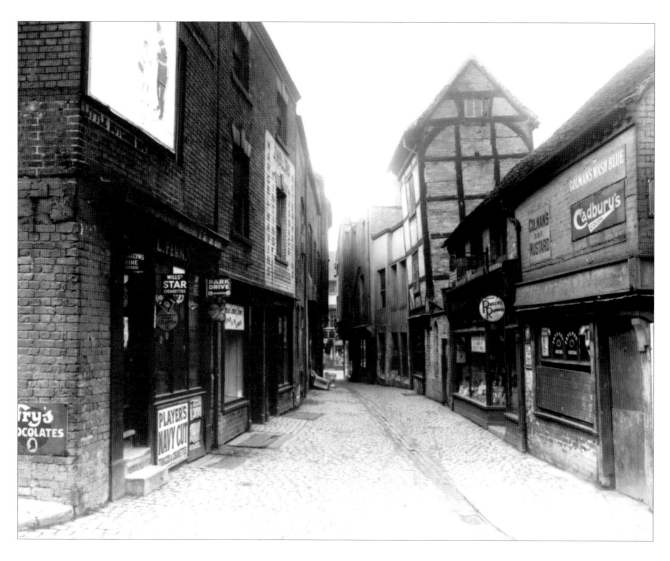

▲ Little Butcher Row, off
Great Butcher Row,
looking west in *c*.1935
shortly before demolition.

permitted questions of cost to cramp his inspiration'.[60] By comparison, the City Engineer seemed almost a preservationist. Possibly exhibiting the taste for for half-timbered Tudor typical of his generation, Ernest Ford was concerned about the fate of Ford's Hospital, 'one of the most famous timber buildings in the country', which in 1940 had 'received a direct hit but escaped annihilation by fire, and can certainly be reconstructed'.[61] For Gibson, however, it was an 'unnecessary problem', as it stood in the way of his proposed nice new straight street from Broadgate to the railway station. One version of his plan shows it standing pathetically on a roundabout in the middle of this road. In the event, the ancient timber almshouse was reconstructed on its original site in 1951-53.

An exhibition of 'Coventry of the Future' mounted in 1945 was visited by a quarter of its citizens. No poll was taken as to their opinions on the proposals, but newspapers suggest that a majority probably sympathised with one correspondent who pleaded, 'Give us Coventry back as we knew it'.[62] The council, however, was determined to press ahead with something conspicuously modern and, owing to Coventry's symbolic international status as a martyred city, it was able to pursue the rebuilding more vigorously and faster than was the case in other bombed cities. The redeveloped Broadgate was opened by the Queen in 1948 and work then began on the shopping precinct to its west. The other symbol of Coventry's renaissance, the new Cathedral designed by Basil Spence and built next to the ruins of the old, was consecrated in 1962 and was surely the last modern building that the general public queued to see.

However, a number of historic buildings still stood, both in Priory Row to the north of the Cathedral and elsewhere in the city, where they impeded the realisation of Gibson's vision. The Society for the Protection of Ancient Buildings had estimated that 120 timber houses had survived the war and a survey by the National Buildings Record in 1958 found a hundred still remaining. Two thirds of these would disappear over the next few years as Arthur Ling, Gibson's successor as City Architect and Planning Officer, continued with Gibson's revised plan and pushed forward the construction of the ring road and of new buildings like the Lanchester College of Technology. In August 1961, as piles of old timbers from demolished houses in Little Park Street were burning, the *Coventry Standard* ran the front-page headline, 'Demolition Recalls the Days of the Blitz'. A few buildings were retained, however, but removed from their original sites and re-erected near the surviving Bablake School and Bond's Hospital in Spon Street as a sanitised and inauthentic historic quarter – a sort of *skansen*, the type of open-air museum pioneered in Stockholm consisting of rescued timber buildings.

When Nikolaus Pevsner visited the city in 1964 for the *Warwickshire* volume of the *Buildings of England*, he found that 'the centre of Coventry . . . can only be treated in C20 terms. All else is very minor, and the mediaeval buildings above ground are an alien body . . .' And although he considered that the re-planning was 'of international interest', he had to admit that the new buildings (apart from the Cathedral) were 'undistinguished'.[63] Today, whatever integrity the post-war rebuilding ever had has been undermined by subsequent undistinguished alterations and replacements. Coventry has been more transformed in the course of the 20th century than any other city in Britain, both in terms of its buildings and the street pattern. The three Mediaeval spires may still stand, but otherwise the appearance of 'England's Nuremberg' can only now be apprehended in old photographs. Perhaps it would have been better if the city council had listened more to those it represented, such as 'An Old Citizen' who wrote to a local newspaper back in 1941 that 'We should like the new Coventry to be something of the old Coventry, and not merely a fourth-rate provincial city on futurist lines'.[64]

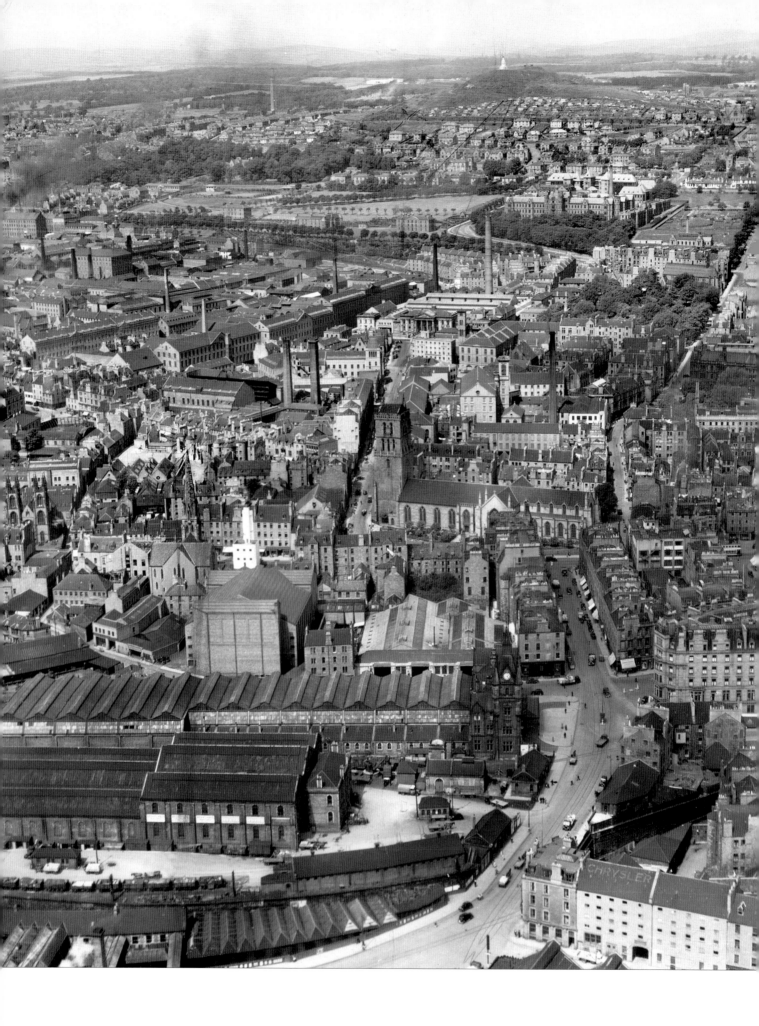

6: DUNDEE

It is very hard now to imagine that Dundee could ever have been described, as it was in 1689, as 'a very pretty town' with 'buildings such as speak of the substance and riches of the place'.[65] Situated magnificently and strategically on the Firth of Tay, Dundee long prospered through trade with the Baltic, yet almost the only relic today of its Mediaeval origins is the much restored Old Steeple of the twin City Churches. Evidence of later centuries has also been systematically eliminated, but to no great effect. 'Dundee has none of the formal planning so proudly displayed in Edinburgh, Glasgow or Aberdeen,' write Charles McKean and David Walker in their architectural guide to the city; 'and it has obliterated the ancient topographical features that shaped it – the shoreline and harbour, the Corbie Hill, the Castle Rock, and the Scouring Burn. As a consequence, the impression it now presents to the casual visitor is one of randomness if not incoherence.'[66]

Dundee has certainly suffered from misfortunes, perhaps the most celebrated being the collapse of the first Tay railway bridge during a dreadful storm in 1879 ('Which will be remember'd for a very long time', as Dundee's notorious local poet, William McGonagall, memorably rhymed), taking a train and its passengers with it into the water. Much more serious was the murderous sacking of the town in 1651 during the Civil War. Yet it had recovered its prosperity by the 18th century, and in the 20th it escaped serious damage from aerial bombardment. As is so often the case, Dundee's modern wounds are almost entirely self-inflicted. Writing just after the Second World War, G.S. Fraser was ruder than any modern commentator. 'Dundee is the third city in Scotland,' he noted, 'a centre of the jute industry, noted for its resourceful female labour, famous for its jams, its marmalades, its cakes studded with almonds, its black indigestible; but it has no beauty that a man should desire it; it tore down its Town House, which was one of William Adam's best buildings, and it is mere chance, I suppose, that the fine steeple of its Town Church is still intact. It has no shape or soul . . . a sad, floundering thing.'[67] And that was in 1948, before the most destructive architectural assault since General Monk's had begun.

◀◀ An aerial view looking north in 1947 before the city centre was ripped apart by roads and shopping precincts. The railway station is in the foreground, the City Churches in Nethergate in the middle distance.

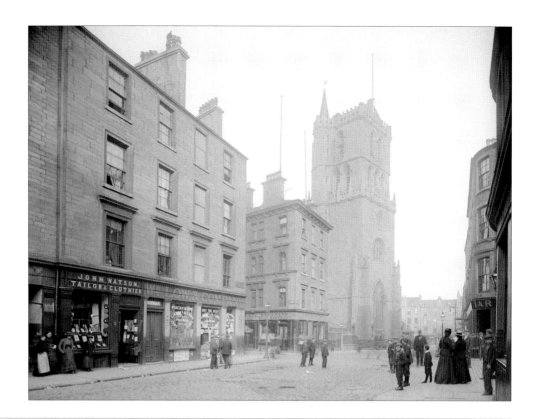

▶ Lyndsay Street looking
south to Nethergate,
photographed by
Alexander Wilson in
the late 19th century.
All these buildings as
well as the street have
disappeared apart from
the 15th-century Old
Steeple.

56

Fortunately, the buildings and streets of an older Dundee were recorded in a series of magnificent photographs taken in the late 19th century by an amateur photographer, Alexander Wilson, who bequeathed them to the city. These reveal how fine were the old streets of the town centre, and how distinguished some of the buildings – particularly those of the 18th century, like the Trades Hall and Union Hall at either end of the High Street, both now gone. Above all there was the magnificent Town House in between, with its arcades and steeple, designed by William Adam, the father of Robert and James. That this could have been demolished in 1932, albeit for a grand Classical new City Square, remains incomprehensible and unforgivable. Today, Georgian Dundee has largely disappeared, although some of the best of Victorian Dundee has managed to survive.

There was, however, a dark side to the city. Its prosperity in the 18th century combined with the good communications by sea attracted other trades and industries, and in the 19th century came mills and factories – many associated with the linen industry. And with all these came a rising working-class population that was largely crammed into the old streets and tenements. As the Dundee-born historian, David Walker, has written, 'there grew up a town of distressing ugliness'. The Victorians, however, decided to do something about these social evils and, after the passing of the 1871 City Improvement Act, many of the worst slums were dealt with while new streets were laid out. Unfortunately, this usually also meant the obliteration of so many relics of the ancient burgh of Dundee – 'buildings of exceptional architectural and historical interest' – while the new streets laid out by the Burgh Engineer, like Commercial Street and Whitehall Street had facades that were as uniform as they were mediocre.

▶▶ The High Street in
c. 1910 with, on the right,
William Adam's
magnificent Town House,
built in 1732-34 and
demolished in 1932.

Then, in the 20th century, it was the turn of the Victorian city to be replaced. Writing in 1955, David Walker observed that 'Demolition and reconstruction have already obliterated much of the structural evidence of Victorian prosperity, and the historian's task becomes harder as the years pass'. The process of destruction greatly increased in the following decade. Dundee was once known for 'jam, jute and journalism', but the linen industry had collapsed and the city had to cope with the usual consequences of

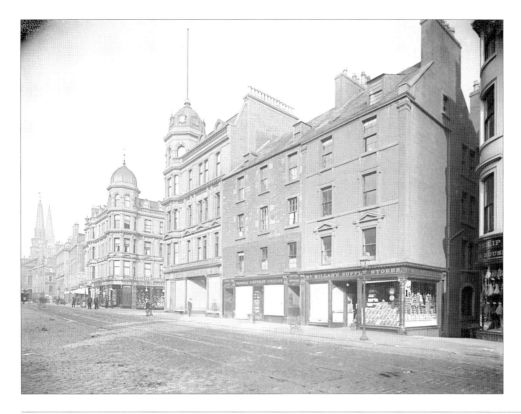

◁ Nethergate looking east to the High Street in the late 19th century; photograph by Alexander Wilson.

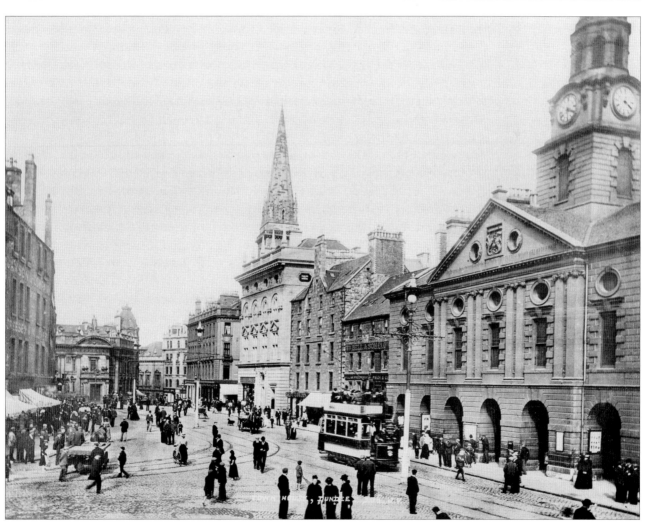

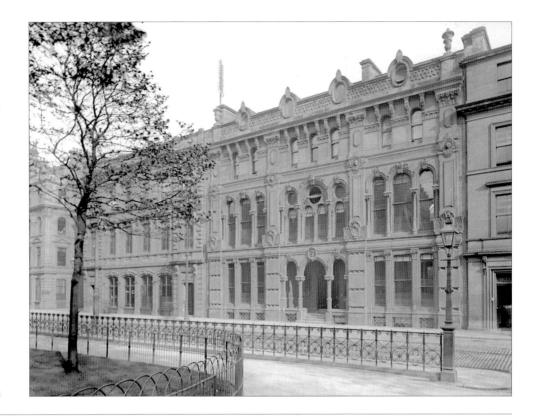

▶ The Eastern Club on the south side of Albert Square, an extraordinary building by F.T. Pilkington of 1870 photographed by Alexander Wilson in the later 19th century and demolished a century later.

58

industrial decline (today it is only really journalism that flourishes as the city remains the home of the *Dandy* and the *Beano*). The response of the authorities was brutally conventional. In the guide David Walker wrote with Charles McKean, it was observed that Dundee's 'instinctive attitude after the Second World War was to view its Victorian history as that of an industrial Babylon to be obliterated as a scar on the face of humanity. A new Dundee was to be created, of bypasses, shopping centres and prominent (indeed, very prominent) housing estates.'

A number of fine Victorian buildings fell victim to this attitude. The striking Eastern Club in Albert Square – the city's cultural heart – designed by that intriguing 'Rogue' architect, F.T. Pilkington, was torn down because it was regarded as unsuitable for conversion into a bank. And J.T. Rochead's grotesque but lovable Royal Arch, erected by the docks to commemorate the visit by Queen Victoria in 1844, was gratuitously removed to make way for slip roads connecting with the Tay Road Bridge. This new bridge, opened in 1966, could easily have been built further to the east and so caused less damage; as it was, its approaches required the filling-in of several of Dundee's old docks, leaving them as silly open spaces. New roads did their worst: the inner by-pass swept away much of Overgate and Nethergate and severed the city centre from the inner western suburbs where the University is situated; it then swept round to the east to separate Dundee from the river Tay.

Worst of all was the comprehensive redevelopment of the city centre in the 1960s. The small-scale buildings which gave interest and character to the High Street and Nethergate were eliminated. The Overgate, the ancient western route from the High Street out of the city, was entirely obliterated from the map in favour of the Overgate Centre, a blandly overweening and nasty new shopping centre by Ian Burke, Hugh Martin & Partners which opened in 1967. Similarly, the Wellgate, part of the ancient route north to Hilltown, was replaced by the repulsive Wellgate Centre by James Parr & Partners opened in 1977. But enough was enough. Since the 1980s, Dundee has begun to appreciate its past and discovered the value of conservation. Surviving mill buildings

▶▶ The Royal Arch, an endearingly grotesque neo-Norman structure designed by J.T. Rochead erected between the Earl Grey and King William IV docks to commemorate the visit of Queen Victoria in 1844, and gratuitously dynamited in 1964.

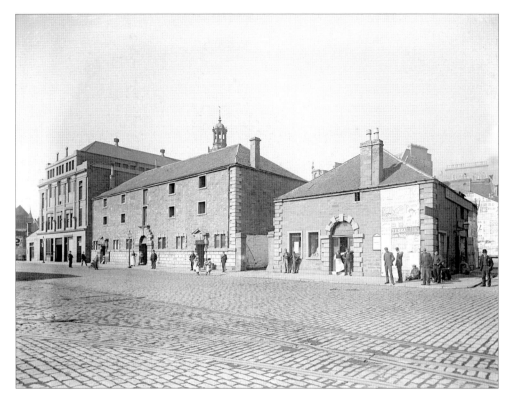

◀ Dock Street photographed by Alexander Wilson; on the left is the back of the Gilfillan Memorial Church of 1879 by Malcolm Stark, while the severe Palladian building in the centre was the now demolished public warehouse designed by William Robertson of Leven and built in 1758

DUNDEE

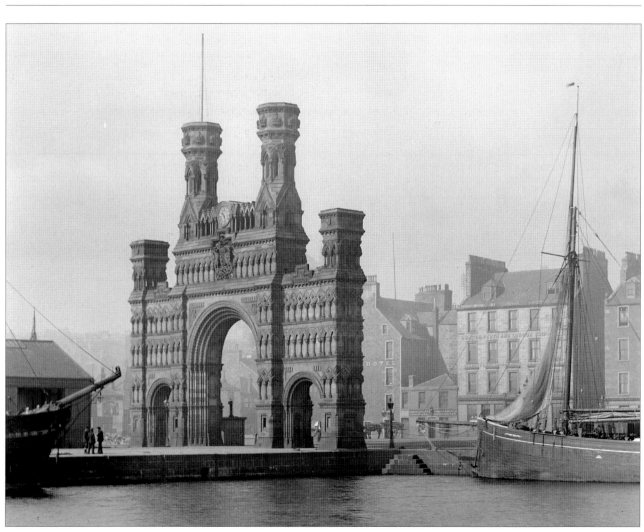

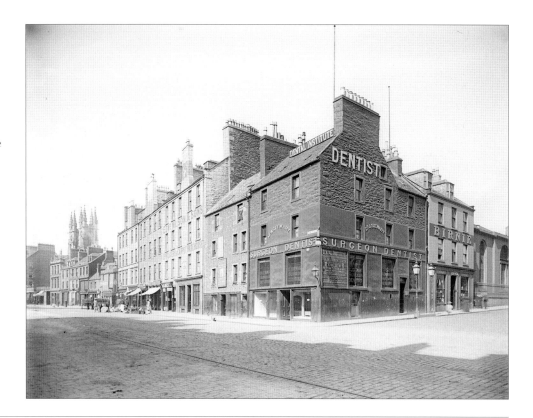

▶ Looking west along Nethergate from the corner of Lindsay Street photographed by Alexander Wilson in the late 19th century. All these buildings disappeared in the mid-20th century including St Enoch's Church with its twin towers.

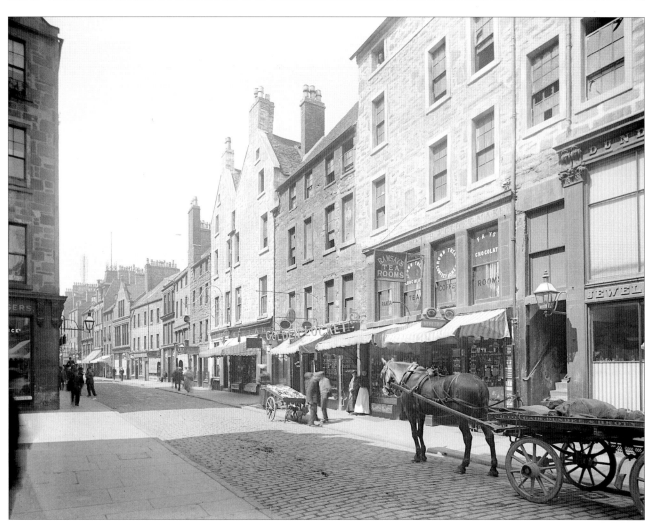

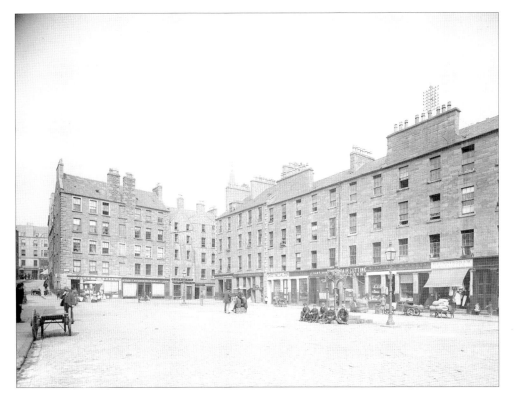

◀ The Greenmarket with
Crichton Street on the
left leading to the High
Street, photographed by
Alexander Wilson in
c.1888-89. This public
space disappeared in the
early 20th century.

have been converted into flats, the precious relics of earlier centuries at last cared for, and some of the many yawning gaps filled. And some of the brutal mistakes of the 1960s have begun to be undone.

By 1993, McKean and Walker optimistically wrote that the Overgate Centre, 'for which Dundee destroyed most of its surviving 17th-century heritage, may soon prove to be a transitory aberration as the city discovers the innate character of its spaces'. And so it has come to pass: the Overgate Centre has now largely been redeveloped and the Wellgate Centre revamped. But nothing can bring back the life and character of the old streets of Dundee, which can now only be recreated in the mind with the aid of maps and Alexander Wilson's precious photographs, while the challenge of civilising the Shore of the Tay remains. Writing of the Overgate Centre in the first edition of their architectural guide, published in 1984, Charles McKean and David Walker wrote that 'A development of this type has to be seen in the context of its time'.[68] True enough, as it must be of any building or event of any era. But, for all the revisionism of architectural history that now, rightly, tries to see merit in the best productions of the 1960s, contemplating the cities of Britain in general and Dundee in particular it is hard not to conclude that that context was one of ruthless arrogance and blinkered ignorance – the consequence of naïve utopianism fuelled by a mixture of self-interest and self-hatred. Such attitudes now seem neither admirable nor sympathetic.

◀◀ Overgate, the old route
out of the city to the west
in the late 19th century.
The street was completely
eliminated in the 1960s to
make way for the Overgate
Centre.

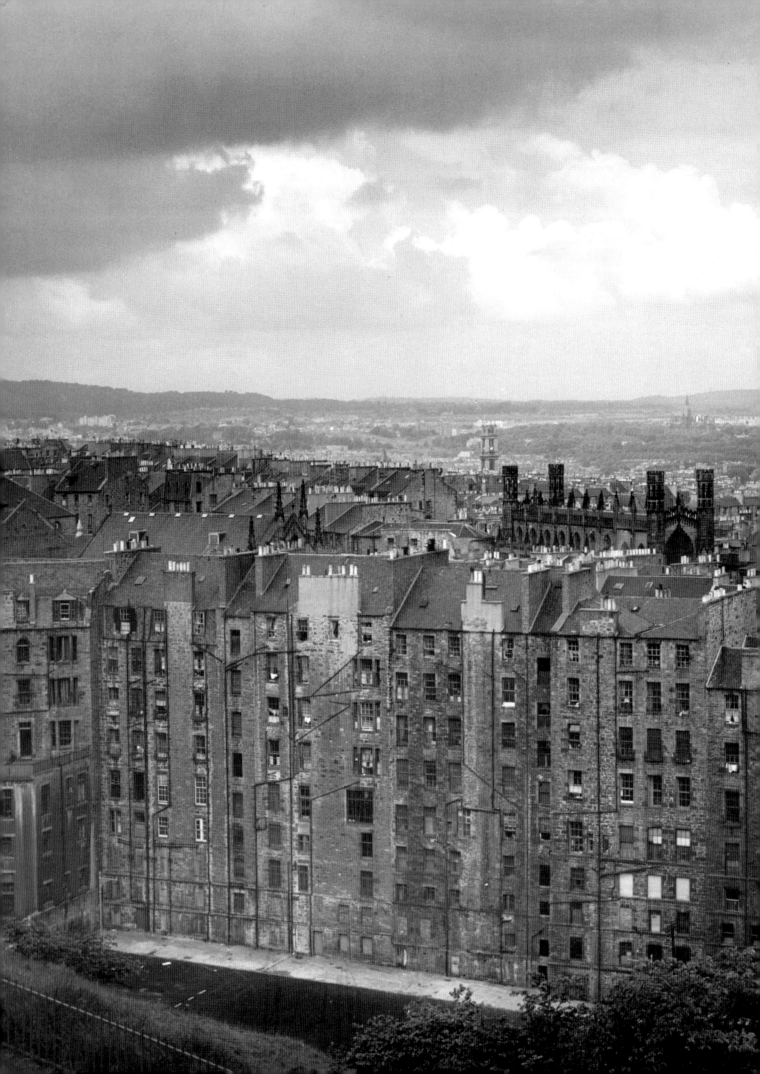

7: EDINBURGH

Although the consequences may now seem highly regrettable, it is possible to understand and even to have sympathy with the thinking which led to Dundee and Glasgow or the cities of the north of England to pursue policies of comprehensive redevelopment in the decades after the Second World War. Their Victorian and earlier buildings, often smoke-blackened and neglected, were inextricably associated not only with the trauma of industrial decline and the loss of civic pride but also with the ruthless capitalism and the social injustice and class-division of earlier and seemingly less enlightened times – especially after the privations suffered in these cities during the Depression in the 1930s. No wonder they wished to erase the memory of the past and, seduced by the rhetoric of modernity, replace it with a bright, new, progressive future – a future which, crucially, was *planned*.

None of the above was true of Edinburgh, yet the capital of Scotland was also gravely damaged by redevelopment schemes and by town-planning proposals during the same decades. Edinburgh, once – surely rightly – described by the painter James Pryde as 'the most romantic city in the world', knew that it was special, uncommonly beautiful and incomparable. Of course it could not be treated as sacrosanct – no city is perfect and can remain static – but its carefully composed and highly regarded physical fabric should have been treated with rather more respect. The damage done was inexcusable, and those who spoilt Edinburgh in the 1960s therefore deserve infinitely more censure. 'A plan for Edinburgh must needs be a hazardous undertaking: there can be few cities towards which the inhabitants display a fiercer loyalty or deeper affection, feelings which have existed in the past and which persist today. Even its blemishes are venerated . . ', wrote (Sir) Patrick Abercrombie, the celebrated town planner, along with Derek Plumstead in their *Civic Survey & Plan* for the city published in 1949. 'The planner who dares to propose improvements must go warily and whatever he proposes he must expect sharp and informed criticism'.[70] This did not, however, prevent them from proposing that new roads should be carved through the city centre nor from regarding much of its urban fabric as expendable.

◀◀ The view looking north-west from Calton Hill photographed by Edwin Smith in 1963; the tenements along Greenside Place, the continuation of Leith Street, with their surprisingly tall nine-story rear elevations were cleared in the early 1970s.

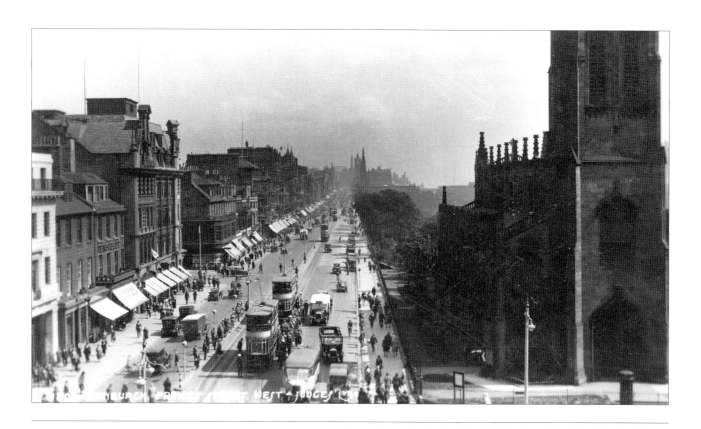

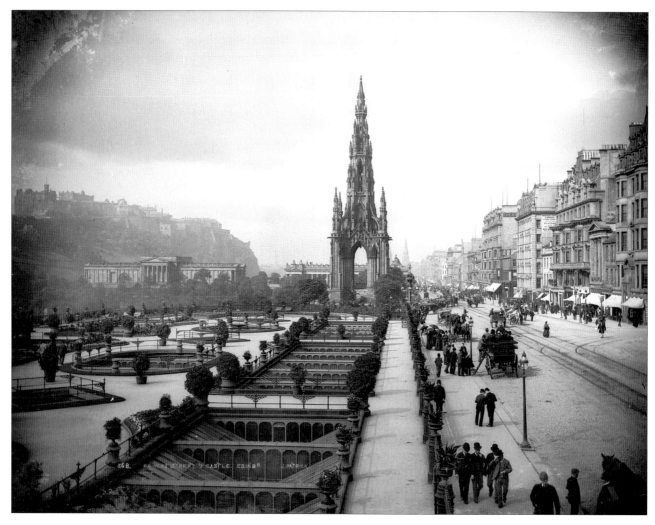

The extraordinary beauty and excitement of Edinburgh come both from its dramatic topography and from the fact that it consists of two quite different urban fabrics, which, by both accident and design, are inextricably connected to produce a highly romantic townscape. There is the Old Town, originally developed along the Royal Mile, the long street which runs on the top of the volcanic ridge that stretches from the castle in the West and the Palace of Holyroodhouse to the east. This, until the middle of the 18th century, was Edinburgh. Then, after the final defeat of the Jacobites at Culloden, a New Town of superb cut stone was laid out parallel to the old on the high ground to the north, overlooking the Firth of Clyde. This, in its planned geometrical orderliness and Classical style was, whether for better or worse, an affirmation of Britishness and of loyalty to the Hanoverian crown in London.

But although divided by Princes Street Gardens, the former loch which, now a park, is one of Edinburgh's glories (enhanced by the railway running along its bottom), the two towns are visually integrated. New north-south streets cut through the dense fabric of the Old Town and, in the New, every vista is closed either by a view of the towering buildings of the Old Town, or by a portico or monument, or by a glimpse of mountain-side or the sea. For once, planning resulted in an urban landscape in which the man-made and the natural, the Classical and the Romantic, are held in balance. The unique character of Edinburgh, in fact, results from the combination of the planned and unplanned. And the planned is of the highest quality – no wonder today that the New Town is a World Heritage site. 'It is . . . to be hoped in this age when everything is planned, or supposed to be planned,' wrote Ian G. Lindsay in 1948, 'that the planning of a previous age may be respected and furthermore with this example before them it may even be possible, should they be humble enough, for the present-day planners to learn just a little, not only of the possibilities but of the limitations of planning'.[71]

It was to the Old Town that the 20th-century planners first turned their attention. The problem here was the advent of the new Town, to which the wealthy and important had soon fled. In consequence, many of the picturesque but closely packed ancient buildings along the Royal Mile and in the surrounding streets and closes became dilapidated, densely populated and perceived as slums. The rebuilding of the Canongate, the lower end of the Royal Mile, was begun by the Town Council in the 1930s but, fortunately, this was at least done vaguely according to the theories of the great Scots urbanist, Patrick Geddes, who recommended renewal by 'conservative surgery'. After the Second World War, Ian Lindsay could write how

> Here and there are ancient houses of great merit, but those which have been kept in reason-
> able repair can almost be counted on the fingers of one hand. This is a most deplorable state
> of affairs which would not be tolerated in most countries. Thus the old town, in spite of its
> history, which doesn't necessarily interest everybody, cannot afford to rest on its laurels
> much longer if anyone, except the paper historian, is going to enjoy it in the future.

Rebuilding in the Canongate continued in the 1950s, but this was still in the spirit of Geddes, and if rather more was replaced than may now seem to have been necessary, at least the essential character of the Royal Mile was maintained.

It was the Georgian and Victorian parts of Edinburgh that came under most attack. In 1948, Lindsay felt it necessary to warn that the New Town should not be 'wantonly hacked about as was the old town in the past or merely allowed to decay like the Old Town at present'. That the New Town could seem to be threatened – at the very time when the Edinburgh Festival was founded – is symptomatic of the essential malaise which affected the city in the mid-century. Perhaps this was a reflection of the mood of Scotland as a whole, which was one of loss of direction, cultural cringe and defeatism masquerading as a belief in the new, but in Edinburgh this was compounded by a

◀◀ Princes Street looking east from St John's Church towards Calton Hill in the 1930s; many of the buildings lining the street have since been replaced.

◀◀ Princes Street looking west from the North British Hotel towards the Scott Monument and the Mound in c.1890.

▶ The corner of Leith Street and Little King Street, leading towards St James's Square, in 1966, shortly before it was all swept away.

66

marked reluctance to spend money on maintaining historic buildings. In recalling the conservation battles of the 1960s, Alistair Rowan has recently written how

> It should not be forgotten that these were far from easy times for those of us who were concerned about the future of historic buildings and wanted to see a more responsible attitude towards their preservation and conservation. The Scottish establishment was hostile to expertise and what it saw as interference in the legitimate pursuit of its ends. That time was a much more reverential age and those of us who wanted to see a change of attitude to historic buildings had to cope with cautious and timid administrators whose principal concern seemed sometimes to be their own careers and an instinctive determination not to ruffle the government's feathers or to spend government money.[72]

What happened to Princes Street in the 20th century is characteristic and revealing. A long, one-sided promenade defining the edge of the New Town, overlooking the gardens in the valley to the south and the panorama beyond created by the Castle Rock together with the wall of tall old buildings that defines the old Town, it ought to be one of the most beautiful streets in Europe. But it is not. Instead, it is now largely lined with discordant modern buildings which are mostly of the utmost mediocrity. When in 1929 the young John Summerson, who had recently discovered Le Corbusier, wrote in the *Scotsman* newspaper that 'the Edinburgh of the future, a glittering spectacle of steel, glass and concrete, is already a conception by no means unimaginable', this was found very shocking by the city's introverted and conservative establishment.[73] Yet by the 1950s the entire rebuilding of Princes Street – envisaged by Abercrombie (who proposed traffic running beneath the road) – could be contemplated.

The Princes Street Panel, consisting of three architects, was set up in 1954 and recommended that new buildings should have first-floor balconies which would eventually form a continuous walkway. This idiocy, abandoned by the end of the 1970s, was used as an excuse for doing away with two of the best buildings in the street. These stood close to the Mound and its Greek Revival institutional monuments. One was the

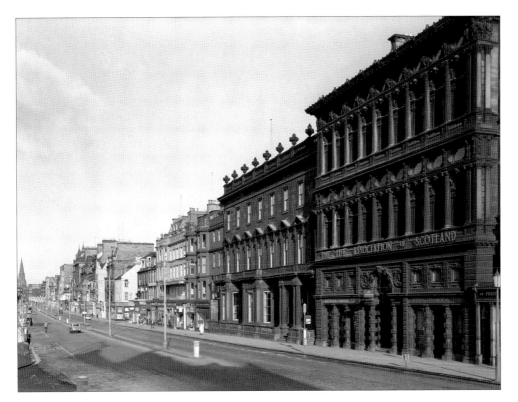

◀ Princes Street, with William Burn's New Club and its neighbour, the Life Association of Scotland building with its rich Italianate façade by David Rhind, in the early 1960s. Both – perhaps the finest buildings in the street – were demolished in 1966-67.

EDINBURGH

67

New Club with is severe Italianate façade by William Burn; the other was its immediate neighbour, the Life Association of Scotland building. This last, designed by David Rhind in 1855 with help from Sir Charles Barry, had a magnificent sculptural façade and was described by Henry-Russell Hitchcock as 'the best of all buildings in Britain in the Venetian High Renaissance style'.[74] Both buildings could have accommodated the wretched walkway behind the windows at first floor level, but both came down – the first in 1966, the second a year later. Strong representations in favour of the listed Life Association building were simply ignored by the Secretary of State for Scotland.

Such was the fate of two individual buildings of great merit, but there were two whole districts in Edinburgh, both of great architectural and topographical importance, whose comprehensive rebuilding in the 1960s did immense damage to the city. The first was the area between the New Town and Calton Hill where the road from Leith joined Princes Street and Waterloo Place. Here, behind Robert Adam's Register House, was St James's Square, laid out by James Craig after 1773. This was not only the oldest part of the wider New Town but also the city's first attempt at unified terrace design. Just a little to the east was Leith Street, whose steeply descending gentle S-bend was defined by severely elegant stone terraces. St James's Square – which Abercrombie had earmarked for rebuilding as a cultural centre – had fallen into industrial use and was cleared away in 1965 to make way for the St James's Centre, a tawdry and unpleasant covered shopping precinct which has had to be greatly improved since, together with New St Andrew's House, a government building whose sinister bureaucratic function was well conveyed by its banal, repetitive system-built exterior. Things might have been even worse, as the celebrated Café Royal tucked behind the Register House was also threatened with demolition in the late 1960s.

As for Leith Street, the Georgian terraces on the west had to be cleared for the St James's Centre while most of those on the eastern side, together with most of the steep street now called Calton Hill, were destroyed in 1973-74 to make way for a mercifully unrealised traffic interchange for the planned inner ring road – a proposal stemming

▶ The south-east side of St James's Square, the oldest part of the New Town, in its last sad days in 1966, shortly before demolition.

from Abercrombie which blighted eastern central Edinburgh for decades. Leith Street today is a mere traffic artery, dominated by the shopping centre and disgorging into an incoherent cleared space, with no proper urban boundary set against the hillside of Calton Hill. It is perhaps the most depressing part of the city, especially when one knows what stood here before.

The other area transformed in the 1960s was George Square, a Georgian development on the other side of the Old Town. The square was laid out by James Brown in 1766 and was once the smartest address in Edinburgh. Abercrombie, however, considered that 'the Square, as a whole, should not be rated as high as some in the 'New Town' . . . The case for preservation should not only take the architectural and historical value into account but also what can be achieved by building anew'. This qualification reflected the fact that Edinburgh University had its eye on the site. In 1958 the Secretary of State for Scotland declined to hold a public inquiry into its plans for redevelopment and over the following decade the whole of the south side, half of the east side and most of the north side of George Square were replaced by University buildings. The best of these, perhaps, was the University Library by Basil Spence, Glover & Ferguson of 1965-67, but that is not really the point. As Alistair Rowan has written, recalling articles he wrote in 1969 about the University's further redevelopment plans,

> it is astonishing to consider the wrong-headedness and perverse determination of the City Council and University authorities at that time. People's reputations were bound up with whether a building was allowed to survive or was torn down. Indeed there were those who took grim satisfaction when Hunters' men – the major demolition contractors in the city – arrived and a massive steel ball began to be swung relentlessly against some hapless Georgian façade.

Ostensibly seats of learning, committed to civilized values and debate, Universities seem always to be utterly convinced that their own perceived needs transcend any wider issues of civic responsibility or public interest and so can behave with disgraceful

◀ The north-west side of James Craig's St James's Square in 1963, shortly before its demolition.

◀ The south-east side of Leith Street, originally called Greenside Street, in 1968 (see plate on p. 62); these terraces would all be demolished within a few years.

arrogance. This was soon demonstrated in Edinburgh by the Factorial Secretary's determination to pull down the Crichton Street triangle near George Square, a courtyard of tenements built after 1778 by James Brown. Arguing that it would be too expensive to restore them, and dismissing arguments that they could be converted into student residences, they were bulldozed in 1970. The site then remained empty, used merely as a car park, for the following thirty-five years.

Some good came of the wilful destruction of George Square, in that the threat to it

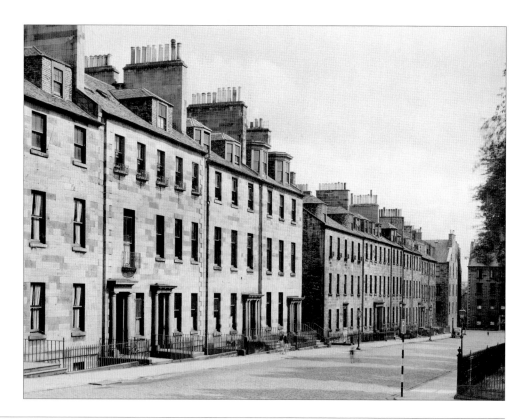

▶ The east side of George Square, photographed by Miss Tait in the 1950s, shortly before the right hand terrace was demolished by the University of Edinburgh.

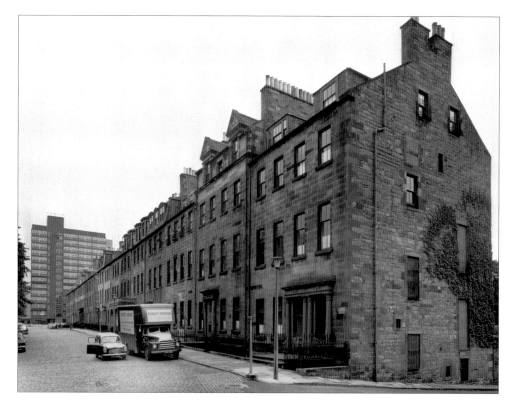

▶ The south side of George Square, with the David Hume Tower in the distance, in the mid 1960s, shortly before the whole terrace was demolished to make way for the University Library.

provoked the foundation of the Scottish Georgian Society – now the Architectural Heritage Society of Scotland – in 1956, followed by the formation of the Scottish Civic Trust a decade later, in 1967. Oddly enough, the most important boost to the cause of conservation in Edinburgh came with the *volte-face* performed by the modernist architect and planner, Sir Robert Matthew, whose firm, Robert Matthew, Johnson-Marshall & Partners, had been responsible for the University's Arts Tower replacing

◀ The north-west side of Leith Street leading up to the North British Hotel, photographed by *Country Life* shortly before the First World War for Arthur T. Bolton's proposed book on the architecture of Robert & James Adam. These houses, not in fact by Adam, were demolished in the 1960s to make way for the St James's Centre.

the south-east corner of George Square. 'In the last few years', he said in 1969, 'and I speak from long and bitter experience, public opinion on the quality of environment has visibly moved from almost total indifference to one of concern, if not alarm'.[75] Although, inevitably, complacently accepting of change, Matthew became interested in the preservation of the New Town and was the moving force behind the influential New Town Conference held in 1970. As A.J. Youngson concluded in his great study of *The Making of Classical Edinburgh* published in 1966, 'No vigorous and healthy society today will neglect or impair what was done then. It is for those who inherit the achievement of Edinburgh's classical age to understand it, to adapt it, to use it, and to enjoy it.'[76]

Although individual buildings of disgraceful mediocrity and inappropriateness continue to be erected in Edinburgh, no wilful destruction of any important monument or characterful district has taken place since the 1970s. There has been one major loss of a valuable portion of the precious historic fabric of the Old Town, but this was the result of accident rather than planning: the destruction by fire of a portion of Cowgate west of Nicholson Street in 2002. Whether this area can be rebuilt in a sympathetic manner remains to be seen.

8: EXETER

73

'We have chosen as targets the most beautiful places in England', announced German radio broadcasts on 4 May 1942. 'Exeter was a jewel. We have destroyed it'.[77] With its 14th-century Cathedral, remarkable for its long vaulted interior, its ancient buildings in the city centre and its Georgian inner suburbs, Exeter was certainly a most beautiful and interesting city. 'The character of a place depends less on its monuments than on the common run of its buildings', wrote the town planner Thomas Sharp immediately after the Second World War. 'Built up and overrun though it was in the last hundred years, Exeter still retained before the blitz some of the best vernacular buildings in England, and even today there are good early warehouses, good Georgian work, a number of early nineteenth-century examples of housing developments, which are hardly to be bettered anywhere'. As for the Georgian set pieces like Southernhay and Dix's Field, 'here was domestic building of the most civilised refinement and beauty. It was *these* buildings, along with the Cathedral and Bedford Circus, which made Exeter an architecturally important city.'

As with other bombed cities, however, blame for the destruction – or, rather, the spoiling – of this jewel cannot be heaped on the Luftwaffe alone. As Anne Treneer admitted, 'We had blasted much beauty ourselves before the Germans came to work more rapid destruction for us, breaking in a mad few hours the cohesion of centuries'.[78] This blasting was mostly done between the wars, and done to the ancient crossroad of streets in the city centre. As Sharp wrote about the High Street, 'The buildings of five centuries crowded together there: and, as in Fore Street, the buildings of the twentieth century, whether they were fake-mediaeval, anaemic-genteel or plain-brutal, were rapidly pushing out all but the irresistibly picturesque few, about whose removal there would have been a public outcry . . . It was in fact in very danger of becoming much like the main street of many other provincial towns'. And the Exeter-born historian W.G. Hoskins lamented that, 'Somewhere between 1860 and now, Exeter ceased to be a cultured city'.[79]

Much worse was to come. During the night of 23 April 1942 radio beams which the

◀◀ The so-called Chevalier House in Fore Street, in which Charles I is said to have made his head-quarters during the Civil War, photographed in *c.* 1913. This timber-framed building would perish in 1942.

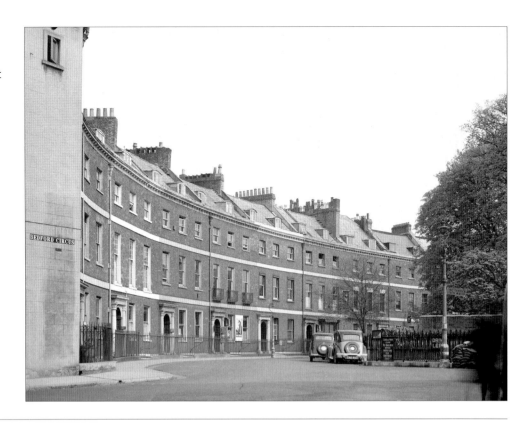

74

RAF had failed to jam guided German bombers to Exeter. As the city was not of any military importance, it was virtually defenceless and its citizens had not expected to be attacked. But this was the first of what were to be known as the Baedeker Raids: the attacks on historic cities in revenge for the British bombing of Lübeck and Rostock – Mediaeval cities full of timber buildings which, as Air Marshall Sir Arthur Harris calculated, burned well. In Exeter, incendiary bombs gutted much of Southernhay, the houses in Dix's Fields and the whole of Bedford Circus, 'something near perfection of its kind'. Many citizens assumed that the Cathedral had been the main target, and now thought that it 'ought to be dynamited because it was a guide and target for the bombers'.[80] A week later, during the night of 3 May, the Luftwaffe returned to extract further revenge. This time the Cathedral was hit and a high explosive bomb demolished St James' Chapel and much of the south choir aisle. Incendiary bombs rained down on the city centre, setting South Street, Fore Street, the High Street and Sidwell Street ablaze. A German pilot recorded that, 'Over the town I saw whole streets of houses on fire. Flames burst out of windows and doors, devouring the roofs. People were running everywhere and the firemen were frantically trying to deal with the flames'.

In all Exeter suffered 19 raids. They left a huge area of devastation to the north and east of the Cathedral. Six churches were gutted and 400 shops and some 1,500 houses destroyed. Many ancient buildings in the Close were badly damaged, the bombs having 'opened out an unwelcome vista' (although the church of St Mary Major, a mediocre and discordant Victorian rebuilding right opposite the west front of the Cathedral was – to the regret of many – spared: it was finally demolished in 1971.). The Medieval hall of the Vicars Choral was destroyed; other casualties included the new City Library and the Lower Market by Charles Fowler, architect of the Hungerford Market and the Covent Garden market buildings in London. Soon after the war, Nikolaus Pevsner recorded that, 'The German bombers found Exeter primarily a mediaeval city, they left it primarily a Georgian and Early Victorian city. The close-knit pattern of mediaeval

An aerial view of the city from the north-east before the Second World War; Bedford Circus is to the left, the High Street to the right.

streets and alleys, mediaeval churches and houses is irretrievably gone . . .'[81] Just as in Rostock, old houses were easily destroyed. But what is depressing is to realise that (as in Canterbury) many damaged buildings that could have been restored were rapidly cleared. Photographs taken for the newly established National Buildings Record show that, immediately after the raids, the Georgian facades of Bedford Circus and the damaged parts of Southernhay were still standing: surely they could and should have been shored up and retained?

At least Exeter City Council decided to consult a sympathetic and intelligent town planner to decide how to rebuild the scarred city rather than use the excuse of bomb damage to widen roads and to build something entirely new and different, as happened in other blitzed cities. This was Thomas Sharp who, in 1946, published *Exeter Phoenix: A Plan for Rebuilding*. He took pains to explain his respect for the 'genius' of the city and the value of its surviving historic buildings which gave it architectural distinction, while insisting that 'Exeter was not wholly a jewel. And the Germans did not wholly destroy it'. As far as he was concerned, Exeter was 'A city which, before being bombed, was greatly in need of an overhaul: which, after bombing, must now, in great part, be rebuilt. A city in need of reconstruction'. He did not want to change its character, rather to make it 'a much improved city of the present kind'.

As a planner, Sharp was, needless to say, pre-occupied by roads. But he did not recommend the usual concentric ring-roads. 'A ring road', he argued, 'should arise "naturally", almost incidentally, out of a series of cross routes, rather than be artificially imposed on a town'. Instead, he proposed a 'central by-pass' which, to do least damage, would loop to the north before running down the west side of the city. As for the opportunity presented by the Blitz for road widening, this 'should be taken with caution'. In the devastated and cleared areas to the east of the Cathedral he proposed a new commercial development, with a cultural centre north of the High Street. Such new buildings must correspond to an appropriate scale and pattern to harmonise with old Exeter. As to the vexed question of their style, Sharp was of course certain that while

◀ St Sidwell's Church; this
Mediaeval church with its
19th-century tower was
destroyed in 1942.

EXETER

77

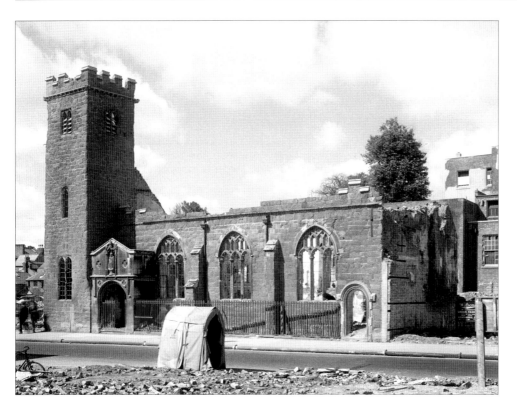

◀ St Lawrence's Church
photographed by
Margaret Tomlinson after
it had been gutted by
fire in 1942. The whole
Mediaeval building was
subsequently demolished.

'There is no doubt that the city *could* be rebuilt in the form of a mediaeval city . . .
The result would not be Exeter, or any live city. It would be a dead museum; and a fake
museum at that'. He was also opposed to rebuilding 'in imitation of the 18th- and early
19th-century buildings . . .' while happy to learn from the qualities that made them
'new and modern' in their day. In short, 'The new buildings should undoubtedly be
new in the full sense'.

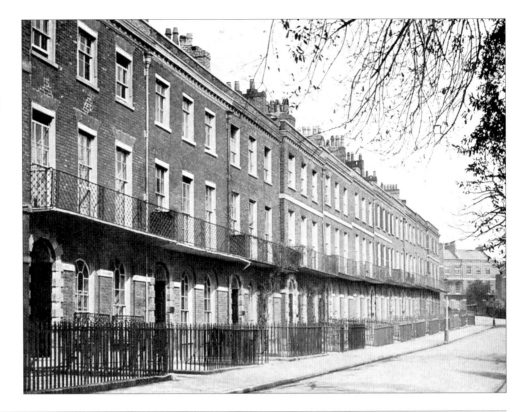

▶ The northern end of Southernhay West, the section of the Late Georgian brick terrace that was badly damaged in 1942 and subsequently cleared.

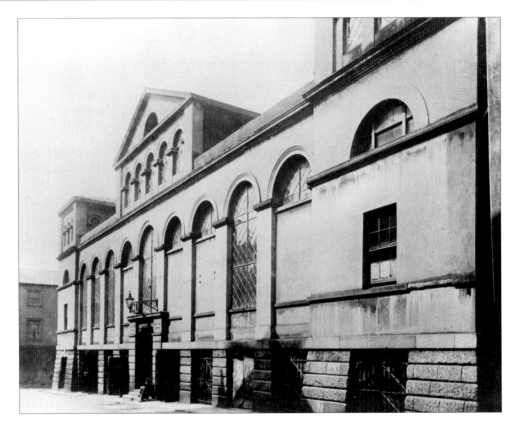

▶ The entrance front of the Lower Market by Charles Fowler of 1835-36; gutted in 1942, it was subsequently cleared.

Whether an Exeter rebuilt according to Sharp's vision would have been successful we cannot know. Inertia, financial constraints and, above all, vested interests naturally ensured that such a careful and sensitive plan was not followed. The authors of the *Shell Guide* to *Devon*, published in 1975, recorded that 'rebuilding has been gradual and very slow. For many years the flattened bomb sites were used as car parks. But now, nearly

thirty years later, the city of the mid-twentieth century is taking shape; at the moment of writing it does not seem unduly exciting: there are many office blocks'.[82] That is to be charitable: the rebuilding supervised by the City Engineer and Surveyor, John Brierley, was largely inappropriate, incoherent and dismal. W.G. Hoskins, who was furious at what was happening to his native city, described how 'Much has been rebuilt in a

▲ The magnificent interior of Charles Fowler's Lower Market before it was destroyed in 1942.

▲ Regency houses in Heavitree Road, several of which would be gutted in the 1942 bombing.

▶ The former West of England Fire Assurance Office in the High Street of 1833 by the local architect Andrew Patey, photographed by Margaret Tomlinson in 1942. Gutted in the air raids soon after, it was one of many damaged buildings in the city subsequently and surely unnecessarily cleared.

commonplace style that might belong anywhere . . . The narrow streets are being torn apart and much of old Exeter is being lost because everything must be sacrificed to enable the motorist to go one mile an hour faster . . . The motorist's demands upon our city are endlessly greedy and selfish. But people are more important than vehicles'.

Writing in the second edition of the *Buildings of England* volume for *Devon* and describing the old city centre, Bridget Cherry rightly complained that, 'With the widening of the High Street one is plunged into a mediocre post-war world, long dull ranges on each side, brick with stone trim, horizontal emphasis rather than the verticals imposed by the old plots – a total break with the character of the old town. The buildings of the 1950s are neither confidently modern nor skilled in their use of the occasional pinched classical detail.'[83] As for the quarter to the south of the Cathedral, between Fore Street and South Street, this was 'the most disappointing'. It had already been spoiled by pre-war slum clearance and further destruction was now caused by it being cut up by an inner ring road – precisely what Thomas Sharp tried to avoid.

Nor was the rebuilding confined to the devastated areas. To add insult to injury, buildings and ancient back lanes which had survived the blitz were destroyed – including the best surviving Mediaeval frontage, in North Street – to make way for the Guildhall shopping centre and its associated car parks north of the High Street, begun in 1969: a development which Cherry could only describe as 'a crushing disappointment'. The fact that, despite all the cruel losses sustained in the Blitz, Exeter was still prepared to sweep away distinctive and interesting old buildings provoked Hoskins and others to found the Exeter Group – today the Exeter Civic Society – in 1960. Since the 1970s, planning policies in Exeter have been, on the whole, more sensitive – but the damage has been done. The Exeter Phoenix is not an inspiring creature. Would modern Exeter really have been any worse had it been rebuilt in the fake-mediaeval manner that Thomas Sharp so feared? The Cathedral remains glorious, but the city is certainly no longer a jewel.

9: GLASGOW

'Glasgow has been called the greatest Victorian city in Britain, and its architectural wealth may surprise those who visit it.'[84] So considered *The Architects' Journal* in 1964 on the occasion of the annual conference of the Royal Institute of British Architects being held in the city. Modern visitors may be less surprised as, since it was European City of Culture in 1990, Glasgow has promoted its architecture and now relentlessly exploits the legacy of its belatedly canonised *art nouveau* hero, Charles Rennie Mackintosh. Yet visitors today probably remain unaware of Glasgow's long and dreadful history of ruthlessness towards its architectural and civic heritage, for an alarming number of distinguished historic buildings as well as whole swathes of the city have disappeared since 1964. Well might the local historian Francis Worsdall have entitled his 1981 lament for Glasgow's demolished architecture *The City that Disappeared*. It was a book intended 'to indicate just how much of the architectural and historical heritage of the city has been destroyed by people and institutions who should have known better. In the great majority of cases, the demolition was unnecessary and could have been avoided with a little foresight and imagination.'[85]

It must be admitted that a certain indifference to the legacy of the past necessarily went hand in hand with the optimism and vigour that made Glasgow into the 'Second City' of the British Empire by the beginning of the 20th century. Sentimentality seldom stood in the way of the new, but the compensation was that, for most of its history – until the Second World War, perhaps – the new was usually better than the old. Apart for the splendid, and underrated, Cathedral, Mediaeval Glasgow has almost entirely disappeared – the old buildings of its ancient core being replaced as part of a very necessary slum clearance exercise under the Glasgow City Improvement Act of 1866. But it is surely permissible to regret the move of the university from the polluted and densely crowded High Street several miles west to more salubrious Gilmorehill at the same time, which not only doomed that ancient part of the city to decline and neglect but necessitated the loss of the remarkable buildings of the Old College. Similarly, there are now precious few survivors of the many and splendid elegant tobacco lairds' mansions that

83

◀◀ William McGeogh & Co.'s Warehouse, on the corner of West Campbell Street and Waterloo Street, in 1969. This building of 1904-08 by J.J. Burnet was as remarkable and progressive in its way as C.R. Mackintosh's now-celebrated School of Art, but was demolished in 1971.

The High Street in 1973 with the two blocks of Professors' Houses that once faced the Old College of the University. Designed by James Adam, Robert Adam's younger brother, in 1793, they were wantonly destroyed later that year.

once testified to Glasgow's great prosperity in the 18th century. It was typical that a banker's house in Buchanan Street designed by the great John Soane of London had a life of less than forty years before its site was redeveloped.

What replaced these earlier Glasgows was an ambitious and ebullient stone-built city, enhanced with many grand public buildings and fine parks, which testified to the fact that, by the end of Victoria's reign, it was an international model of a well-run municipality. Although it had a dark side, of overcrowded slum property and industrial pollution, Glasgow's pride and confidence was expressed in the architecture of its principal streets. This, however, began to ebb by the mid-20th century as the old heavy industries – above all shipbuilding – went into decline. Although nearby Clydebank was horribly damaged by bombing in 1941, the Second World War left Glasgow comparatively unscathed – the principal architectural casualty (Scotland's worst) being Alexander 'Greek' Thomson's Queen's Park Church. The real destruction began in the 1960s.

By the 1950s, Glasgow was perceived – and perceived itself – as a smoke-blackened, decaying industrial Victorian city. The mood was caught by the journalist J.M. Reid in 1956 when he wrote that, 'In the middle of this century Glasgow seems to hang in the balance'. And although 'There are the makings of a sort of city just as great as anything in the past . . . There are plenty of influences abroad in the world that could destroy it: not only those which threaten an utterly devastating sort of war but subtler ones which tend to make it lean not on its own courage and self-confidence, but on other people'.[86] But Reid was in a minority in admiring Glasgow's buildings and arguing that 'the best, even the second-best, of them are worth preserving in our day, when nothing of the same sort can be expected to replace them. Our century is producing its own work, and the city, like other cities, will change. But we have a better chance than our grandfathers had to make the most of what the past has left us'.

Fuelled by a horror of the city's Victorian past which, in retrospect, seems little more than self-hatred, Glasgow's authorities were gearing up radically to transform the city. As elsewhere, this transformation was to be effected by two interrelated campaigns. One

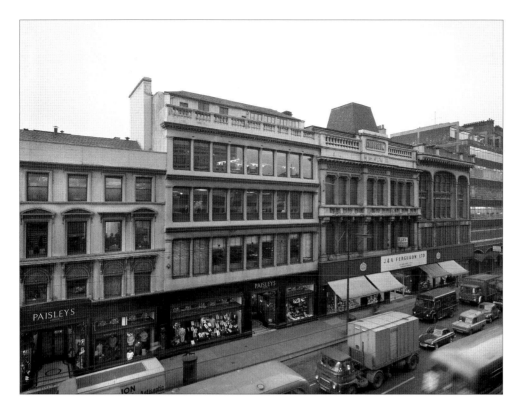

◁ The west side of Jamaica Street in 1968. These remarkable 1850s commercial buildings with cast-iron façades were cleared in the 1990s.

◁ Charing Cross looking east along Sauchiehall Street in the early 20th century. Although Burnet's Charing Cross Mansions in the distance survives today, the Grand Hotel in the foreground, opened in 1882, was destroyed in 1968 to make way for the sunken motorway that cuts the city in half.

was to build new roads; the other to rebuild whole areas of the city under the name of slum clearance. Roadbuilding is always an effective way of wiping out property. In Glasgow, after some councillors had visited Los Angeles and been hugely impressed by American freeways, it was decided that the city centre should be ringed by motorways – despite the fact that the city had one of the lowest proportions of car-ownership in Britain. The M8 motorway was brought in from the east along the immediate north side of the heart of the city, then swung south, cutting a great swathe though Charing Cross and Anderston to cut off the West End from the centre, so as to cross the Clyde before

▶ The entrance to a tenement block in Abbotsford Place in Laurieston on the south side of the Clyde in the area loosely known as the Gorbals, photographed by Edwin Smith in the 1960s and subsequently demolished.

▶ Apsley Place in Hutchiesontown south of the Clyde photographed by Frank Worsdall in the 1950s and demolished not long afterwards.

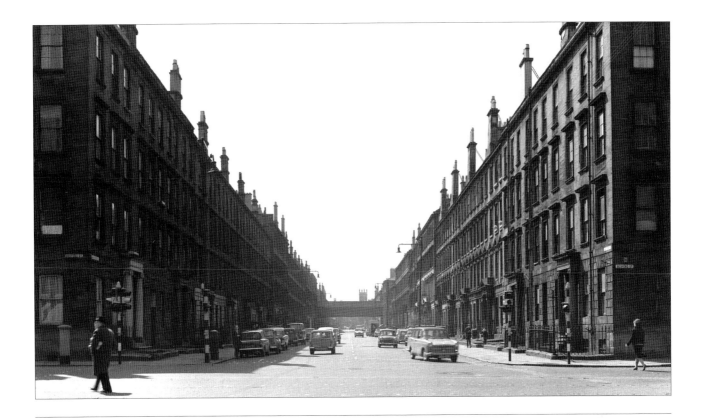

swinging back towards the west. The damage caused by this motorway was immense and, even after forty years, the wounds have not healed.

Mercifully, the intended eastern and southern flanks of this proposed box of motorways were not then carried out. But what is interesting is that the basic configuration of all these roads was essentially that proposed by the City Engineer, Robert Bruce, in his *First Planning Report* issued in 1945. This terrifying document also envisaged the removal of every single building in the city centre (including City Chambers and the famous School of Art) and their replacement by isolated blocks of flats or offices. A new north-south axis was to be created – partly a civic centre and partly an avenue – running from a new railway station in the north to another new station on the south side of the Clyde. In other words, the concept was a mediocre and inept version of such pre-war city plans as Albert Speer's proposal for Hitler's Berlin. Such was Glasgow's vision of the future.

There can be no doubt that parts of Glasgow suffered from dreadful housing conditions, but the process of declaring numerous comprehensive redevelopment areas led to the complete transformation of the landscape of large parts of the city and sweeping away of many older buildings which could and should have been repaired. And of no part was this more true than the 19th-century inner suburbs just south of the Clyde generally known as the Gorbals. Parts of this notorious district had already been rebuilt under the 1866 City Improvement act. Now the regular terraces of stone tenements were to be replaced again, even though the problem with many of them was primarily overcrowding and neglect. But only outsiders, it would seem, could see how splendid – or potentially splendid – many streets in the Gorbals were. One was Ian Nairn, who dared say so in 1960.

> I can hear the cries of outraged planners already: 'Really, this fellow Nairn has gone too far this time'. But I would plead with them really to go and have a look at the Gorbals, while it is still there. It was laid out on a grid, with immensely dignified, four-storey, stone-built terraces . . . There are far too many people living there, and the state of the

▲ Abbotsford Place looking south, photographed by David Wrightson in the mid-1960s and entirely demolished in 1972. This view confirms the magnificence of the early 19th-century stone streets and terraces in the Gorbals.

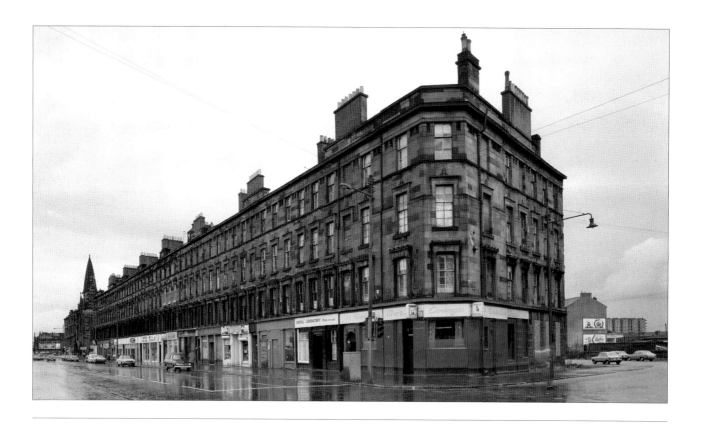

▲ Queen's Park Terrace in Eglinton Street in 1978, the finest and most inventive block of tenements designed by Alexander 'Greek' Thomson; having been compulsorily purchased by Glasgow District City Council and despite being a category 'A' listed building, the whole long terrace was demolished in 1980-81.

backyards and the communal staircases with their lavatories on the half-landings are intolerable and must be altered. However, the actual outside appearance, in other circumstances, would be applauded as a splendid piece of urban design.

All that has now gone. And the new Gorbals which replaced those dignified terraces, a redevelopment of isolated multi-storey blocks of flats and of towers, has also now gone – so inadequate physically and socially did it turn out to be. The prodigious waste of resources involved, over a period of some forty years, suggests that the urban vision of comprehensive redevelopment was as culpably thoughtless as it was ruthless. Almost the only relic left today of the large and dense complex of stone-built architecture which lay south of the Clyde is the pathetic ruin of the famous Caledonia Road Church designed by 'Greek' Thomson, which Glasgow Corporation allowed to be gutted by fire in 1965. The year before, the convenor of the city's planning committee had told the (astonished) RIBA conference that the Corporation had to decide between keeping this church and the other church by Thomson in St Vincent Street as 'the time may come when we have to consider putting up a plaque instead of retaining certain buildings'.[87] As Andor Gomme insisted in the magnificent book he wrote with David Walker on *The Architecture of Glasgow*, the Caledonia Road Church 'is one of Glasgow's greatest buildings – indeed one of the greatest nineteenth-century buildings anywhere . . . in almost any other country than our own, so great a work of art would call out enthusiastic and complete restoration as a matter of course'.[88]

After revisiting in 1967, Ian Nairn concluded that, 'Unless the city wakes up to a sense of its own greatness, Glasgow is headed for disaster. There seems no break in the bland self-confident surface that doesn't care and doesn't want to care. This is true philistinism, and when they have a mind to the Lowland Scots can do it better than anyone else'. This is particularly and painfully evident in the treatment meted out to the work of one of the two independent architectural geniuses of international stature produced by Glasgow in the 19th century. One was Mackintosh, and today it seems a miracle that his church and two schools did not give way to new roads. The other was

▲ The magnificent twin train sheds of St Enoch Station, the terminus of the Glasgow & South Western Railway, closed in 1966. Although it could have been converted to another use, the train shed was destroyed in 1975, the year this photograph was taken.

◀ The St Enoch Hotel in 1975; despite having been recently refurbished, this (incomplete) hotel designed by Thomas Willson in 1870 was demolished in 1977 and a shopping centre was eventually built on the site.

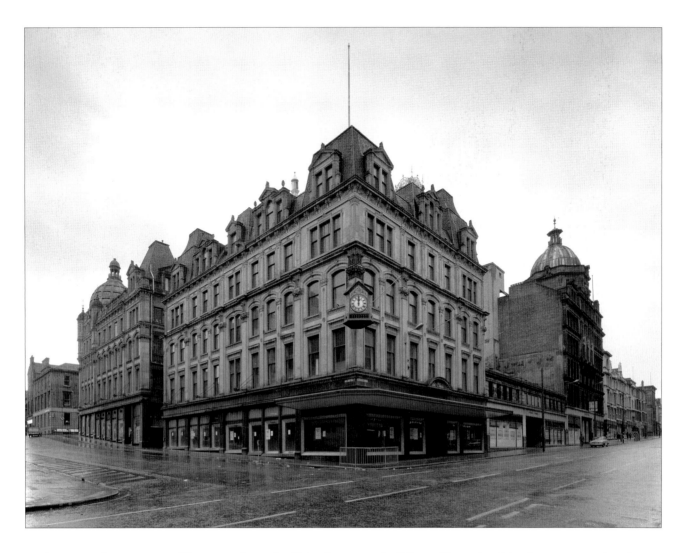

The corner of Wellington Street and Sauchiehall Street with the department store of Messrs Copeland & Lye in 1971; Pettigrew & Stephens' store, of 1896-97 by Honeyman & Keppie, is further along Sauchiehall Street to the right with, in between, the now mutilated façade of Burnet's Fine Art Institute. All were demolished in 1973-74 to make way for the peculiarly nasty Sauchiehall Centre.

Thomson. Several of his city centre buildings disappeared in the post-war decades, as did his tenements opposite Mackintosh's Queen's Cross Church. A particularly sad and unforgivable loss was that of Thomson's largest and finest tenement, Queen's Park Terrace in Eglinton Street, which had been compulsorily purchased by the local authority. 'The work of demolition began on St Andrew's Day 1980,' noted Worsdall. 'Surely there is some significance in that choice of date? To demolish one of the treasures of Scottish architecture by Scotland's greatest architect, on Scotland's national day, seems to me to be deliberately perverse. It is, however, typical of the attitude of the District Council, which frequently shows a disregard of the wishes of those who know and love this sadly dismembered city'.

Nor was it just Victorian buildings that were so casually bulldozed. It seems incredible as well as unforgivable that the surviving relic of the Old College in the High Street, the pair of Professors' Houses designed by James Adam, brother of Robert, in 1793 could have been demolished as recently as 1973 – on the very eve of European Architectural Heritage Year. Their sites remain empty. The sober Classical houses of the 1780s in Charlotte Street, once the smartest in the city, have also mostly gone – that lived in by David Dale, the creator of New Lanark, disappearing in the 1950s. Other demolitions were plain stupid. The great train shed of the St Enoch terminus, whose equivalent in Manchester has been converted into a successful conference centre, was destroyed in the 1970s along with its associated Victorian hotel, a solid and useful building which had recently been refurbished. The replacement is a glass-fronted shopping centre of painful mediocrity which now addresses poor St Enoch Square.

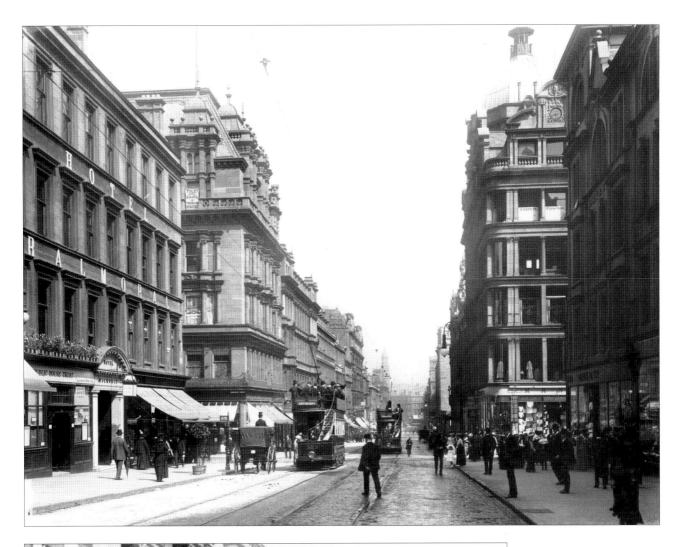

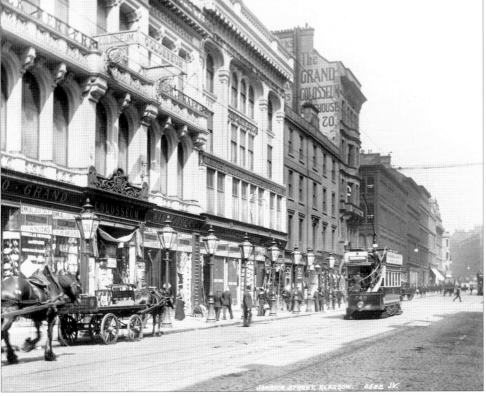

Sauchiehall Street looking east from Blythswood Street, photographed by Annan in 1905 with Pettigrew & Stephens' department store on the right. Almost every building visible has since been replaced by something inferior.

The west side of Jamaica Street photographed by Valentine & Sons of Dundee in c.1900. All the buildings to the left of the tram, including remarkable cast-iron facades of the 1850s, have since been demolished.

▶ The uniform stone villas of the 1780s in Charlotte Street on the east side of the city, mostly demolished by the 1950s to leave but one survivor. In the distance is the more elaborate house built by David Dale, the creator of New Lanark.

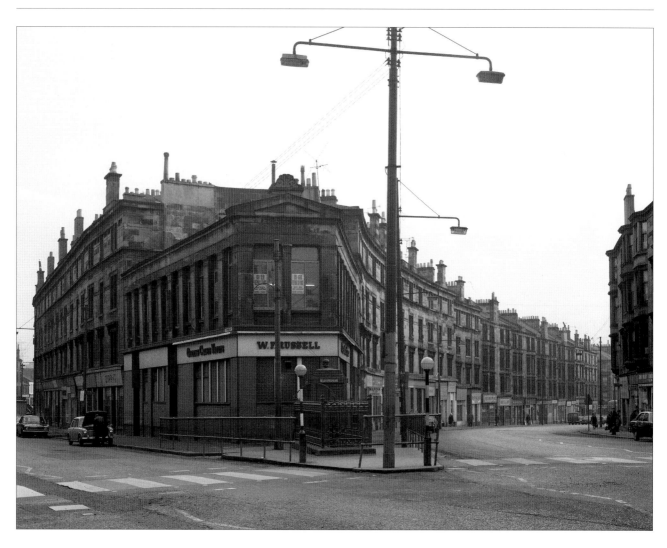

Nor was such vandalism confined to the 1960s and 1970s, the intoxicated years of comprehensive redevelopment. Despite Glasgow's much-vaunted year as European City of Culture, the rare and enchanting Crown Arcade in Virginia Street, a structure largely dating from the Regency, was allowed to disappear in the 1990s on the usual mendacious grounds of structural instability. And when the handsome Neo-Classical Elgin Street Congregational Church, now a discotheque, 'went on fire' (as goes the local parlance) in November 2004, the city rapidly began the demolition of its handsome Ionic portico – which could easily have been incorporated into a new development – on the following Boxing Day.

It is not just individual listed buildings in the historic centre which have been so casually lost. Whole streets – not in comprehensive redevelopment areas – have been transformed. In Sauchiehall Street, so euphonious and famous, so many of the florid stone Victorian and Edwardian commercial blocks have been replaced by cheap structures of the utmost mediocrity that what once seemed a smart and imposing shopping street now seems tawdry and squalid. Several of the remarkable mid-Victorian cast-iron buildings in Jamaica Street – which, back in 1951, Henry-Russell Hitchcock had considered to be 'among the most successful Victorian commercial edifices to be found on either side of the Atlantic' – were allowed to disappear as recently as the 1990s.[89] Then there are the many parts of the city which have been partially cleared but never properly rebuilt, leaving a few surviving earlier buildings surrounded by squalor and desolation; such districts are more reminiscent of, say, Detroit than of any other city in Britain. The consequence is that today, for anyone who knows this extraordinary city, there are two Glasgows: one the present physical reality, still with so much of interest and magnificent but so painfully damaged and incomplete; the other the Glasgow of the historical imagination, articulated by the historic buildings and streets which once existed and whose reality and beauty can still be recaptured in the mind with the aid of maps and photographs like those that fill this book.

◀◀ The block of tenements by 'Greek' Thomson between Maryhill and Garscube Roads opposite the Queen's Cross Church by C.R. Mackintosh, shortly before they were demolished in c.1980.

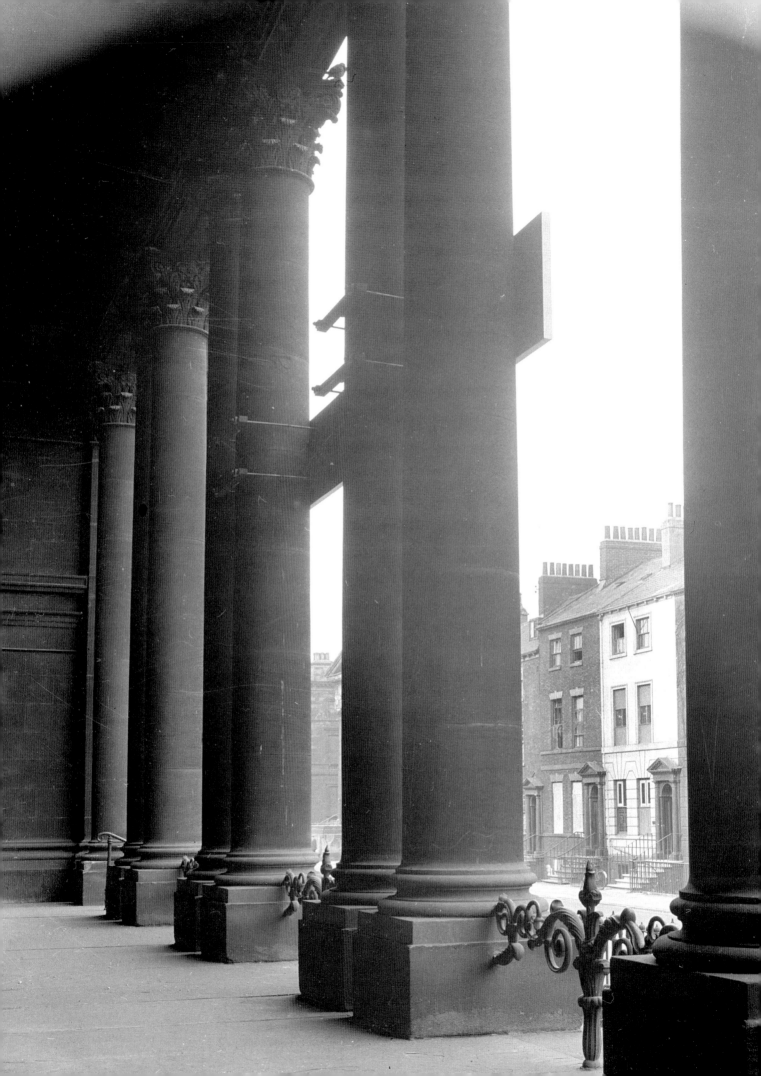

10: HULL

Properly called Kingston-upon-Hull as it stands where the eponymous river joins the Humber, by the 14th century it had become the principal port on the East coast of England. Today, only the great parish church of Holy Trinity – which can claim to be the largest in England, depending upon how the measurement is made – now testifies to the Mediaeval importance of Hull. Other Mediaeval establishments have either disappeared or, like Trinity House, been rebuilt. Unlike other Mediaeval ports, Hull did not decline; it retained its pre-eminence through the 18th and 19th centuries and into the 20th. Today, however, all this is hard to appreciate. Georgian Hull, once magnificent, has suffered grievously, as has the best of Victorian Hull. The town has been very badly damaged by the usual combination of pre-war planning and modernisation, wartime bombing, and post-war planning, rebuilding and neglect. Losses from enemy action were unavoidable, but it is clear that even worse losses were self-inflicted. Only in the last twenty years has Hull begun to appreciate what is left of its architectural heritage.

The old centre of Hull was bounded by the rivers Hull and Humber and by the city walls to the west and north. In the later 18th century, the northern section gave way to the long, thin Queen's Dock, the first of Hull's enclosed docks, constructed in 1775-78. North of here the New Town was laid out, with handsome Georgian terraces and mansions. As Hull prospered, expanding further to the west once the railway arrived in 1840, so fine churches and public buildings were raised, many of them Greek Revival in style and many of them designed by the city's talented local architect, Henry F. Lockwood. Most have disappeared. 'Altogether, Hull has lost several of its best buildings not always for acceptable reasons,' wrote Nikolaus Pevsner in his *Buildings of England* volume for the East Riding, published in 1972. 'This applies chiefly to the Greek Revival. The Master Mariners' Almshouses of 1834, the Albion Street Congregational Church of 1842, both with mighty Greek Doric porticoes, and the Great Thornton Street Chapel of 1842 with its octastyle Corinthian portico and side pavilions, and also the Royal Institution with the row of coupled giant columns of its long front of 1854, have all disappeared.'[90]

95

◀◀ The houses in Albion Street seen through the colonnade of Cuthbert Brodrick's Royal Institution in 1941.

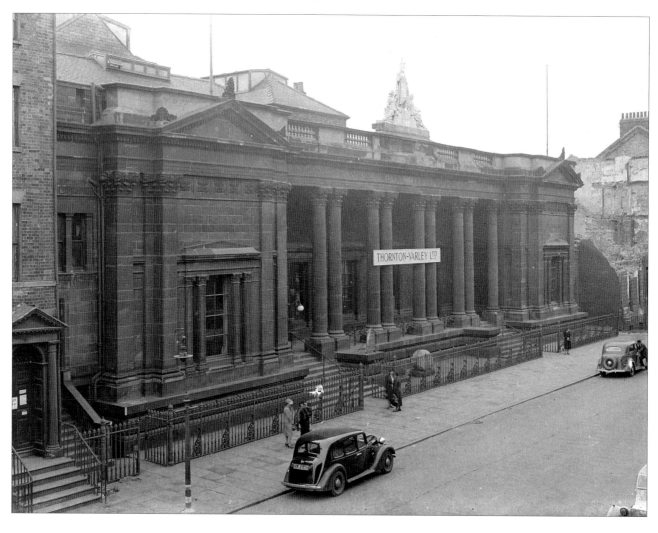

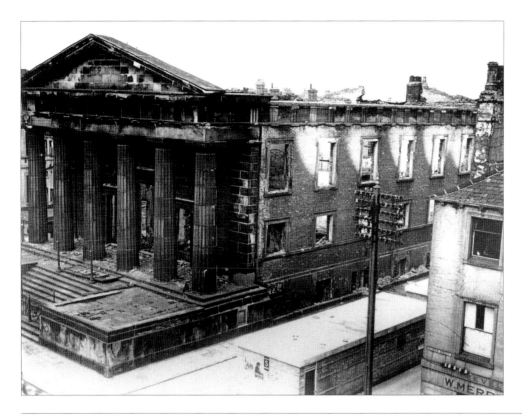

◀ The Albion Congregational Church, Greek Doric by H,F. Lockwood of 1842, after it had been gutted by incendiary bombs in 1941; the shell was subsequently demolished.

◀◀ The Queen's Dock with, on the left, the Dock Offices, before the dock was filled in the 1930s to make Queen's Gardens.

HULL

97

The last was a wartime casualty and had been the work of Cuthbert Brodrick, Lockwood's successor. Brodrick is best known for Leeds Town Hall; in his native Hull he also designed a town hall, but that was replaced in 1912 by a grander and larger Edwardian Guildhall designed by Edwin Cooper to reflect the importance of Britain's third port. It was in the 20th century that things began to go wrong. In the early 1930s Hull decided on what Pevsner rightly called 'the planning folly' of filling in the Queen's Dock and laying out the space as a banal park instead of retaining a long stretch of water in the city centre. And in 1935 the Wilberforce Column was moved from its site next to the Classical 1860s Dock Office and re-erected at the far east end of this new Queen's Gardens. Today it has as a backdrop the large and mediocre 1960s building for the College of Technology designed by Frederick Gibberd – which even Pevsner thought 'run-of-the-mill'. Other planning follies were also envisaged in the 1930s, such as the demolition of the Master Mariners' Almshouses in Carr Lane. In the event, it was the Luftwaffe that destroyed this fine Greek Revival building designed by Charles Mountain.

As a major port facing Continental Europe, Hull was naturally a prime target during the Second World War and it was repeatedly and very badly hit. The city suffered its fiftieth raid by June 1941 and it was one of the three most bomb-damaged areas in Britain. Some three and a half thousand houses were destroyed. The docks and the Old Town were heavily bombed and, in addition to the almshouses, several of the best public buildings, including Lockwood's Congregational Chapel and Broderick's Royal Institution, were casualties. The chapel, however, was only gutted; the Greek Doric portico survived and the building could have been restored, but to repair rather than replace did not accord with the mood in Hull when the war was over.

Before the war, the architect Sir Edwin Lutyens and the planner Patrick Abercrombie had been asked by the City Council to consider the re-planning of Hull. Lutyens died in 1944 but Abercrombie continued with the project and in 1945 *A Plan for the City and County of Kingston upon Hull* was published. As Alderman J.L. Schultz, chairman of the Reconstruction Committee wrote, 'the only fitting tribute that could be paid to the

◀◀ The Royal Institution designed by Cuthbert Broderick, the future architect of Leeds Town Hall, and built in 1852-54. Damaged by bombs in 1941, the year this photograph was taken, this splendid building was subsequently demolished and its site is now a car park.

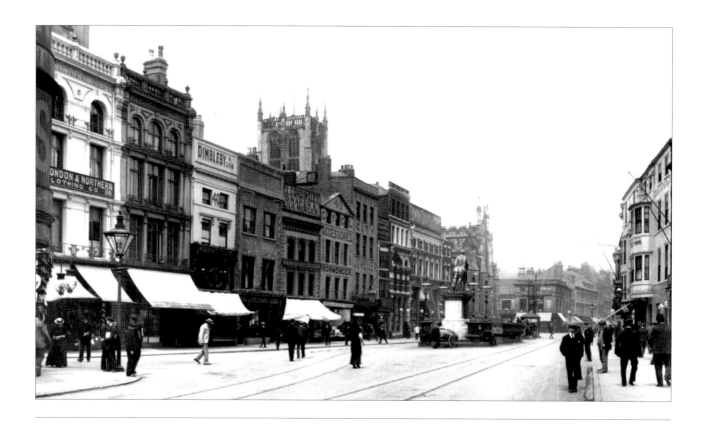

The Market Place in c. 1900 with the tower of the great Mediaeval parish church of Holy Trinity rising above; all the houses here that survived the Second World War were destroyed by the end of the 1960s.

devotion and courage of a brave people was to rebuild our City in a manner worthy of its citizens. Out of the ashes of the old would arise Phoenix-like a fairer and nobler City than we had ever known.'[91] Abercrombie admitted that it would be possible and practicable simply to repair the damage – 'one might be tempted to say that all streets which have any intact buildings facing onto them should be retained' – but this would inhibit the possibility of making a 'real improvement'. A comprehensive scheme therefore envisaged the replacement of almost every surviving building, historic or otherwise, and, naturally, new roads were an integral part of this vision. A 'new sub-arterial highway' was to entirely replace the High Street and then swing west across the Market Place south of Holy Trinity Church. Much of what remained of the Old Town was to become a park.

In the event, as the economy of the port steadily declined, only a few of the destructive road proposals were carried out, but the three decades after the Second World War saw the gradual erosion of many of the most interesting and characterful surviving buildings in Hull, usually on the grounds of slum-clearance or the necessity of road widening. When Colin Amery and Dan Cruickshank surveyed Hull for their depressing book, *The Rape of Britain*, published in European Architectural Heritage Year, 1975, they wrote that 'the chances are that precious little of Hull's old centre will survive'.[92] Many of the most interesting buildings were then owned by the Corporation, which had allowed them to become derelict. Almost all the dock warehouses, almost all of the Georgian chapels and almost all of the Victorian and Edwardian churches of Hull have now disappeared.

Houses and terraces in the Georgian streets of the New Town which had survived the bombing were gradually cleared – fine houses in Charlotte Street disappearing as late as 1969. As for the most historic part of the city, Ivan and Elisabeth Hall wrote in their 1978 study of *Georgian Hull* that 20th-century planning 'has reduced much of the Old Town to an unoccupied waste'.[93] The wide Market Place, the setting for the glorious parish church, was once lined with a variety of buildings; today it is characterless.

◀ The remains of the
Master Mariners'
Almshouses in Carr Lane,
designed by Charles
Mountain in 1834, after
bombing in 1941.

99

Unforgivably, the east side disappeared in the 1960s. A little to the south, Myton Gate
was wiped out by that 'sub-orbital highway', now called the South Orbital Road. Worst
of all is the ancient High Street. A few historic buildings have managed to survive,
notably the 17th-century birthplace of William Wilberforce, but otherwise the planned
new road might as well have replaced it. 'What a High Street!' wrote Pevsner. 'Narrow,
winding, with desolation at the S[outh] end and a N[orth] end as if this were Wapping'.

The 'fairer and nobler City' confidently predicted by Alderman Schultz in 1945 has
not arisen. Anything of interest in Hull is a survival from the past. But, as Ivan Hall
recently concluded, 'What has gone are the accents of the cityscape, the varied shapes,
textures and materials, the undoubted wealth of craftsmanship, the unexpected or even
bizarre incident; items that there is now no way of matching, for neither money nor
skills are forthcoming'.[94]

11: LEEDS

The origins of Leeds can be traced back to the Middle Ages, but the oldest building in the city today is St John's Church, a remarkable early 17th-century building which managed to escape replacement in the 19th century. In the 18th century Leeds prospered, but it was in the following century that Leeds came into its own. With its magnificent proud Town Hall, built in a grand Classical manner in the 1850s, Leeds is essentially a Victorian city, as its principal older streets were rebuilt with exuberant commercial buildings in a variety of styles. 'The Kirkgate and the Briggate', wrote John Betjeman in 1933, 'cast off their Georgian glory and assumed the Jacobean, the Romanesque, the Holbeinesque, the Early English, the Perpendicular and the neo-Georgian, in Leeds phorpres brick and stone and terra-cotta'.[95] It could also boast some of the best Victorian and Edwardian churches in the country. 'No city of the North of England,' Betjeman continued in 1969,

> has so fine a swagger in the way of 19th- and early 20th-century architecture as Leeds, whether it is in churches, mills, shops or private houses, stone, brick or terra-cotta. Everybody knows about Cuthbert Brodrick's superb Town Hall of Leeds, but who knows about Corson and Ambler, local Leeds architects, every bit as virile and original in their way as was Brodrick? Leeds was so important a City, that the big men from London came and did their best here.[96]

After the First World War, it was recognised that Leeds had its problems – above all, acres and acres of sub-standard housing, much of it back-to-back terraces. A major slum-clearance policy was initiated and a substantial new housing development constructed: the Quarry Hill flats, one of the best things of its sort in Britain: a vast complex of streamlined modernistic flats, built of steel and concrete and strongly influenced by progressive Continental architecture. What was done in Leeds between the world wars was done well. Partly to relieve unemployment, Brodrick's Town Hall was complemented by the new Civic Hall designed by the doyen of town hall builders, E. Vincent Harris. A new street was created by widening and extending the Headrow, with regular Classical facades, designed

◀◀ The Royal Insurance Company's building of 1870-72 by Alfred Waterhouse in Park Row, once the city's finest Victorian commercial street; demolished a few years after the photograph was taken in 1961.

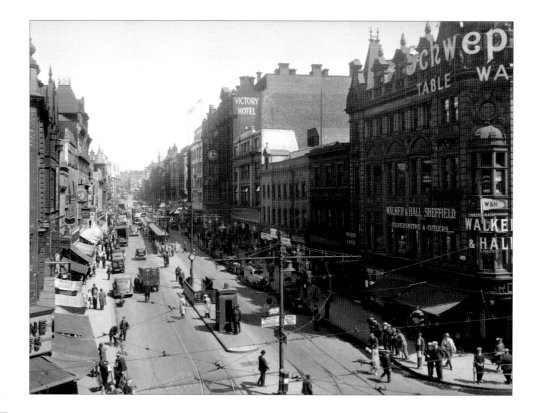

▶ Briggait, from the crossroads with Boar Lane, soon after the Second World War.

▶ The Westminster Bank, formerly Beckett's Bank, in Park Row of 1863-67 by George Gilbert Scott with William Perkin shortly before it was demolished in 1964.

by Sir Reginald Blomfield, though some, like Betjeman, found this pompous and alien.

Surprisingly, although an important industrial city, Leeds was not badly damaged in the Second World War. There were only nine bombing raids, aimed at the mills and factories outside the centre, and the only significant architectural casualty was the Philosophical Hall in Park Row. This was the street which Nikolaus Pevsner considered, in his *Buildings of England* volume on the *West Riding of Yorkshire* first published in 1959,

◁ The Public Baths which
began as the Oriental
Baths of 1866, designed
by Cuthbert Brodrick in an
appropriate style but
remodelled with a Gothic
façade in 1882, and
demolished in 1969.

◁ The Sun Fire Office,
formerly the Headland
building, of 1877 by
George Corson in Park
Row, photographed in
1962 shortly before
demolition.

gave 'the full flavour of commercial Leeds'.[97] Here were magnificent buildings such as
Gilbert Scott's Beckett's Bank – Gothic, of course. The dour magnificence of this street
was well conveyed by Atkinson Grimshaw in his painting of it made in 1882. Today, how-
ever, almost every building that Grimshaw carefully depicted has disappeared, mostly
since the Second World War. As with so many other British cities, most of Leeds's
wounds are self-inflicted.

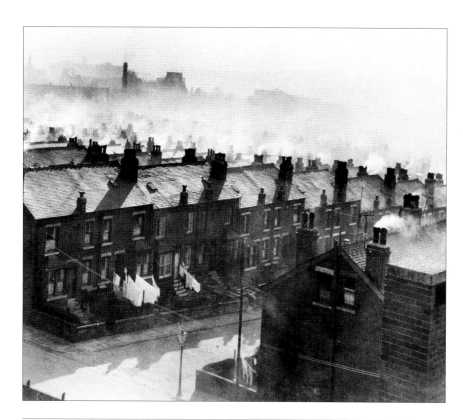

▲ Back-to-back terraced housing of the sort which brought so much 19th-century architecture into disrepute, and almost all of which would be bulldozed in the 1960s.

▶▶ The main entrance into the Quarry Hill estate designed by R.A.H. Livett shortly after completion in 1938 and now completely demolished.

Like other Victorian cities, Leeds was consumed by self-hatred in the 1950s and 1960s. Encouraged by conventional prejudice, it was keen to replace its 19th- century past – both bad and good. Individual buildings began to go, one of the first being Scott's Beckett's Bank in Park Row, demolished in 1964. Others followed, denuding South Parade, Bond Street and Albion Street of any architectural interest. Much of the north side of Boar Lane disappeared for a tawdry shopping centre. When Colin Amery and Dan Cruickshank published their polemic on *The Rape of Britain* in 1975, there was huge pressure on Leeds to redevelop and 'it is far from certain that there is sufficient appreciation of her tough Victorian heritage to ensure that the real quality of Leeds will survive'. Nor was it just Victorian buildings that were discarded. Pevsner complained that in Briggate, 'The last surviving façade in Leeds exhibiting timber-framing has recently been wantonly demolished. One would have thought that the Ministry of Housing and Local Government and the Corporation of Leeds could have prevented that'.

Old lanes off the principal streets – of the sort that the Victorians made into handsome shopping arcades – were simply swept away. The biggest threat came in the 1970s when it was proposed to demolish much of the south side of Boar Lane for a large new development. Although, after a public inquiry in 1974, the Secretary of State pronounced in favour, mercifully this never happened owing both to the bankruptcy of the developer and a change of policy in the city. Perhaps the Council began to appreciate what Betjeman – who loved the city – wrote in 1969: 'The individuality of Leeds is expressed in its buildings, private mansions and public halls and churches. A record like this is invaluable. If Leeds loses these buildings, it might just as well be a bit of that international nothingness which is turning so many of our historic and industrial cities into cheap imitations of America'.

Much has been unnecessarily lost in Leeds but much more could have gone. The biggest and most surprising loss was Quarry Hill. After the Second World War this huge and impressive complex of council flats was perceived to have become a run-down slum,

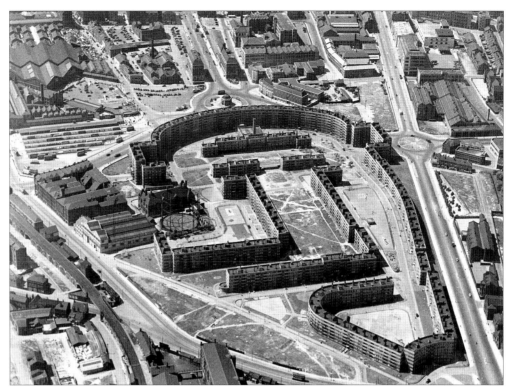

although the excuse for demolishing it all after 1975 was the corrosion of the structural steelwork. What had been intended as the progressive solution to the city's housing problems had lasted a mere forty years. Utopia can have a very short life. In contrast, the Victorians built to last, and their buildings survive today – except where they have been so foolishly and unnecessarily destroyed.

▲ Quarry Hill from the air in c.1939 showing the extent of this massive slum-clearance scheme, entirely demolished in the late 1970s.

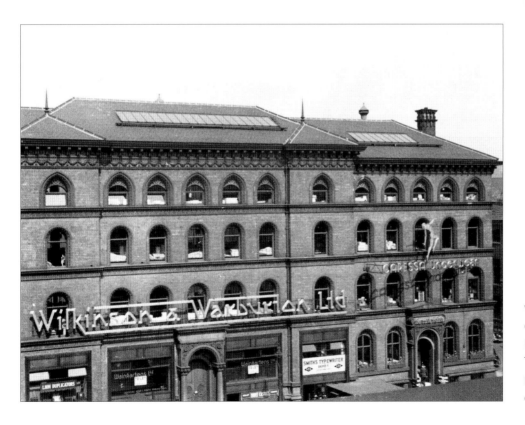

◀ The palatial group of warehouses in King Street designed by Cuthbert Brodrick, architect of the Town Hall, photographed not long before it was demolished in 1967.

12: LIVERPOOL

A century ago, the *City of Liverpool Official Handbook* could confidently – and accurately – describe the great conurbation on the estuary of the river Mersey as 'the second seaport of the world . . . the principal gateway from the West into Europe'.[98] No longer: Liverpool's decline in the 20th century has been so dramatic and catastrophic that, by the 1980s, it was regarded as an intractable problem by the British government. Englishmen who know only South-East England find it surprising that the cities of the North can be so fine, but the architectural magnificence of Liverpool is in fact astonishing. What may also seem surprising, given the economic, political and social difficulties experienced in the latter half of the 20th century, exacerbated by the utopian dreams of urban planners and local politicians, is that so much of that magnificence still survives. It was the city's historic architecture that was very much responsible for it being chosen as European City of Culture in 2008, but Liverpool would have had even greater claim to that accolade had not extraordinarily foolish and destructive decisions been made in the decades after the Second World War.

Liverpool was established in Mediaeval times but practically nothing visible remains of the city's early past and only the name of Castle Street hints at the former existence of a fortress. Liverpool's earliest surviving architectural monuments date from the 18th century and (unlike its rival Manchester) it can still boast many fine Georgian terraces – though many have gone. Liverpool's prosperity was based on the Atlantic trade and the first recorded cargo from America arrived in 1648. The Bluecoat School, the magnificent Town Hall – by John Wood of Bath and James Wyatt – and the austere Neo-Classical Lyceum Club – which housed the first gentlemen's subscription library in England – all testify to Liverpool's growing civic pride and architectural ambition, although behind this civilized architecture and the intellectual life of the city lay (as in Bristol) the unspeakable business of the slave trade. There were also many churches built in the Georgian decades, although many have since disappeared – 'a disgraceful record' as Nikolaus Pevsner commented in his *Buildings of England* volume on *South Lancashire* published in 1969.[99]

◀◀ The newly completed tower of Sir Giles Scott's Anglican Cathedral soon after the Second World War when the surviving Late Georgian houses in Washington Street were falling into decay. These streets of houses, which gave scale to the huge building, were all cleared away in the 1960s and 1970s.

The grand Greek Ionic portico of John Foster's now demolished Custom House facing the docks along the river Mersey.

It was in the 19th century that Liverpool defeated Bristol to become the principal arrival and departure point for steamships to and from America, and it remained so until the Cunard Line moved to Southampton in the early 20th century. And it was in the 19th century that, consumed by growing civic ambition, Liverpool erected many of its finest buildings as well as laying out fine parks and new avenues. The most obvious symbols of the city's importance were the series of dock and warehouse buildings erected along the Mersey. The best of these were designed and erected by Jesse Hartley; built in brick, cast-iron and granite on an heroic scale, this was, as Pevsner put it, 'an architecture for giants'. And behind all the docks was the proud domed Custom House, a monumental building by the local architect John Foster which reflected the city's taste for the Greek Revival.

Then there were the civic buildings, the finest of which was St George's Hall, a monumental structure of the 1840s designed by the young Harvey Lonsdale Elmes. Pevsner, indeed, could describe it as 'the freest neo-Grecian building in England and one of the finest in the world'. Later, other civic buildings rose nearby, including the Walker Art Gallery, to create a sort of cultural forum. The precedent of Rome was certainly in the minds of Liverpool's merchant princes, so the letters SPQL – 'The Senate and the People of Liverpool' – are cast on the great bronze and iron doors in St George's Hall.

The tradition established of enlightened architectural patronage was continued into the 20th century, and on an even larger scale. At the very beginning of the century, the design of a huge new Anglican cathedral, to be built on a magnificent elevated site overlooking a disused quarry that had become St James's Cemetery, was entrusted to Giles Gilbert Scott, then aged only 22. Destined to be the last great monument of the Gothic Revival, it was finally completed in 1979. The Roman Catholics in this deeply sectarian city were not to be outdone and, in 1929, commissioned a vast cathedral from Sir Edwin Lutyens which was to have a dome even larger than that of St Peter's in Rome. But only part of the crypt of this stupendous undertaking had been built when, in much less propitious conditions after the Second World War, the project was abandoned.

The gutted but still magnificent stone shell of Foster's Custom House in 1942. A few years later it would be demolished (rather than restored), ostensibly to relieve unemployment.

South Castle Street photographed by Stewart Bale in 1907, with the vista closed by the portico and dome of John Foster's Custom House. Every building in this view was destroyed during or after the Second World War and the street pattern changed.

A similar civic megalomania is also perhaps expressed by the three large Edwardian buildings at Pierhead, now known as the 'Three Graces', while the scale of the grand Classical steel-framed commercial buildings of the 1920s designed by Herbert Rowse showed that the cities Liverpool now wanted to emulate were New York and Chicago. But, by this date, Liverpool was in fact already on its downward slide.

As a great port handling transatlantic trade, Liverpool was naturally a target for the

▶ The Strand in 1919 photographed by Stewart Bale with, in the centre, the so-called Goree Piazzas, grand early 19th-century warehouses which were damaged in the Second World War and demolished soon afterwards. On the right is the White Star Line offices designed by Norman Shaw, and just visible on the left is the Liverpool Overhead Railway which closed in 1956.

▶ Lord Street looking west towards St George's Church in a stereoscopic photograph of the 1860s. The Georgian church would be replaced by the Queen Victoria Monument and the Regency terraces lining the street would be obliterated during the Second World War.

◀ Exchange Flags and the Nelson Monument behind the Town Hall at the end of the 19th century. These florid buildings of the 1860s by T.H. Wyatt were replaced in the 1930s.

LIVERPOOL

Luftwaffe and the city suffered terribly. It was, in fact, the principal German target outside London. Between 9 August 1940 and 9 May 1941, Merseyside suffered 68 air raids. These culminated in eight continuous nights of heavy bombing in May 1941 – 'the longest, unbroken series of serious attacks on any provincial area of the whole war', recorded the official historian.[100] After this, 'the tally of famous buildings damaged and destroyed reads like a guide book to Liverpool'. Many churches were hit, including the parish church of St Nicholas by Pierhead; the Custom House was gutted and the commercial area behind, around South Castle Street, Derby Square and Lord Street, almost entirely destroyed.

As in other cities, however, damaged buildings which could have been repaired were subsequently cleared away. Despite the vocal protests of the Georgian Group, which had been advised by Sir Charles Reilly (who had done so much for Liverpool's architecture), Sir Albert Richardson and Patrick Abercrombie, the gutted ruin of Foster's Custom House was demolished soon after the end of the war in order to 'lessen unemployment'[101] in Liverpool' – it presumably having not occurred to the authorities that the building could equally well have been *restored* to relieve unemployment. Repeated attempts to remove the gutted ruin of Foster's Perpendicular Gothic St Luke's Church fortunately failed, so that today this impressive structure still plays a crucial role in the city's townscape. The damaged Goree Piazzas, magnificent early 19th-century warehouses along the Strand, were also cleared. This was no doubt to facilitate the proposed new Ring Road.

Well might the authors of the revised *Buildings of England* volume conclude that 'Wartime bomb damage was less destructive than the subsequent efforts of architects and planners'.[102] For many, like the architect Alderman A. Ernest Shennan in 1948, the bombing was an opportunity. 'Liverpool of the future will spring from the city of today, war-torn and depressing as it is. But, unlike the old, the new growth will be authoritatively controlled by a long term-planning policy.'[103] And, of course, 'Governing the whole lay-out must, of course, be a basic road system'. Roads had long been an obsession, since

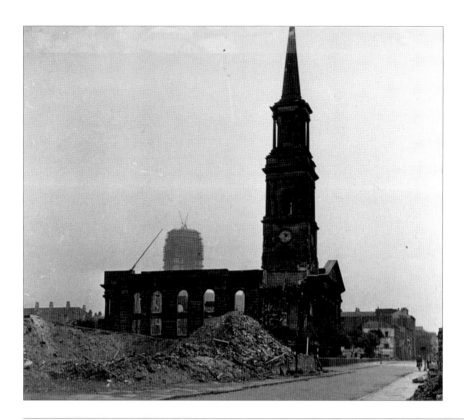

J.A. Brodie, the City Engineer, had laid out outer ring roads and promoted the Queensway, the road tunnel under the Mersey, in the early 1930s. Somehow characteristic of the time is the fact that after the pediment sculpture at St George's Hall, designed by C.R. Cockerell and carried out by W.G. Nicholl, had been taken down in 1950 as unsafe, it ended up as hard core for road building.

In the event, the immediate post-war plans were not realised and, as the rebuilding of Lord Street proved to be so disappointingly mediocre, in 1961 Graeme Shankland was brought in to make a comprehensive design for central Liverpool while Walter Bor was asked to prepare a comprehensive plan for the whole city. Naturally the Shankland Plan envisaged an inner ring road which, to quote from *Seaport*, Quentin Hughes's magnificently illustrated book on Liverpool, was to be 'a 50-mile-an-hour motorway raised high above the existing street pattern to which it is looped by flyover intersections feeding the distributed car-parks and the city centre'.[104] Mercifully, only part of this nightmare was ever realised. Meanwhile whole areas of terraced housing in inner suburbs, like Everton, were wiped out, their inhabitants being decanted to new council estates on the periphery.

Two parts of the inner city are particularly depressing to visit today. One is the University area in the streets around Abercromby Square east of the cathedrals. Back in the early 20th century, Charles Reilly, as Professor of Architecture, had the vision of a civilised urban campus taking its cue from the Late Georgian elegance of Abercromby Square with Bedford Street 'a processional way' with 'great gateways . . . to commemorate great events'.[105] Some hope: what eventually happened was that the interesting stuccoed Regency houses in the street were systematically cleared away to make way for a discordant set of university buildings. One of these, the 'deliberately outrageous' Sports Building by Denys Lasdun, was so ill-mannered as to provoke the ire of Pevsner, who wrote it was 'doubly painful because it refuses to blend in not only with the designs of its contemporaries but also with the Georgian square at whose corner it stands'. The second is the area around Scott's towering cathedral, where the rows of streets of

Georgian terraced houses which emphasised its scale and drama were all cleared away in favour of a new precinct designed in the feeblest Post-Modern manner. Another loss is that the cemetery in the quarry below, a city of the dead, was cleared of almost all its gravestones and monuments in the late 1960s.

It is difficult not to conclude that, in its relentless post-war economic decline, Liverpool became consumed by hatred of its own past. This was shown above all by the repeated attempts to demolish or ruin the Albert Dock, Jesse Hartley's masterpiece. Pevsner was moved to warn in the mid-1960s that 'To pull down the Albert Dock would be a black disgrace' and the following decade, out of sheer malice, the Mersey Docks & Harbour Board deliberately opened the sluices so the dock filled up with mud. In the event, it was saved, to become the focus of Liverpool's cultural regeneration, owing to Michael Heseltine, Secretary of State for the Environment. Heseltine was also responsible for saving Thomas Harrison's Lyceum Club building, which was threatened with replacement by a shopping centre. (Even when economic conditions were at their worst, Clayton Square could be cleared away for another characterless shopping centre.) Intervention by central government was probably essential, for by the 1980s Liverpool was the scene of violent urban riots and run by a Militant Socialist council which actually proposed that the top floors be lopped off 19th-century houses so that they could be council houses no more than two storeys in height.

Today, the situation has greatly changed, but the award of the title of European City of Culture for 2008 is being used as an excuse by the Council to encourage rampant commercial development at the expense of the surviving historic fabric of the city. Some of these proposals are actually threatening the status of World Heritage Site granted to the Pierhead area by UNESCO. The sad conclusion of an architectural history of the city since the Second World War can only be that Liverpool is its own worst enemy.

▲ A clever terrace of Regency houses in Bedford Street North giving the appearance of being separate villas, photographed by A. Piercy in 1942 and demolished after the war; it would be interesting to know the architect.

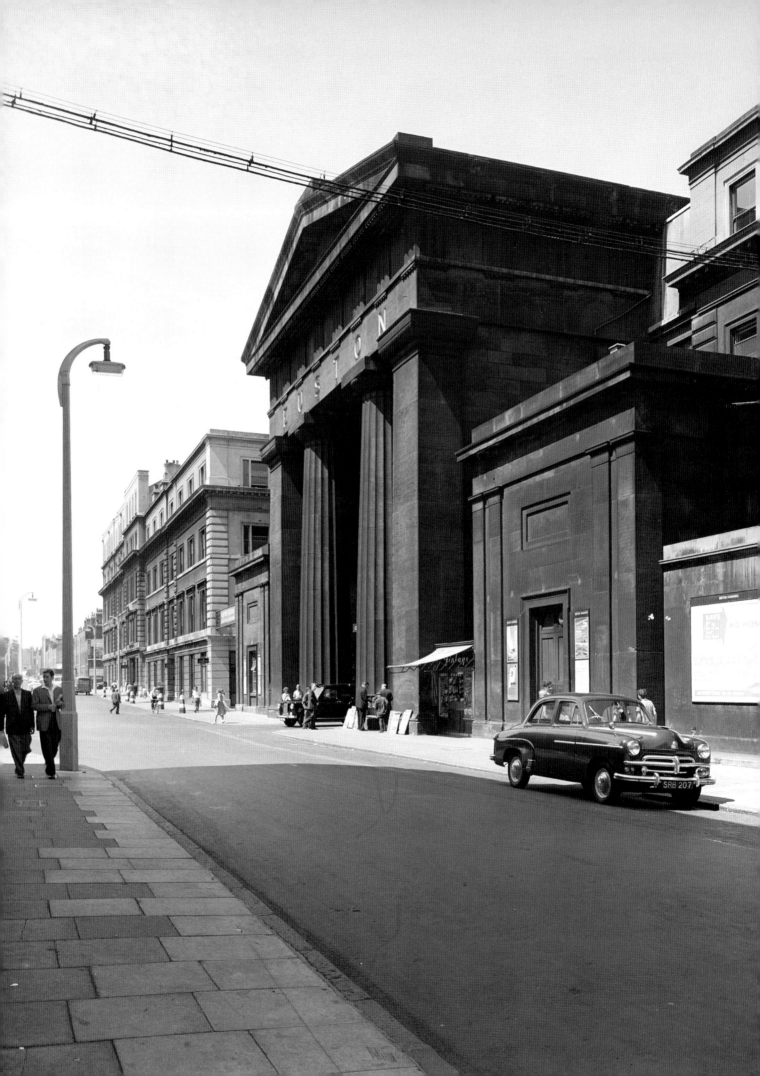

13: LONDON

Photographs of lost London buildings, streets and squares could easily fill this volume. As the capital, London was not only so very much larger than any other city in Britain, it was also the place where the pressures for change, the destructive tendencies that led to the replacement both of individual buildings and of whole districts, first became manifest. This was particularly true of the decades following the First World War. It was the demolition of important monuments of the 18th and 19th centuries in the 20th in London that led to the foundation of both the Georgian Group and the Victorian Society to protect other fine buildings of both those periods. And, having already suffered damage from both German airships and aeroplanes in the First World War, London was the principal target for bombing raids and flying bomb and rocket attacks in the Second. When one contemplates London's history over the last century, it seems a mercy that much more was not lost.

The long and complex history of the architecture and development of London is too big and familiar a subject even to sketch out here. What, however, needs emphasising is that, in a city that was and is a commercial as well as an administrative centre, change is inevitable and that certain areas – notably the City of London but also parts of Westminster – have been redeveloped several times over. But most important is the fact that London had long ago endured a destructive catastrophe greater in scale than that suffered by any British city in the Second World War; that is, the Great Fire of 1666. It was a disaster which destroyed over four-fifths of the area which today falls within the boundaries of the City Corporation. The fire raged for four days and not only razed over thirteen thousand houses – mostly built of timber – but also destroyed or badly damaged St Paul's Cathedral and 87 parish churches and 44 livery company halls as well as the Royal Exchange, the Guildhall and other public buildings. Destruction, of course, is always also an opportunity and in the case of the Great Fire of London so it proved for Christopher Wren.

In addition to the constant process of renewal and improvement, London also underwent profound and concentrated changes in the 19th century which were hugely

◀◀ Philip Hardwick's Euston 'Arch', the entrance to the London & Birmingham Railway opened in 1837 and the most noble monument of the Railway Age, in 1960. Owing to the malice and philistinism of British Railways and Harold Macmillan's government, its unnecessary destruction commenced a year later.

▲ The Quadrant of John Nash's Regent Street in *c*. 1900. The whole street was rebuilt higher, and in Portland stone rather than stucco, in the mid-1920s.

destructive. While the construction of docks and canals affected only the periphery, the building of railways created large areas of devastation in the city centre. Although the main lines from the north were not permitted to advance beyond the line of the New Road – the Marylebone and Euston Roads – the southern railway companies smashed their way through South London and over the Thames, into Victoria, Charing Cross, Blackfriars and Cannon Street. The height of railway building was during the 1860s, when what is now the Circle Line, constructed by 'cut and cover', was largely created. Then there were the street improvements, several of which – like the construction of Holborn Viaduct and of Queen Victoria Street – compounded the chaos of building work in central London during that decade.

Earlier new streets, like John Nash's Regent Street, were both elegant in conception and comparatively tactful in their construction, but the mid-Victorian improvements, pursued by the Metropolitan Board of Works, were cruder in design and partially conceived as slum clearance exercises. The construction of Victoria Street, the Charing Cross Road and Shaftesbury Avenue were therefore very destructive of property, while the building of Northumberland Avenue required the demolition of Northumberland House, the greatest of the surviving great houses of London. The last of these major town planning exercises was the creation of Kingsway and the Aldwych at the beginning of the new century. Promoted by the new London County Council, it required the removal of many ancient streets north of the Strand, like Wych Street, full of picturesque old gabled houses which, fortunately, had been recorded by the Society for Photographing Relics of Old London and by others.

Although in the reign of Edward VII the pace of redevelopment accelerated, with

higher steel-framed structures faced in Portland stone replacing brick and stucco, the capital emerged from the Great War with Georgian London largely intact. However, by the outbreak of the Second World War two decades later, many of the finest buildings erected in the city in the 18th century had disappeared. Between the two world wars, the West End of London, in particular, was transformed. Commercial pressures resulted in the widespread replacement of houses by blocks of flats while the constant complaint of motor traffic congestion led to numerous road widenings. Strongly influenced by contemporary developments in the United States, London began to expand upwards. Victims of this process were many. 'The record of notable casualties seems to grow larger each year to make up for the lull in the war,' complained James Bone in 1925. 'The appetite of the destroyers sharpens with exercise, for now Waterloo Bridge and several of the City churches are demanded . . .'[106]

Six years before the Great War, the historian E. Beresford Chancellor could publish *The Private Palaces of London, Past and Present*, a lavish celebration of 'those splendid mansions that still remain, and which are not only among the proudest possessions of London, but, in some sense, one of the glories of the country.'[107] These aristocratic town houses still made London comparable with Paris, Rome, Vienna and Prague. But already Chancellor saw clouds on the horizon; several of these private palaces had already gone, so, 'What then are we to suppose will be the fate of some of those which to-day would seem to be armed so as to defy time? Some we know are held on leasehold tenure, and when their time has run, may be ruthlessly demolished; others stand proudly in the midst of ever-changing conditions of building development; will they be, in their turn, attacked, and if so – what then?'

▲ To prevent the demolition of these houses in Abingdon Street opposite the Palace of Westminster to build the King George V Memorial was an early battle fought by the newly founded Georgian Group in 1938. This photograph was taken by Dell & Wainwright in 1943 when war damage was used as an excuse to pull the whole terrace down.

▶ William Kent's Devonshire House, built off Piccadilly in the 1730s, being demolished in 1924.

▼ Dorchester House, the grand 1840s *palazzo* in Park Lane designed by Lewis Vulliamy, photographed by Harold P. Clunn in 1929, shortly before demolition to make way for the modern Dorchester Hotel.

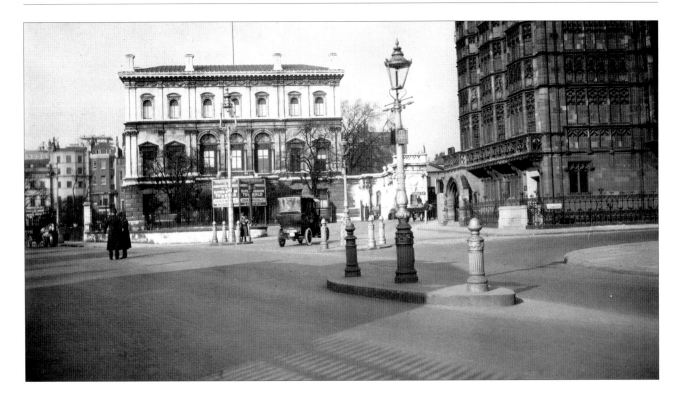

What soon happened was that the owners of these great Georgian houses rapidly sold up, and there was no legislation to protect and architectural monuments considered of value built after 1714. So Devonshire House in Piccadilly, designed by William Kent and once a palace of treasures, was demolished in the early 1920s and its extensive grounds entirely occupied by a large block of apartments, not only American in inspiration but American in design. This loss was soon followed by those of Dorchester House, Chesterfield House and Norfolk House while Lansdowne House was half-

◀ Norfolk House, the London mansion of the Dukes of Norfolk in St James's Square, built by Matthew Brettingham in 1748-52, photographed shortly before it was demolished by Rudolph Palumbo in 1938 .

demolished and mutilated. All these stood in Mayfair or the West End; other fine Georgian buildings which disappeared between the wars included the Foundling Hospital in Bloomsbury – which could have formed the nucleus of London University – and most of Soane's Bank of England in the heart of the City.

Whole streets and squares were also rebuilt. Regent Street disappeared in the 1920s, its Regency buildings being replaced by taller structures faced in stone. Nash's oil-painted stucco fronts had few defenders then, although Trystan Edwards extolled their merits. 'If

▲ Lansdowne House by Robert Adam seen from Berkeley Square before the house was mutilated and the gardens were built over in 1933-35.

▶ Adelphi Terrace overlooking the Thames in c.1934 with the new Shell Mex House in the distance. Most of the development by the Adam Brothers was demolished in 1936.

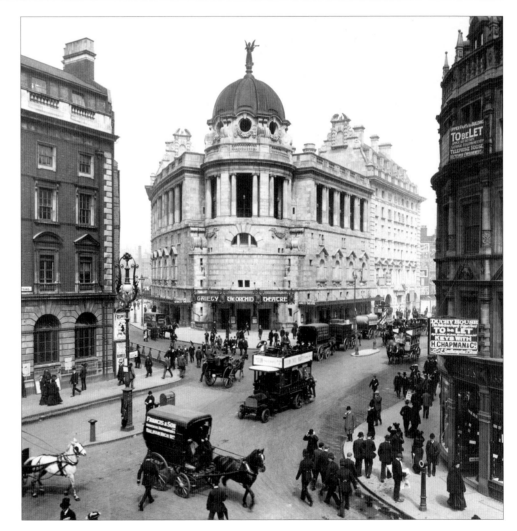

▶ The new Gaiety Theatre on the corner of the newly laid-out Aldwych and the Strand in 1905. This Edwardian Baroque theatre, with facades by Ernest Runtz and Norman Shaw, was gutted in the Second World War and the shell demolished in the 1950s.

◀ The Pantheon in Oxford
Street in the 1930s, by
then used as offices;
the façade of this once-
celebrated building by
James Wyatt was taken
down in 1937 for
re-erection by Edward
James at West Dean in
Sussex, but war
intervened.

LONDON

121

London had been subject to a foreign conquest preceded by bombardment it is difficult
to conceive that the architectural products expressive of the highest genius of the
English people could have fared so ill as they have done at the hands of our own native
vandals, our most literary and artistic vandals.'[108] Then there was the destruction of most
of the Adelphi, that remarkable development of houses overlooking the Thames by the
brothers Adam. Almost every Georgian Square in central London lost its integrity in this
period, with taller buildings changing their scale and destroying their symmetry. Nor
was there any legislation to protect their gardens from being built over, as the loss of the
south half of Euston Square demonstrated.

One of the saddest losses was that of Waterloo Bridge, because it was unnecessary.
Some of the piers of the Doric bridge designed by John Rennie, described by the
sculptor Antonio Canova as "the noblest bridge in the world [. . .] alone worth coming
from Rome to see," began to subside in the early 1920s. Many rallied to its defence, like
the architect W.R. Lethaby, who wrote that 'Waterloo Bridge is the most representative
monument after St Paul's. The two buildings . . . should be regarded as sacred works of
art' and argued that it could and should be repaired.[109] Its fate, however, was bound up

▶ Looking eastwards over Waterloo Bridge in the early 1920s when the dominance of the dome of St Paul's in the City's skyline was still unchallenged and John Rennie's noble Doric bridge had yet to cause problems.

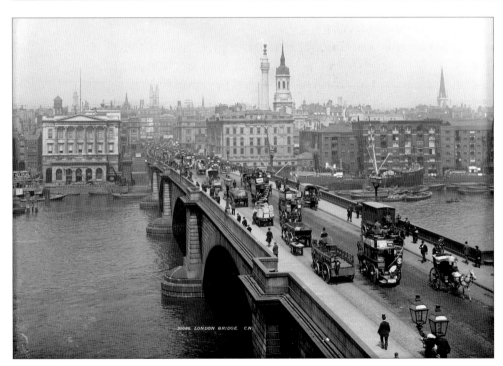

▶ Looking north over London Bridge in *c.* 1900; of the buildings facing the Thames, only Fishmongers' Hall on the left hand side of the bridge survives today.

with the proposal to replace the Hungerford railway bridge into Charing Cross with a new road bridge. Controversy raged, but, in the end, the Hungerford Bridge, which everyone agreed was hideous, survived while it was old Waterloo Bridge that was replaced. Such is the way we manage things in Britain. The attitudes which encouraged its destruction, and that of much else, were summed up in the contemporary writings of Harold P. Clunn, author of *The Face of London*, who was concerned only with property values and accommodating traffic and who dismissed those who wanted Rennie's Waterloo Bridge to be retained as 'short-sighted fanatics'.[110]

In the end, the fanatics fought back by founding the Georgian Group (of the Society for the Protection of Ancient Buildings) in 1937. The prime mover was the novelist Douglas Goldring, who wrote that

> It is no exaggeration to say that, since 1920, nearly every architectural feature of London which was as characteristic of our national temperament and as expressive of our taste and culture, as the Place Vendôme and the Place des Vosges are expressive of the taste and culture of the French, has been either destroyed or partially ruined. Even the Squares of Mayfair and Bloomsbury – those masterpieces of by-gone town-planning, that were so long a source of justifiable civic pride – have all, with the exception of Bedford Square, been hopelessly defaced.[111]

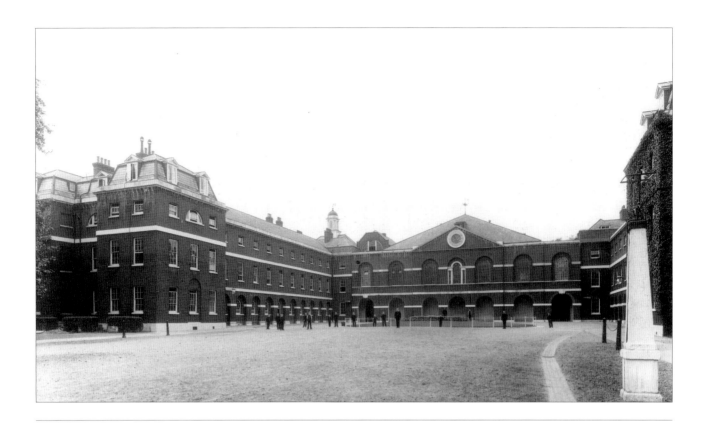

▲ The Foundling Hospital in Lamb's Conduit Fields in the early 20th century before it moved out to Berkhamsted. A proposal that London University should move in having foundered, the buildings were demolished after the site was sold in 1926, but the land was eventually saved as an open space, Coram's Fields, by public subscription.

A new society was needed to try and overcome the widespread prejudice against the Georgian. As Goldring again wrote,

> Many people who never give architecture a thought are fully conscious of amenities and resent their destruction. But undoubtedly the delusion still persists that because a Georgian house, street, square or terrace cannot be described as 'ancient', therefore its demolition cannot be opposed on architectural grounds, however much it may be regretted for reasons of sentiment. And sentiment, as Big Business is never tired of telling us, must not be allowed to impede the march of 'progress'.[112]

The extent to which London was being destroyed was surveyed in the excoriating pamphlet entitled *How We Celebrate the Coronation* written by the society's deputy chairman, Robert Byron, that same year. He was unsparing in his criticism:

> The Church; the Civil Service; the Judicial Committee of the Privy Council; the hereditary landlords; the political parties; the London County Council; the local councils; the great business firms; the motorists; the heads of the national Museum – all are indicted, some with more cause than others, because of some more decency might have been hoped for, but all on the same charge. These, in the year of the coronation, 1937, are responsible for the ruin of London, for our humiliation before visitors, and for destroying without hope of recompense many of the nation's most treasured possessions; and they will answer for it by the censure of posterity.[113]

What, even now, seems extraordinary is that even churches by the supreme national architect hero were not safe, despite the fact that the cult of Sir Christopher Wren as an English gentleman reached a crescendo between the bicentenary of his death in 1923 and the tercentenary of his birth in 1932. City churches had been disappearing since the passing of the Union of Benefices Act in 1860, their sites being sold to pay for new churches in the suburbs. After the Great War, in 1919, the Bishop of London attempted to accelerate the process and proposed the demolition of nineteen churches, by Wren,

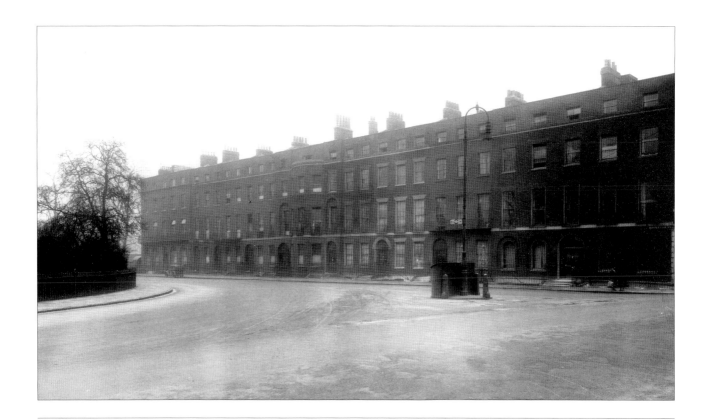

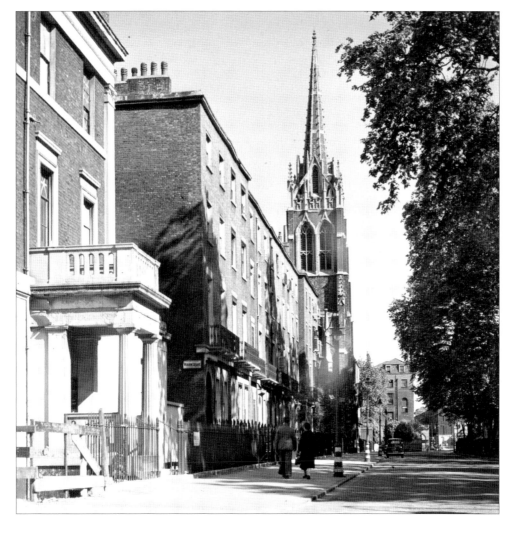

▲ The south side of Brunswick Square in the 1930s. Originally laid out in the 1790s, this was one of several London squares threatened with redevelopment before the Second World War and, following bomb damage, the south side was demolished soon after the war.

◀ Woburn Square, Bloomsbury, in 1941 with the steeple of Christ Church by Lewis Vulliamy, 1831-33. The church and most of the square was demolished by the University of London in 1974.

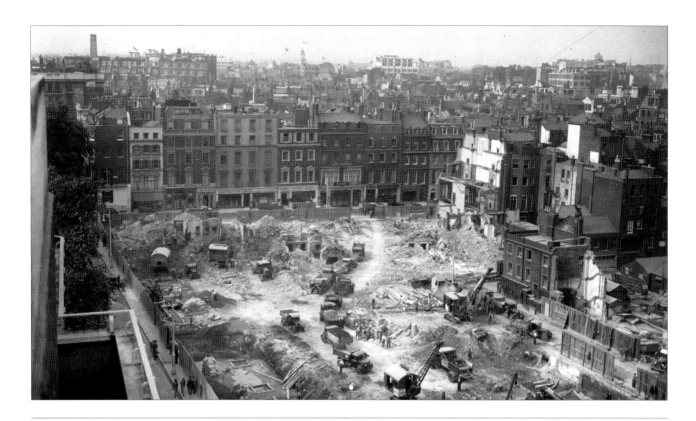

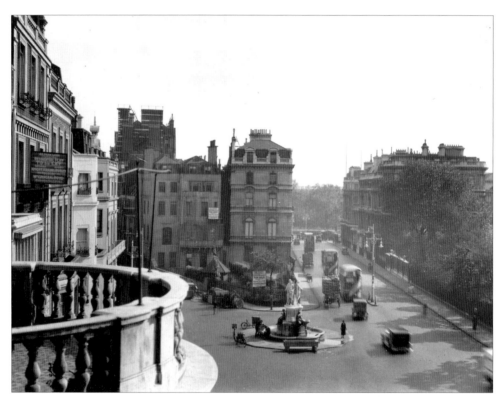

▲ The east side of
Berkeley Square in
c. 1950, looking north over
the large site being
prepared for the building
of Berkeley Square House.

▶ The southern end of
Park Lane looking south
down Hamilton Place,
photographed by E.R.
Jarrett in c.1930. All the
buildings visible perished
after the Second World
War and were mostly
replaced by modern hotels
– the houses to the left
would give way to the
Hilton tower

Hawksmoor and others. This, as Byron later put it, 'was too much even for a nation of
shopkeepers' and the scheme was quashed by Parliament. The Church then selected its
victims one by one, and hunted them down with success. Two City churches came down
between the wars, the second – All Hallows', Lombard Street, which was demolished in
1938, actually being by Wren.

With hindsight, we can see that the Bishop of London could have avoided controversy

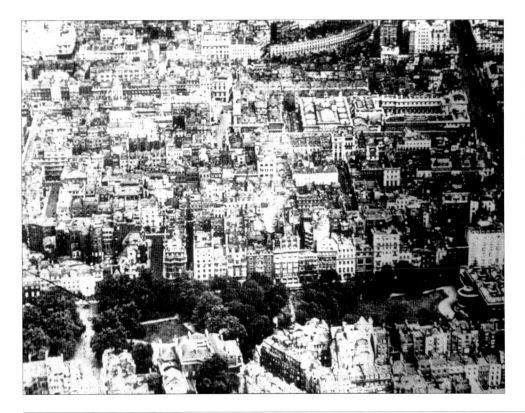

◁ An aerial view of Mayfair looking east in the early 1920s with Nash's Regent Street in the distance and, in the foreground, the contiguous gardens of Berkeley Square, Lansdowne House and Devonshire House – the latter two spaces soon to be built over.

◁ All Hallows' Lombard Street shortly before it was demolished in 1938 so that Barclays Bank could build on the corner of Gracechurch Street. The tower of Wren's church was re-erected the following year next to a new church in Twickenham.

▶ St Ethelburga's
Bishopsgate before the
little shops in front, so
typical of the old City of
London, were removed in
1932. The restored façade
of the Mediaeval church
would be blown up by an
IRA bomb in 1993.

and merely waited a couple of years to let the Luftwaffe do his work for him. The first
bombs dropped on the City of London on 24 August 1940. The first big raid on the Docks
came on 7 September. After that, the air raids were almost continuous for the next nine
months. One of the most destructive raids was on the night of 29 December, when the
whole City seemed to be on fire as the dome of St Paul's rose above the smoke and flames
– as recorded in the (slightly doctored) famous photograph by Herbert Mason. Eight Wren
churches were gutted that night. The worst raid came on 16 April 1941. James Lees-Milne
was in Piccadilly that night, when Wren's St James's was gutted, and recalled how

> The sky had the gunmetal solidity of sky before a snow storm. Cinders showered upon
> our hair, faces and clothes. On all sides columns of smoke sprang from raging fires, the
> glint of whose fames could be seen above the rooftops, trembling upon chimney stacks
> and burnishing the dull surface of the sky. I was reminded of Pepys's description of the
> Great Fire of London in 1666, 'a most horrid malicious bloody flame, not like the flame
> of an ordinary fire'.[114]

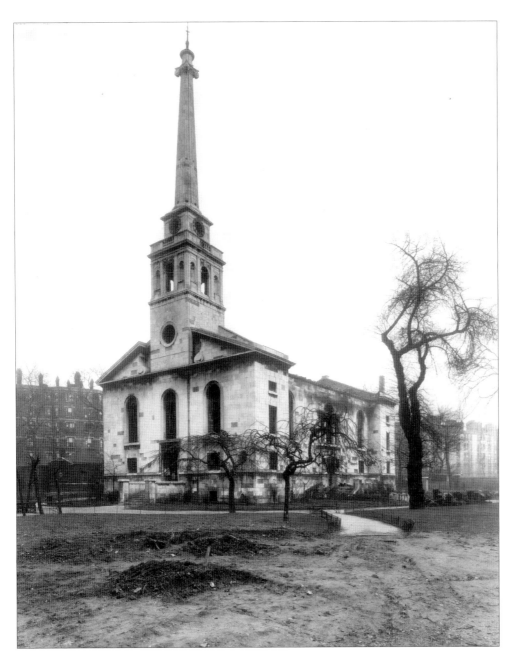

◀ St John's Horsleydown, the church by Nicholas Hawksmoor and John James with its extraordinary steeple which stood behind London Bridge Station in Bermondsey – shown here after it had been gutted by incendiary bombs in 1941. The shell was subsequently demolished rather than restored.

LONDON

129

A last heavy bombing attack came on the night of 10 May, when the House of Commons was gutted. After that, the raids began to tail off. But for the capital the war was certainly not yet over. Three years later, London – unlike the other blitzed cities – suffered a second devastating aerial assault, this time not from conventional bombers but from the 'V' weapons. And this time, the damage was more widespread and dispersed. The first flying bomb came down in Bow on 13 June 1944, and the first devastating V2 rocket fell on Chiswick on 8 September. London had to endure more destruction, more loss of life, more suffering, until almost the end of the war.

The architectural casualty list is long and depressing, particularly as many buildings which could have been restored were not or – as is the case with most of the gutted Wren churches – the reconstructions were generally inauthentic and mediocre. Dozens of City churches were damaged, as were the celebrated English Baroque churches by Hawksmoor and Archer. Hawksmoor's St George-in-the-East managed to survive but his St John's Horsleydown was needlessly swept away after the war. Some of the very best Victorian churches also disappeared, such as Pearson's St John's, Red Lion Square, and the younger

▶ Looking east down Paternoster Row in the 1930s; this was the spine of the area immediately to the north of St Paul's Cathedral which was devastated in the air raid of 29 December 1940.

▶▶ No.11 Warehouse of London Docks in New Gravel Lane, Wapping, photographed by Herbert Felton and later published in J.M. Richards' book on *The Functional Tradition* (1958). Most of these austerely beautiful warehouses by Daniel Asher Alexander would be demolished in the 1970s.

Scott's St Agnes', Kennington. Other casualties included many livery halls in the City; several Inns of Court; a few of the surviving large aristocratic houses – notably Holland House and Portman House; the Queen's Hall – London's finest concert hall, which would eventually be replaced on a different site by the architecturally outstanding but acoustically inferior Royal Festival Hall – as well as thousands of more ordinary Georgian houses. Just under a third of the built fabric of the City of London was razed – including whole quarters like that around Paternoster Square – while vast swathes of Stepney and the East End of London were destroyed.

When it was enemy bombs rather than the Church of England, the government or rapacious speculators which destroyed historic buildings, it was regarded as an outrage, and in a changed climate of opinion legislation was enacted which permitted the statutory 'listing' of buildings. Nevertheless, as in other cities, post-war reconstruction often involved comprehensive redevelopment which led to the destruction of many

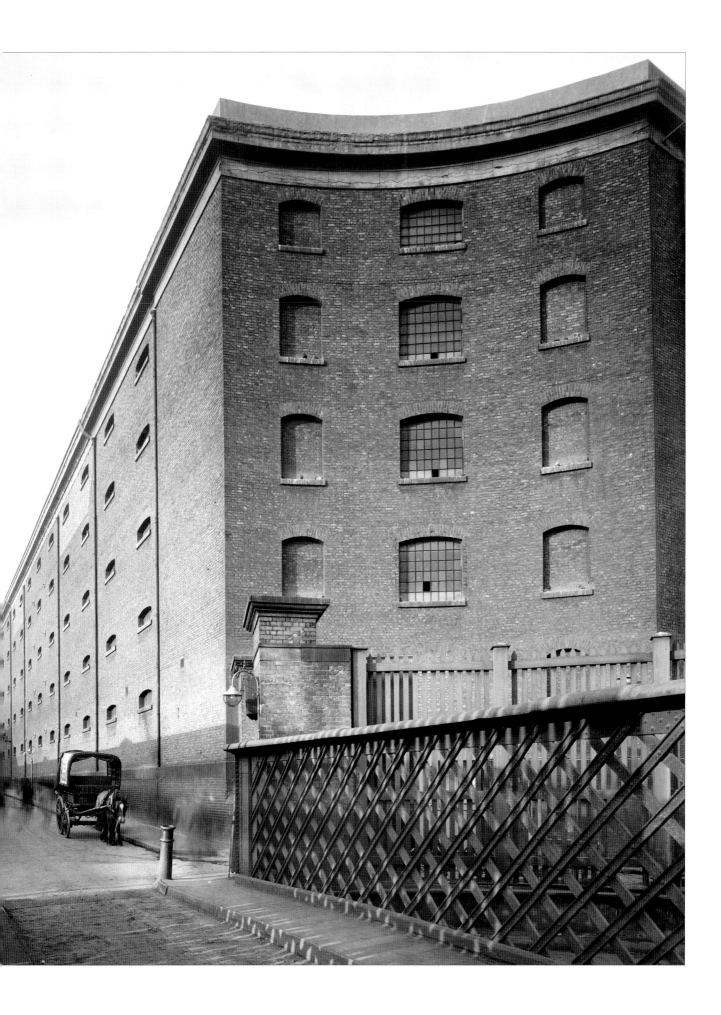

▶ The Coal Exchange on the corner of St Mary at Hill and Lower Thames Street by J.B. Bunning of 1847-49, photographed by Edwin Smith in 1958. A most remarkable structure, it was disgracefully demolished by the City of London Corporation despite strong opposition in 1962, ostensibly for road widening.

wartime survivors. 'By 1960,' wrote Colin Amery and Dan Cruickshank in *The Rape of Britain*, 'more of East London was derelict than was devastated during the war. The threat of comprehensive development caused whole areas to stand and rot, and it became obvious that what was being cleared away was not bomb damage and slums, but the very character and history of East London'. As for the City of London, where several developers made their fortunes by buying up bombsites, 'More . . . stands devastated and is doomed now than was destroyed during the Blitz of 1941'.

In the City, the pressure to redevelop was, as ever, commercial, and it has been continuous ever since, post-war buildings today giving way to even taller structures as London surrenders to the crude American model of the skyscraper. In the West End, commercial developers also attempted to resume the pre-war pace of change, particularly during the Macmillan government when the so-called 'carnivores' replaced the temporary ascendancy of the 'herbivores'. It was typical of the time that Park Lane

was enlarged into an urban motorway, destroying the coherence of Hyde Park Corner, while other important and busy roads were disfigured with underpasses. The motor car seemed all-important, all-conquering. Meanwhile, the first important Victorian buildings began to come under attack, the gratuitous destruction in 1962 of the Euston 'Arch', the greatest monument of the Railway Age, soon followed by that of the Coal Exchange in the City.

In retrospect, London was fortunate, as many doomed buildings and areas survived, like Spitalfields just east of the City. St Pancras and King's Cross Stations were not demolished as planned in the 1960s; Covent Garden was not swept away as intended and Piccadilly Circus escaped several radical proposals for reconstruction; Scott's Foreign Office and Shaw's New Scotland Yard still stand. A sea-change occurred during the 1960s as the Greater London Council began to favour conservation, while the best Victorian architecture began to be taken seriously. A particularly merciful escape came with the cancellation in 1973 of Ringway 1 or the 'Motorway Box', the innermost of a series of three concentric rings of urban motorways around London proposed by the G.L.C. in the 1960s. By the 1980s, conservation might seem to have triumphed in London. However, development pressure today is as strong as ever and, in these early years of the 21st century, with the Mayor of London encouraging more and yet higher commercial developments, the character of central London seems more under threat than for many decades. To look east from Westminster Bridge at the City of London skyline beyond the South Bank is a painful experience if you reflect on the same view back in 1951 at the time of the Festival of Britain, when the dominance of Wren's dome of St Paul's had yet to be challenged.

▲ The South Bank of the Thames seen from Hungerford Bridge after the Second World War. The demolition of the Lion Brewery, designed by Francis Edwards in 1836, commenced in 1948 to clear the site for the Royal Festival Hall, but D.R. Roper's Shot Tower of 1826 was incorporated into the Festival of Britain in 1951 – only to be taken down a decade later for the building of the Queen Elizabeth Hall.

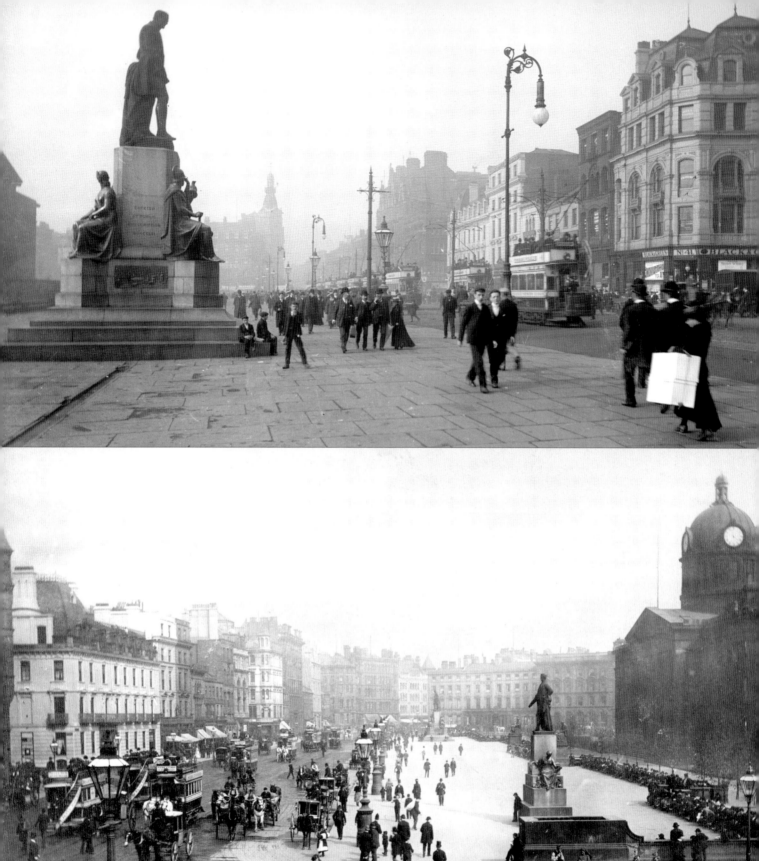

14: MANCHESTER

'Manchester is essentially a Victorian city', wrote Cecil Stewart half a century ago in his book on *The Stones of Manchester*. Despite changes since, that is still true today. Manchester is much older, of course, and can boast a magnificent Late Mediaeval parish church – now the Cathedral – but, as Peter de Figueiredo has written, 'In spite of the terrible destruction of war and brutal 1960s redevelopment, the achievements of Victorian and Edwardian architects still give the city a distinct identity.'[116] This is because, in their reforming zeal and commercial confidence, the Victorians replaced an older Manchester, an industrial town that was notorious for its social conditions throughout the world. Mediaeval and Georgian Manchester has largely disappeared. And the destruction continued. 'Nor is much left of Tudor and Early Stuart building,' Nikolaus Pevsner wrote in 1967, 'and what there is has been scandalously treated by the Corporation. To see house after house decaying, neglected, pulled down, or beyond repair leaves one speechless with incomprehension and anger.'[117] Inevitably, much of Victorian Manchester has now also gone and today, perhaps, its loss is more keenly felt.

In his study of *Victorian Cities*, Asa Briggs described Manchester as 'the symbol of a new age'. The cotton industry made Manchester great and famous, and a range of visitors came to be amazed by, or appalled by, the landscape of steam-powered cotton mills and the dreadful conditions in which those who worked in them lived. The great Prussian architect Schinkel visited in 1826 and sketched the multi-storey, iron-framed mills by the Rochdale Canal which astonished him; miraculously, most of them survive today. Friedrich Engels and Thomas Carlyle commented on the social conditions, the contrasts of great wealth and desperate poverty, and the division of classes, while novelists like Elizabeth Gaskell and Benjamin Disraeli developed these themes – the latter making one of his characters say that Manchester was 'the most wonderful city of modern times'. During the Industrial Revolution, Manchester generated great wealth; it also was a centre for radical politics.

The slums – mostly Georgian – that shocked visitors have gone, along with the densely packed houses that once surrounded the ancient parish church in the inner

135

◀▲ Piccadilly in 1903 looking west towards Market Street; the statue by Matthew Noble of the Duke of Wellington still stands in Piccadilly Gardens today.

◀◀ Piccadilly looking east in *c.* 1900 over what today is Piccadilly Gardens. The Manchester Royal Infirmary on the right, originally erected in 1755 and later enlarged, was taken down in 1909.

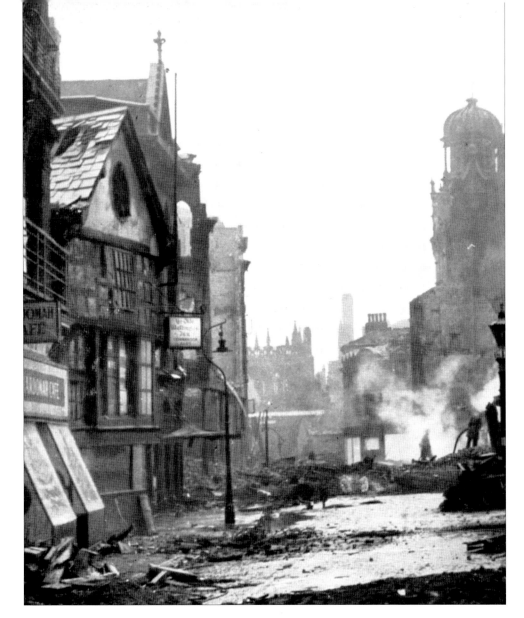

◀ The Market Place, looking north towards the Cathedral, immediately after a heavy bombing raid in 1940. This street has entirely disappeared but the Old Wellington Inn, the 17th-century timber-framed building on the left, would survive to be rebuilt (again) on a nearby site after the area around Corporation Street was devastated by an IRA bomb in 1996.

city, close to the polluted river Irwell that divides Manchester from Salford. Having attracted so much unfavourable attention, Manchester transformed itself during the mid-Victorian decades. The symbol of this is the Town Hall designed by Alfred Waterhouse, one of the greatest monuments of the Gothic Revival. The other buildings which created the character of the city were the huge and grand cotton warehouses, many of them designed in the Italian Renaissance manner. Another local architect, and Gothicist, Thomas Worthington, said in 1875 that 'Manchester is acquiring the reputation of a town of some architectural character; it is the inland metropolis of the North, the Florence, if I may so describe it, of the nineteenth century; it has developed a style of architecture which we may largely call our own, and in which we may take a not unnatural pride.'[118]

Later in the 19th century, terra-cotta and faience was added to the red brick and stone palette of Manchester's architecture as Waterhouse and other local architects erected extravagant and confident warehouse and office buildings, while the Rylands Library in Deansgate, designed in Perpendicular Gothic, exemplified the cultural tradition that went hand in hand with commercial success. Such confidence continued into the inter-war decades, manifested above all by the large but subtle extension to the Town Hall and the adjacent, circular Central Library, both designed by E. Vincent Harris, and a miniature Classical skyscraper bank by the great Sir Edwin Lutyens.

◀▲ Deansgate in the late 19th century, looking north towards the Cathedral; this stretch was widened and straightened in 1869, but most of the Late Victorian buildings lining the street were redeveloped after war damage.

◀◀ Commercial buildings of the 1870s in the northern part of Deansgate, all since demolished.

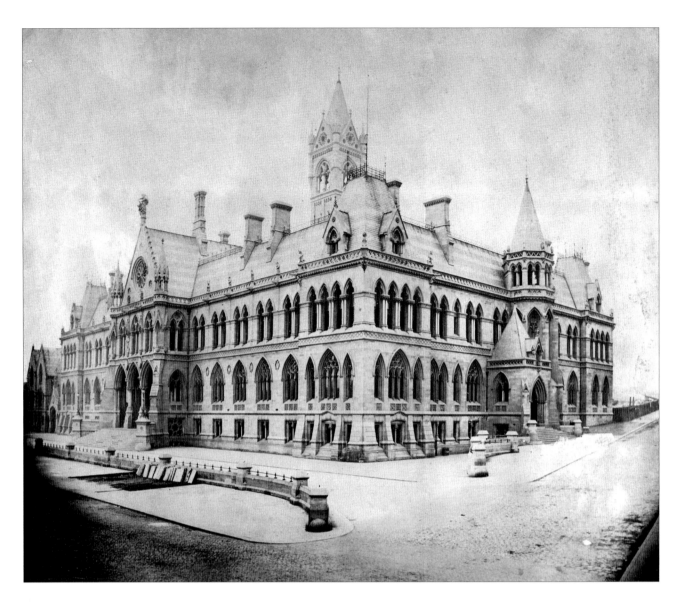

The Assize Courts of 1859-69 by Alfred Waterhouse, the architect of Manchester Town Hall, soon after completion. Badly damaged in 1940, the Gothic Revival building could have been restored but was demolished in the 1950s.

Then came the Second World War, during which the city was badly bombed. Manchester was entirely unprepared when 400 German bombers attacked two nights running just before Christmas 1940. The Cathedral was hit, although – mercifully – Cheetham's Hospital, the precious complex of Mediaeval buildings containing a library and college just to the north, was spared. The worst hit was the area of ancient streets to the south of the Cathedral, the wooden houses in the Shambles went up in flames and several major Victorian buildings, like the Royal Exchange, were badly damaged. The worst architectural loss was the interior of the Free Trade Hall, the noble 1850s palazzo by Edward Walters which celebrated Manchester's role in the campaign to repeal the Corn Laws and which was built on the site of the notorious 'Peterloo' massacre in St Peter's Fields back in 1819.

A plan for the city by Rowland Nicholas was published in 1945 and. after the war, Manchester – like every 19th-century industrial city – began to hate itself, its industrial grime, its past, its Victorian buildings and the acres of mean terraced housing. Ian Nairn caught this defeatist mood, so different from that of a century before, when he wrote in 1960 how 'if today's Manchester has a fault, it is that it looks over its shoulder too much. It is rather ashamed of the dirt, the wet days, the opulent buildings: it would like to be polite. That way lies disaster; if the city of Manchester stops being commercial it will stop being patrician as well. The Manchester spirit is a sublimation of hard cash, and

there is no other way to achieve it.'[119] Inevitably, however, the city followed the contemporary enthusiasm for tall buildings, for allowing the importunate demands of road traffic to dominate, for comprehensive redevelopment. Pevsner, in 1967, surveying the city for his *Buildings of England*, found himself driving 'through areas of total desolation' as 'Manchester . . . is engaged in one of the largest slum-clearance enterprises of all time'. As for what was replacing the repetitive terraces, Pevsner was prescient: 'Do we really want these towers of flats everywhere? . . . Will they not be the slums of fifty years hence?'

The disaster could have been much greater, however. Although an urban motorway now divides the city centre from the southern inner suburbs, no new roads were, in the event, driven though the centre itself thanks to a public inquiry held in 1973. The most radically transformed area was south and east of the Cathedral where so many bombs had fallen, while the huge, drab Arndale Centre of the early 1970s blighted the area between Corporation Street and Market Street. Elsewhere, high buildings began to rise, particularly around Piccadilly Station and on the south side of Piccadilly Gardens. For all his doctrinaire identification with the ideology of the Modern Movement, Pevsner was not impressed. 'Most of the many new office buildings use curtain walling, and yet curtain walling is not helpful in preserving and developing the specific Manchester character of the centre, which is a character of the dour solidity of good ashlar stone.' But sensible decisions were also made, and the best Victorian buildings looked after. Central Station, that magnificent train shed erected by the Midland Railway in the manner of that at St Pancras, could easily have been demolished when it became redundant; instead it was made into the G-Mex conference centre.

Since the 1960s, the much-abused area south of the Cathedral has been transformed again, and again owing to explosives – but this time not dropped by the Luftwaffe but left by the IRA. In 1996, a powerful bomb exploded in Corporation Street close to the Arndale Centre and the principal victims were unlovely buildings of the 1960s and 1970s. The area was replanned and the Old Wellington Inn, that surviving relic of the old town which was originally a 17th-century timber structure and had already survived being jacked up in the 1920s, was rebuilt on a new site. Apart from the Cathedral and Cheetham's Hospital, nothing now remains here as a reminiscence of pre-Victorian Manchester. The rebuilding after the 1996 bomb seems to have stimulated a vigorous and optimistic building boom which, while threatening to remove yet more historic buildings and radically to change the appearance of certain streets, does suggest that the Manchester spirit Nairn identified is alive and well. Even so, it is still true that it is the work of Manchester's Victorian and Edwardian architects which gives the city centre its distinct character, which is why the loss of so much of the 19th-century urban fabric is so painful.

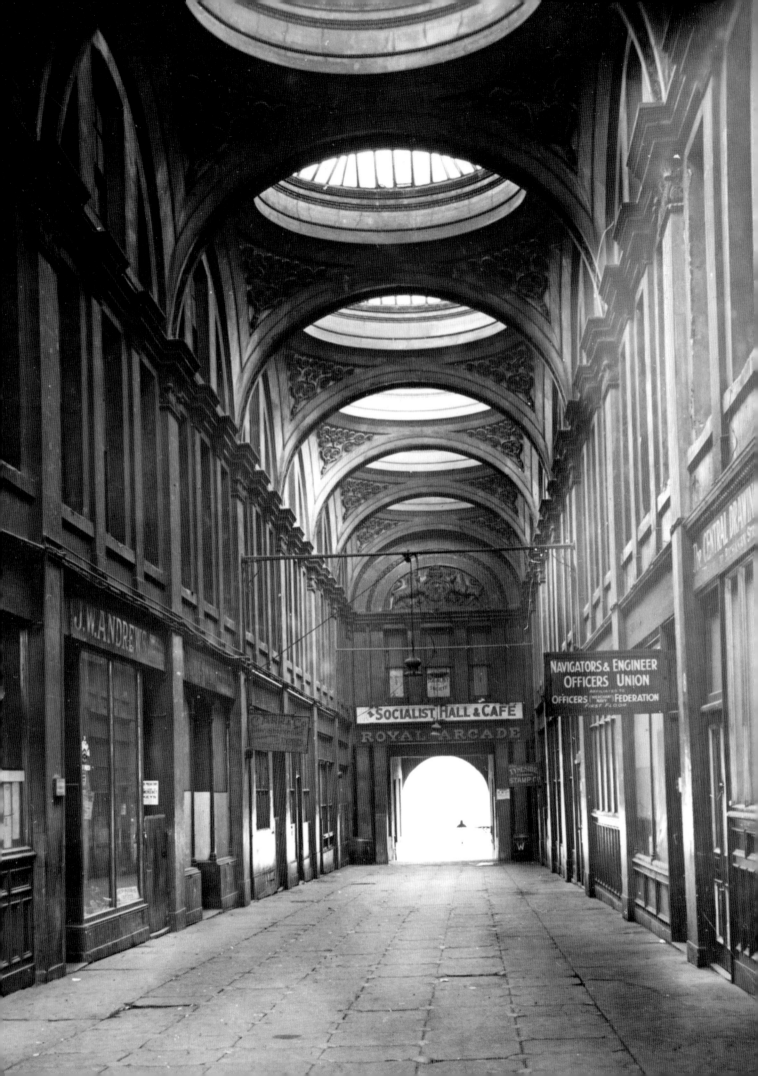

15: NEWCASTLE-UPON-TYNE

An ancient and great port on the river Tyne at the end of the Roman wall, with industries including shipbuilding and locomotive manufacture, a manufacturing and coal-mining town since the early days of the Industrial Revolution, Newcastle would, it might be supposed, have been badly damaged by enemy action during the Second World War. But, as a city, it was not, and one of its principal glories – the pattern of new, elegant streets laid out in the first half of the 19th century by the inspired developer Richard Grainger and the architect John Dobson – survived largely intact. The damage done to Newcastle was self-inflicted and, as elsewhere, largely took place in the 1960s. The planner Thomas Sharp, born in County Durham, in his *Shell Guide* to Northumberland could write in 1954 that Newcastle is 'distinguished among English provincial cities for the quality of its architecture and the attractive-ness of its women.'[120] Mercifully, the former certainly remains true today, but fine buildings have been lost and fine streets disfigured.

What makes this city so different from other industrial cities is the river flowing in its steep-sided valley and separating Newcastle from Gateshead to the south. This valley was crossed in the 19th and 20th centuries by high level bridges, resulting in dramatic changes in scale and violent contrasts in level. It was by the river, along Quayside, that Newcastle's first buildings rose, and some of its most interesting and venerable survive, while at the top of the slope it acquired a castle and a fine Mediaeval church, now the Cathedral of St Nicholas. Grand public buildings, like the Greek Revival Moot Hall, look down over houses and warehouses from this vantage point. Robert Stephenson's High-Level Bridge ruthlessly brought the railway from London into the city, narrowly missing the Castle as it curved round into Central Station, one of the very finest of Victorian railway structures in Britain. And in the 1920s the steel arched New Tyne Bridge brought more road traffic into the centre, its approach narrowly missing All Saints', the Late Georgian church with its remarkable oval nave, and creating trouble for the future.

Architecturally, Newcastle's finest hour came in the 1830s and 1840s when Grainger, with the town clerk John Clayton and largely assisted by Dobson, redeveloped what is now the city centre, north of the Tyne. Developer and architect brought the Picturesque

◀◀ The interior of the Royal Arcade by John Dobson of 1831-32 in 1941. A replica of the arcade was incorporated into Swan House, the 1960s building which stands on the site in the centre of a large roundabout.

Classicism of Nash's London to Northumberland, and carried it out in stone rather than painted stucco. 'They have given the whole centre of the old town a dignity and orderliness,' wrote Nikolaus Pevsner, 'which even the twentieth century advertising hysteria has not succeeded in destroying.'[121] The centrepiece is Grey Street, gently curving upwards from the Tyne valley past the portico of the Theatre Royal to culminate in the tall column of the Grey Monument; this for Pevsner and for many others is 'one of the best streets in England'. W.E. Gladstone, the future Prime Minister, thought it 'England's finest street'. Associated with this are other orderly stone Classical streets, covered markets and handsome terraces. Most, but alas not all, of these buildings by Dobson and other local architects, notably Benjamin Green, survive today.

But Newcastle is not a consistent Georgian spectacle like Bath; it has 'a fine tradition of radical change', as Ian Nairn (who fantasised that he was really a Geordie) put it. Later 19th century buildings added to the city's architectural richness, if with less restraint than shown by Dobson, while in the first half of the 20th century larger-scale commercial buildings, sometimes influenced by Art Deco, have their own impressive qualities. So it was inevitable that Newcastle would change in the post-war decades. Pevsner, contemplating the future when writing his *Buildings of England* volume, published in 1957, wrote that 'Clearly, a new Clayton, a new Grainger, and a new Dobson are called for.' And Nairn, writing in 1960, considered that 'this is or could be one of the great cities of Europe, and it must not be messed up by penny-pinching or the wrong man doing the wrong building. Most of all, it needs a client as far-seeing as Grainger, and the natural choice is the Corporation itself.'[122] Unfortunately, the Corporation signally failed to rise to that challenge.

Soon after the war, David Stephenson's All Saints' Church was threatened, but spared. Eldon Place, however, the last complete street of domestic Georgian in the city, was soon demolished for new buildings for the University. Then Louvain Place was sacrificed for the new Civic Centre designed by the city architect, George Kenyon – a richly crafted example of a more gentle Scandinavian influenced modernism, rich in works of art, whose merits (like those of the contemporary Coventry Cathedral) can now be appreciated. But what followed later in the 1960s is hard to defend. This came with the advent of Wilfrid Burns as City Planning Officer (who had worked with Gibson in Coventry) but, above all, with the rise to power of the charismatic but corrupt T. Dan Smith with his vision of rebuilding the city. Described in the new *Oxford Dictionary of National Biography* as a 'local government leader and criminal', the energetic Smith became chairman of the housing committee in 1958 and the Labour leader on the council two years later. Until he was brought down and subsequently imprisoned because of the political scandal associated with the activities of the 'architect and criminal' John Poulson, Smith did his best to give Newcastle new roads and motorways as well as new housing. For reasons which must baffle outsiders who admire the city, despite his palpable criminality he still has his defenders today. It must be admitted that he had a vision, albeit a naïve one, to make Newcastle the Brasilia, or the Milan, of the North, but what was achieved signally failed to emulate the legacy of Grainger and Dobson – it was more like the Croydon of the North.

There were two principal victims of the comprehensive redevelopment mania of the 1960s in Newcastle, both important in defining the character of the centre. The first was Eldon Square, one of the earliest of Grainger's enterprises, built in 1825-31. The long uniform terraces of fine cut stone on each side of the square were designed by Dobson. Here, wrote Pevsner, 'a claim to formality and monumentality was staked that was new to the town . . . The spaciousness of Eldon Square was a thing quite unheard-of. So was the size of the ranges surrounding the square, and so was also their uniform design.' By the 1960s, the terraces were spoiled by rooftop extensions, alterations and

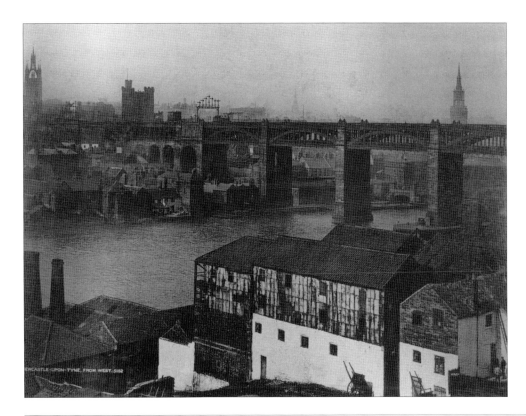

The old city and Robert Stephenson's High Level Bridge seen from Rabbit Banks in Gateshead on the south bank of the Tyne, from a postcard of *c*.1900 by Valentine & Sons.

NEWCASTLE-UPON-TYNE

commercial signage. They could, of course, have been restored as they deserved; instead, they were demolished after a public inquiry held in 1963 at which the Corporation argued that 'excrescences had destroyed the architectural unity of the Square'. Sharp thought the loss 'unforgiveable'.[123] Originally it was proposed that a hotel designed by the distinguished Danish architect Arne Jacobsen should occupy the north side, but this never materialised. In the event, Dobson's terraces to the north and west were replaced by what is rightly described in the second edition of the *Buildings of England* volume as 'a typically introverted shopping centre of the 1970s' designed by Chapman Taylor & Partners.[124] The grand architectural promenade up Grey Street now ends in tawdry bathos beyond the Doric column erected to the memory of the architect of the great Reform Bill.

The second victim was again designed by Dobson: the Royal Arcade, built in 1831-32. The arcade itself was a lovely thing, with eight triple-height top-lit domed bays – modelled on Nash's Royal Opera Arcade in London, itself inspired by the contemporary shopping arcades of Paris – with shops below and offices above. But the building erected by Grainger to contain it was itself both elegant and crucial in town-scape terms, for the 'noble and reticent' façade in Pilgrim Street closed the vista down Mosley Street from the Cathedral. It fell victim to T. Dan Smith's mania for roads, being replaced in the early 1960s by a roundabout placed at the bottom of Pilgrim Street where the approach to the New Tyne Bridge joined the Central Motorway East – a new road which swept away many mid-19th century houses east of the city centre. The advice of the Royal Fine Art Commission, that the Pilgrim Street façade be re-erected near the original site, was ignored, but as a sop to conservation a pathetic truncated replica of the arcade was created inside Swan House, the overweening block, designed by Sir Robert Matthew, which occupies the roundabout. As the authors of the revised *Buildings of England* guide observe, 'Most of the buildings built in association with this road planning and with the contemporary pedestrianization plan for the centre are brutally assertive, to say the least . . .'

▶ The west side of Eldon Square in 1944; this and the north side were demolished after 1963 for a shopping centre.

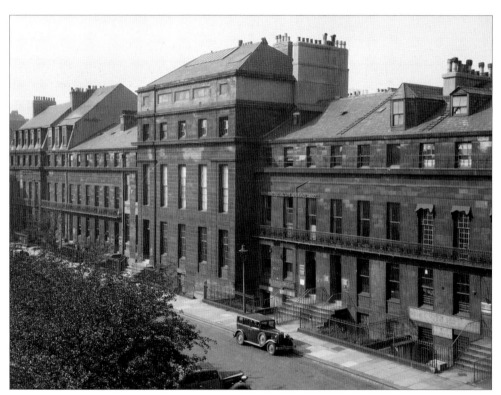

▶ The north side of Eldon Square before its destruction.

Things could have been much worse. The City Planning Committee, established in 1960, proposed that the Central Motorway East should be complemented by the Central Motorway West, which would have sliced between the University and the Civic Centre before smashing its way through to a new bridge across the Tyne, and the two roads connected by a tunnel under the city centre. In 1973, Councillor W.R.S. Forsyth, who had

◁ Dobson's west-facing entrance front of the Royal Arcade building in Pilgrim Street in 1959; it would be demolished a few years later for a roundabout.

◁ Manor Street and the south side of the building containing the royal arcade in 1941. All would be swept away for roads and a roundabout after 1963.

replaced the disgraced T. Dan Smith as chairman of the Planning Committee, confidently announced that 'Seldom before in its long history has the city seen so much constructional activity at one time. We are living in an era of exciting change and everywhere we look there are signs of the new emerging Newcastle; representing the translation of plans into reality.'[125] Mercifully, however, much of the new Newcastle failed to emerge, and in recent decades efforts have been made to look after what remains of Grainger's city centre and to revitalise the long neglected Quayside.

There have been other unnecessary and painful losses in central Newcastle, however,

One of the stone terraces in Pilgrim Street by John Dobson in 1944 and since demolished.

notably the old Town Hall. This was a distinguished Classical building by John Johnston of 1858-63, incorporating the Corn Exchange of 1838 by John & Benjamin Green. It presented a coherent front to St Nicholas Square and the Cathedral, had interesting long side elevations running north along two old curving streets, the Cloth Market and Groat Market, and then revealed its presence in Bigg Market. As it was not threatened by a new road, it is hard to understand why such an important and well-mannered public building could not have found a new use. Its replacement is as mediocre as it is insulting to its neighbours.

In *Tyneside Classical*, their study of the Newcastle of Grainger, Dobson and Clayton

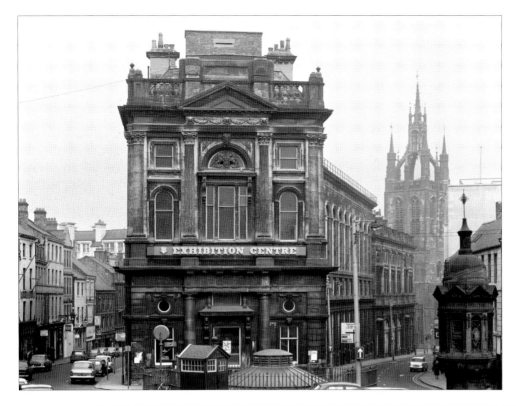

Looking south from Bigg Market down Groat Market to the crown steeple of St Nicholas's Cathedral in 1969. The island block of fine Classical buildings containing the old Town Hall and Corn Exchange was entirely swept away in the 1970s and replaced by offensive mediocrity.

147

St Nicholas Square looking east along Mosley Street towards the Royal Arcade. The ebullient Classical south front of the old Town Hall on the left, which faced the Cathedral, was demolished in the 1970s.

published in that now distant and dark year 1964, Lyall Wilkes and Gordon Dodds wrote that 'One of the ironies of our time is that many of our eighteenth- and nineteenth-century architectural masterpieces were built with somewhat dubious motives – to parade wealth and power – yet these survive today to give pleasure and a visual education to millions. Our modern buildings, many of them built by public authorities out of a deep sense of duty to provide much needed services for the community give no visual pleasure at all.'[126] Newcastle remains a magnificent city, but it would look even better and be even more architecturally distinguished had T. Dan Smith been rumbled and imprisoned much earlier.

16: NORWICH

Norwich is very proud of itself. 'Norwich: A Fine City' is the message on the roadside signs that greet the visitor. And Norwich has much to be proud of. It is a Mediaeval city with a great Mediaeval cathedral and a wealth of Mediaeval churches within the line of its old city walls; it is full of irregular, picturesque narrow streets lined with tastefully painted old gabled timber houses – like those in Elm Hill, a lane which appears in a thousand picture books. Because of its historic interest and beauty, Norwich was selected as a target for one of the "Baedeker" raids during the Second World War. Yet, even after those devastating bombing attacks, the surviving ancient buildings in this ancient city were under threat. 'It is to be hoped that the Cathedral, the Castle and its dependent museums, the Guildhall and most of the churches will be preserved', Arnold Kent and Andrew Stephenson could write in their book, *Norwich Inheritance*, published soon after the war. 'These are the monuments of renown: what will happen to the remaining buildings? It is our opinion that few or none will remain in fifty years time'.[127] Happily, they were wrong – but that was not for want of trying by those who ran the city.

Mediaeval Norwich was second only to London in size. Its wealth came from the wool trade, and is evident today in the remarkable number – and the size – of the parish churches that survive within the walls. Those days passed, but Norwich remained important as a provincial city, a regional capital. By the 19th century industry had arrived – mustard and chocolate manufacture, iron-founding, printing and shoe making – but the railway was repelled from the ancient city and Norwich survived into the 20th century as a country town, an agricultural centre, with a wealth of Mediaeval, Elizabethan and Georgian architecture. Visiting in 1933, J.B. Priestley considered that 'it is not simply an old cathedral city; it is something more – an antique metropolis, the capital of East Anglia'. And it looked genuinely ancient: in the narrow old streets,

> where the feeble light of occasional street lamps showed you ancient, gnarled and gnome-like houses and little shops, you expected to run into characters from *Edwin Drood* going muffled through the chill gloom. It was difficult to believe that behind

149

◀◀ Princes Street looking east towards the tower of St George's Tombland in the 1930s. While all the houses on the left were saved from slum-clearance at that time, much of the opposite side of the street was demolished after the Second World War.

MARKET PLACE, NORWICH.

▲ The Market Place in the 1920s with the church of St Peter Mancroft beyond. All the buildings on the right were removed in the late 1930s as the Market Place was enlarged east-wards when the new City Hall was built.

those bowed and twisted fronts there did not live an assortment of misers, mad spinsters, saintly clergymen, eccentric comic clerks, and lunatic sextons. Impossible to believe that the telephone could find its way into this rather theatrical antiquity.[128]

But there were those all too ready to accommodate not only the telephone but to embrace the new century in its unsentimental, destructive totality. The advent of the motor car soon gave rise to constant complains about traffic congestion in those narrow old streets. Norwich 'has an almost complete ring-road', wrote Nikolaus Pevsner in 1962, 'yet the traffic in the centre is as terrible as ever . . .'[129] The improving spirit got to work early. Incredibly, in 1908 only the casting vote of the Mayor saved the 15th-century Guildhall from being demolished. In 1923, the proposal by Norwich Corporation to replace the Mediaeval Bishop's Bridge across the Wensum provoked a group of architects and archaeologists to found the Norwich Society. The bridge was saved, but the new society had to resist many other destructive proposals over the following half century and more.

One motive for wanting to demolish many of Norwich's old houses was commendable: slum-clearance. Many of the houses within the city walls were in poor condition and inadequate as dwellings, but unfortunately the slum clearance programme was carried out by the Corporation with little regard to architectural or historic interest. By the 1920s, the once-prosperous area to the west of Tombland had degenerated into slums and Elm Hill, whose houses had all been rebuilt after a fire in 1507, was proposed for demolition. The Norwich Society fought this proposal, however, and after 1927 the houses were restored. A similar threat to Princes Street was averted a few years later, although some of the houses on the south side were allowed to disappear after the Second World War.

The principal and most visible change to the fabric of inner Norwich before the war was the enlargement of the Market Place. In 1928 it was proposed that a new City Hall be built on the higher ground to its west. This civic vision involved the removal of a range of buildings running south of the Guildhall as well as the buildings next to

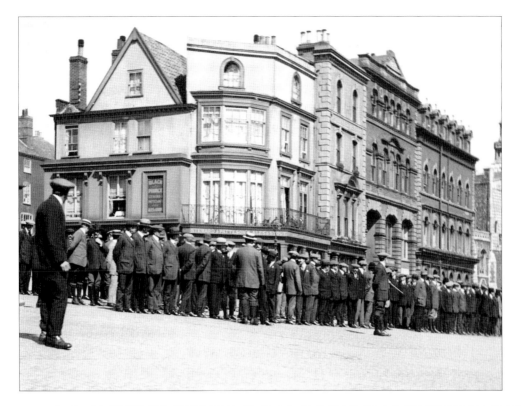

Sunday morning parade in the Market Place with the Norwich Volunteers in 1915. The buildings on the east side of the market running along to the 15th-century Guildhall would be cleared in the late 1930s.

NORWICH

the church of St Peter Mancroft on the south-west side. Today, only the surviving two houses on the south side which now comprise the *Sir Garnet Wolseley* public house testify to how picturesque the Market Place once looked. However, for once such ruthlessness was in a good cause, for the result of the competition for the City Hall held in 1931 was a magnificent Swedish-inspired modern design which overlooks and dominates the Market Place and which Nikolaus Pevsner rightly considered 'the foremost English public building of between the wars'. 'Lest it should be thought that the site of the City Hall contained many buildings of merit', later pleaded its architects, C.H. James and S. Rowland Pierce, 'it should be put on record that practically nothing of either architectural or archaeological importance was demolished . . .' Even so, 'The clearance to make way for the City Hall and the enlarged Market Place was drastic, and it is true to say that in few parts of the City could such a large area of buildings be demolished without serious aesthetic and historic loss'.[130]

Much worse losses soon followed. As Norwich was, to a degree, an industrial target, and also easily accessible from Occupied Europe, so it suffered regular air raids from July 1940 onwards; by the end of 1944 670 high-explosive and 25,000 incendiary bombs had been dropped on the city. 30,000 houses were damaged, with over 2,000 beyond repair. But the most destructive were the retaliatory Baedeker Raids of 1942. Twenty-five German bombers attacked the defenceless city during the night of 27 April, and more returned two nights later. The south-eastern quarter of the city was badly damaged as was the area around St Benedict's Gate, where the Mediaeval church of St Benedict was largely destroyed. Westwick Street and St Stephen Street were also badly hit. In addition to Colman's mustard factory and the City Station, a particular loss was the Boar's Head Tavern, one of the few thatched buildings in Norwich. One observer recorded how, in the second raid, incendiaries 'dropped in thousands. Some went through the roofs of houses to start fires inside; others glanced off the roofs to burn themselves out in streets and gardens, or rolled down the tiles and burned in the troughs until the troughs melted . . . There was no doubt that the Germans had set out that night to destroy the city, and

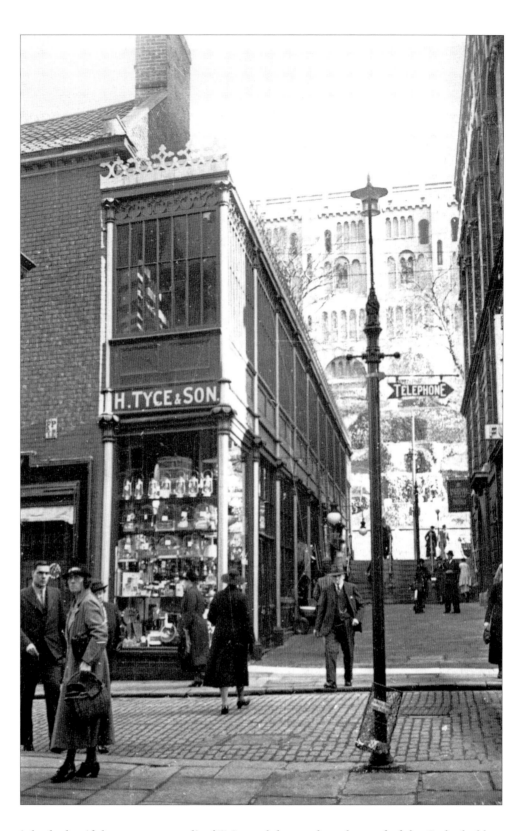

▶ Looking along Davey Place from Castle Street to the Castle in 1944. The curious thin 19th-century cast-iron and glass shop was replaced in c.1960.

it looked as if they were succeeding'.[131] Several dropped on the roof of the Cathedral but were dealt with by fire-watchers. In view of all this, it is cheering to find that the *Norwich Mercury* could still remain rational and state that, 'If Norwich Cathedral were destroyed, it would be no answer to bomb Cologne Cathedral'.[132]

Like most other bomb-damaged cities, Norwich commissioned a plan for the future. As the chairman of the Town Planning Committee wrote, 'It is a truism now to say that the devastation caused by bombardment from the air has given Norwich and

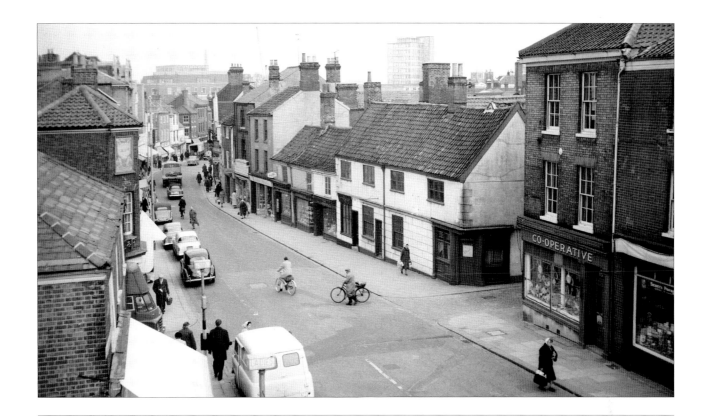

her sister cities in the <u>front</u>-line an unrivalled opportunity to re-plan their physical structure'.[133] Fortunately, the Corporation had the sense to approach the architects of the City Hall to carry this out. Their *City of Norwich Plan* by James and Pierce was published in 1945 and the authors gave

> much thought to the treatment of the many fine old buildings – chiefly churches and houses of the mediaeval and Georgian periods – which still exist in Norwich; and we have not been unmindful of the architectural merits or more material values of buildings of later and of recent date . . . Buildings are the cultural manifestations of the internal conditions of a city; they express the quality of its aesthetic ability and appreciation, the degree of its prosperity and its civic sense. Unfortunately, much energy is sometimes spent in producing meaningless architectural fakes, and comparatively little is directed towards revitalising and maintaining the old buildings of genuine and undisputed lineage.

Naturally, the authors were concerned to alleviate traffic congestion in the city and were prepared to demolish existing buildings, 'where the interests of improved communications, increased road safety or enhanced appearance outweigh the advantages of retention'. The bombing had made some improvements easy, so that there need be 'no heart-burnings about the widening of, for example, St Stephen Street', which had been 'one of the narrowest and most congested streets in the City'. Inevitably, two major ring roads were also proposed, but it is nevertheless impressive that James and Pierce were concerned to place the inner ring road just outside the old city walls as was first proposed in 1936, with a high-level viaduct crossing the Wensum to the east.

However, the sane and conservative approach of the Plan was unacceptable to the new City Engineer, H.C. Rowley, who insisted that the published document contained an appendix stating his reservations and illustrating his own crude plan. This, of course, was much more destructive. North-south routes through the city centre were achieved by widening old streets; the area to the west of City Hall was to be formally re-planned,

▲ St Stephen's Street, looking towards the city centre, photographed by George Swain in 1960, three years before the street was widened and most of these buildings were destroyed.

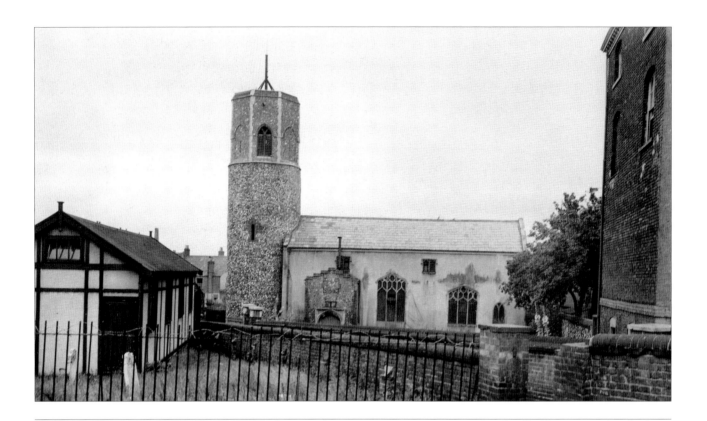

St Benedict's Church in 1941; the following year its Mediaeval nave would be destroyed during the Baedeker Raids and only the tower survives.

requiring the destruction of such ancient streets as St Giles Gate and Pottergate; and to the north of the river the inner-ring road was to come within the city walls. The main Plan, he wrote,

> is designed for a long term, during which period a considerable increase in traffic must be expected. Bearing this in mind, and also bearing in mind that the life of the City depends on its industry and business, I feel that this limited sacrifice of property must be made and that, in the interests of efficiency and safety of the public, my suggestions are the minimum that should be laid down.[134]

Unfortunately, after 1945 it was the influence of Rowley rather than that of James and Pierce's Plan that prevailed – hence the pessimism of Kent and Stephenson. It was a pessimism shared by others. By 1957, Wilhelmina Harrod and the Revd C.L.S. Linnell could write in their *Shell Guide* that Norwich

> is at the cross-roads. Already the planners are at work and huge steel-framed buildings are rising up higher than the church towers. The narrow streets are a nightmare to the motorist and twentieth-century industrialism is increasing on every side. Norwich has been though its bad times . . . but it would be a sad day for Norwich if 'planning' on a large scale destroys its being as a country town and obliterates its mediaeval entity as a collection of villages.[135]

The principal achievement of the wretched Rowley – who also acted as Planning Officer until 1966 – was the Inner Link Road proposed back in 1944 and finally planned in 1965. This runs outside the city walls to the east and then cuts across the inner-city to the north – precisely what James and Pierce had hoped to avoid. In the late 1950s, Magdalen Street running north from the centre had received a 'face-lift' from the Civic Trust, only to have a flyover crash across it a decade later – removing the house of the painter John Crome in the process. All this was done despite the strenuous opposition of the Norwich Society, which successfully took the City Council to the High Court in 1951

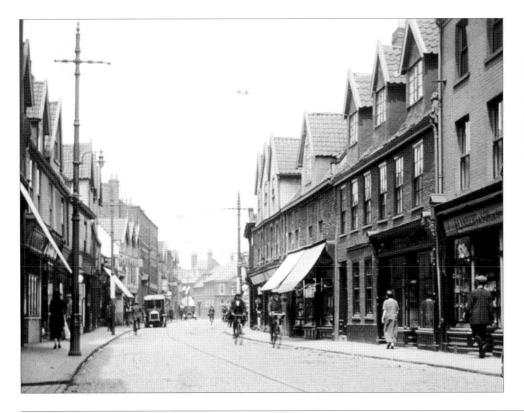

◀ Magdalen Street in the 1920s photographed by W. Buston. In the 1960s the City Engineer would bisect this ancient route north out of the city with a flyover.

NORWICH

155

◀ St Benedict's Gate photographed by W. Buston in the 1930s. In 1942 this fragment of the gate through the city walls and the surrounding buildings would all be destroyed by bombing.

over its plans for Tombland. Elsewhere, the main criticism of the post-war rebuilding must be its culpable mediocrity. In the revised *Buildings of England* volume covering Norwich, Bill Wilson writes that 'Much of the office building of the later 1950s and throughout the 1960s is no better than deplorable,'[136] an opinion from which it is surely difficult to dissent.

Ian Nairn revisited Norwich in 1964 and observed a process of 'gradual attrition . . . all over the city. Elm Hill may be preserved with its cobbles and antique shops, but meanwhile Pottergate and King Street have fallen apart, and Ber Street, with one of the finest sites in the city, looks like the day after the bombing'. Yet this was a street which, less than two decades earlier, could be described as 'the oldest and potentially the finest street in Norwich'. Three years later, Nairn was back to note 'Norwich's steady, complacent slide down to vacuity'. As for the recently widened and boringly rebuilt St Stephen Street, the principal entrance from London, it was 'probably the worst thing of

its kind I have ever seen in what passes for a historic and cultured city . . . I have not much charity left for the rebuilders of Norwich. They had a great opportunity and have botched it from beginning to end'. This story makes it clear yet again that the most destructive force in most British cities in the 20th century was not so much Adolf Hitler as the municipal engineers or surveyors, with their lack of any architectural sensibility and their blinkered obsession with accommodating the needs of the motorist at the expense of all other civilised values.

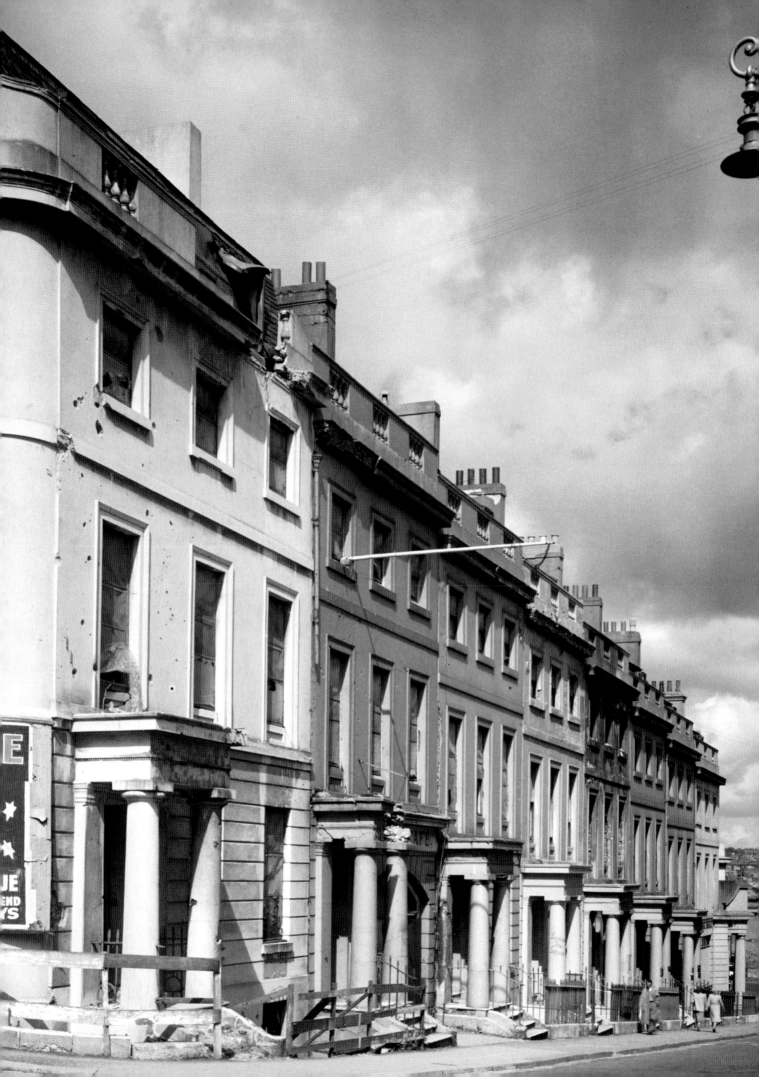

17: PLYMOUTH

Plymouth in the Second World War was the worst blitzed city in Britain. The scale of the destruction was such that a comprehensive plan for its post-war reconstruction seemed not only highly desirable but inevitable. As early as 1943, *A Plan for Plymouth* was published, documenting the radical proposals made by J. Paton Watson, the City Engineer and Surveyor, and the consulting town-planner Patrick Abercrombie. What makes Plymouth today remarkable compared with other bombed-damaged cities is that this plan was carried through almost in its entirety.

Rebuilding 72 acres of the city centre necessarily involved demolishing buildings which had survived the bombing. Whether that further sacrifice was desirable must remain a matter of opinion, but few who have visited the rebuilt city have been much impressed. In 1961, Ian Nairn inspected what the architects, engineers and town planners had achieved, writing that 'It is sad that this should happen to Plymouth, the friendliest and most soft-hearted of cities. Of all places Plymouth needed deep understanding and a gentle touch – and all it got was two prodigious formal axes, Armada Way and Royal Parade, a gridiron of shopping streets round them, a collection of miscellaneous styles which makes one despair of the profession, and the removal of those few fragments of Foulston's Regency Plymouth that managed to survive the Heinkels and Dorniers.'

Furthermore, to add insult to injury, parts of the city which had not been so badly blitzed and which were not included in the city centre comprehensive redevelopment also suffered a steady attrition of historic buildings during the post-war decades. This was painfully the case in the Barbican, the historic core of Plymouth, where remarkable ancient houses continued to be sacrificed to road plans or slum clearance schemes. The author of one recent study has concluded that, 'for all the fine words of Paton Watson and Abercrombie's *Plan for Plymouth*, by the mid-1950s more sixteenth- and seventeenth-century properties in the Barbican had been pulled down by the planners than had been reduced to rubble by the Luftwaffe'.[137] And the destruction continued even after that. The 20th-century architectural history of Plymouth is possibly the most depressing of that of any city in Britain.

◀◀ Houses in Lockyer Street, laid out by Foulston in 1821, photographed in 1943 by Margaret Tomlinson for the National Buildings Record; these were among the many early 19th-century buildings which gave the city architectural distinction but, although damaged rather than destroyed in the Blitz, were swept away after the Second World War.

▶ The Assembly Rooms complex containing the Royal Hotel and Theatre Royal, designed by John Foulston in 1811 and seen in a mid-Victorian stereoscopic photograph. The theatre was destroyed before the Second World War and the remainder gutted in 1941 and subsequently demolished.

Plymouth originally consisted of Three Towns, which were only united administratively in 1914. Set by the sea between two river estuaries with hills behind, their position was considered by Nikolaus Pevsner to be 'superb and indeed hardly surpassed anywhere in England'.[138] There was Plymouth, with its Citadel constructed by Charles II, placed on a hill between The Hoe, the open cliffs facing the sea to the south, and Sutton Harbour. To the south-west lay Stonehouse while further west, across Stonehouse Creek, lay the naval dockyard, named Devonport in 1824. The naval importance of Plymouth can be traced back to Mediaeval times: the English fleet lay waiting in the Cattewater for the Spanish Armada in 1588 and the *Mayflower* set sail from here in 1608. But it was the Napoleonic Wars which made Plymouth grow into the largest town in Devon, and the essential shape of the united three towns was created between 1810 and about 1870.

Plymouth was fortunate in securing the services of a distinguished London architect, John Foulston. In 1811 he won the competition for a group of buildings comprising the Royal Hotel, Assembly Rooms and a Theatre. Foulston then moved to Plymouth and designed the Athenaeum next door as well as several churches, terraces of houses and villas. As well as re-planning the area around the Assembly Rooms, he laid out Union Street, which united Plymouth with Stonehouse and Devonport. Several of his public buildings were strongly influenced by Soane but at the civic centre he created in Ker Street in Devonport 'he indulged in a flight of eclectic fancy', as Howard Colvin put it, by combining Greek, Roman, Egyptian and 'Hindoo' in an extraordinary picturesque group of buildings which was unique in its time.[139] Foulston, indeed, was responsible for some of the finest buildings of Regency Britain, although precious few of them survive

Looking down Lockyer Street to the portico of the Royal Hotel in the 1930s, from a postcard by the Photocrom Company. All these buildings have since disappeared – including the mid-Victorian clock tower.

PLYMOUTH

161

today. They dated from 'the greatest period for good building in England', so John Betjeman claimed just before the Second World War, adding that 'Plymouth must once have been one of the most beautiful cities of England'.[140]

Even before the war the commercial city centre which had evolved between Plymouth and Stonehouse and the railway to the north was considered ripe for redevelopment while historic buildings were allowed to disappear. Francis Drake's own town house was one of many buildings in the Barbican area to disappear in the late 19th century, while Foulston's Assembly Room complex was spoiled in the 1930s where the Theatre was replaced by a modernistic cinema. As for the rest, 'the shopping centre had grown in importance out of all proportion to its narrow streets and bottleneck approach,' wrote Paton Watson and Abercrombie. 'It was ripe for rebuilding; indeed many individual plans were under immediate contemplation'.[141] The Luftwaffe would now accelerate that process.

Plymouth, as a naval dockyard, was naturally a target for enemy action. But the city was unprepared, and even regarded as a safe haven to which children from London and other cities were sent. In 1941, an official report admitted that the authorities had blundered. 'Plymouth should have been made an evacuation area on the fall of France. Central government had many months to decide on this course of action. But nothing was done. The city paid the price.' The first attacks took place in July 1940; nine months later the city had endured over three hundred bombing raids. The most terrible and destructive raids came in March and April 1941, when the Mediaeval parish church and the Charles Church as well as the Assembly Rooms and much else were gutted. Mass Observation reported that 'The civil and domestic devastation in Plymouth exceeds anything we have seen elsewhere'.[142] Its observers also reported that, *pace* what appeared in the press, morale had collapsed, looting and vandalism was widespread, and that civilised life in the city was breaking down. On 24 April 1941 some 50,000 people walked out of the city to seek safety in the surrounding countryside.

At the end of April, the Prime Minister was prevailed on to visit the stricken city, and

▲ The Mediaeval parish church of St Andrew and the 1870s Guildhall. Both would be gutted in 1941 and the church restored but the Guildhall only partially rebuilt.

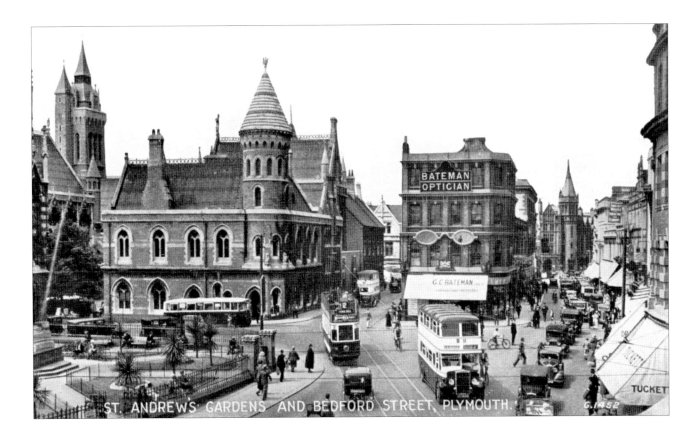

ST. ANDREW'S GARDENS AND BEDFORD STREET, PLYMOUTH.

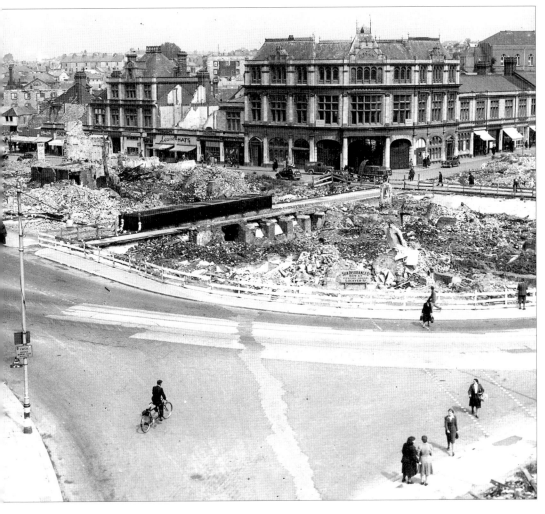

▲ The Guildhall and
the commercial district
around Bedford Street in a
postcard of the 1930s by
Valentine & Son.

◀ Plymouth: a panorama
of the scene of
devastation from bombing
in the commercial district
around Spooner's Corner
and Bedford Street made
by Photographic News
Agencies Ltd in April
1944; surviving buildings
would subsequently be
demolished in the
replanning of the city
centre.

▲ Gutted buildings by Foulston in Princess Square, photographed by Margaret Tomlinson in 1942 and afterwards cleared.

he reacted with typical emotion to the sights that greeted him. 'It's all very well to cry, Winston,' Nancy Astor, the MP for Plymouth, told him. '*But you've got to do something.*' Something *was* done, if only after the raids tailed off. 'The City must be rebuilt, reshaped, translated from vision into fact, from word and line to building – stone and brick', wrote Nancy Astor's husband, Viscount Astor, Lord Mayor of Plymouth, who brought in Abercrombie as consultant to work with Paton Watson on preparing a radical plan for rebuilding. 'The new Plymouth can be no "half-and-half" affair. It must be rebuilt as a unity on land acquired by the public for the purpose'.[143] Although the *Plan for Plymouth* contained proposals for new roads and zoning as well as for the treatment of Devonport and the Barbican, it was principally concerned with rebuilding the civic and commercial centre. The existing street pattern would be replaced by an entirely new concept. There would be no more bottlenecks, no more traffic congestion.

The 72 acres to be re-planned would be surrounded by an Inner Ring Road, 'sub-arterial in character'. Within this, there was to be a new shopping centre on a rectilinear plan placed symmetrically either side of a central wide open axis. Further south, disposed either side of this axis, closer to The Hoe, was to be a new Civic Centre, replacing both Foulston's buildings and the Victorian Gothic Guildhall.

> The authors have permitted themselves one great decorative – even monumental – feature. Those who today plan a straight line, such as an avenue in a park and place something attractive to look at, at the end, are in danger of being called vista-mongers: the authors of this plan are not afraid of this label; they have boldly planned a vista from the Station to the Hoe: not a Renaissance road, but a Garden vista – a parkway, making use, with terraces, slopes, steps, pools, avenues and other contrasting features, of the varying levels . . .

When Pevsner visited Plymouth for his early *Buildings of England* volume on *South Devon*, published in 1952, he found that 'the centre is not a picture to be described in terms of architecture, but of dust or mud and rubble and weirdly shaped fragments of

Houses in Musgrave Street, one of the streets between the Assembly Rooms and The Hoe laid out by Foulston, recorded by Mrs Tomlinson in 1943 and subsequently demolished.

PLYMOUTH

165

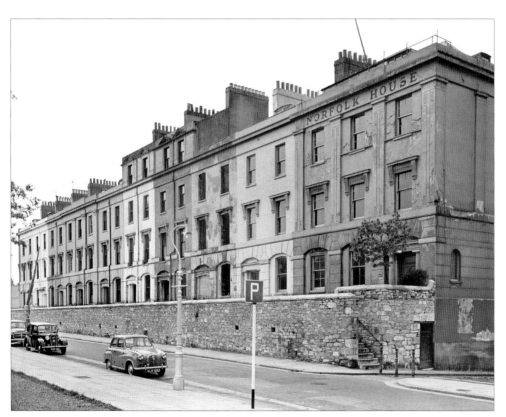

Windsor Terrace, which managed to survive until 1960 to be photographed by F.J. Palmer, before it was cleared away in the cause of axial symmetry in Abercrombie's plan.

walls'. A decade later, when Ian Nairn visited, the rebuilding was almost complete. And he found that 'the axes don't even work as formal spaces: they lead nowhere and focus on nothing'. Worse, perhaps, was that the new buildings were too low in scale, not sufficiently urban in character, and were designed in a feeble compromise between Classicism and the Modern aesthetic. Well might Bridget Cherry complain, in the

▶ Devonport Central Hall in Duke Street, photographed in 1958 shortly before all these buildings were cleared for a housing scheme.

revised edition of 'Pevsner' published in 1989, that they were 'devoid of any local character and dismally unmemorable'.[144] As far as Nairn was concerned, 'it seems utterly appropriate that Charles Church, one of the two oldest churches in Plymouth, should be a ruin on a traffic roundabout – sing hey ho, the traffic flow'. 'The big disappointments in comparing the paper plan with what was carried forward with such energy and enthusiasm in the 1950s,' concluded Cherry, 'are the dominance of the roads and the mediocrity of most of the architecture'.

And to achieve this, good buildings were sacrificed. In their plan, Paton Watson and Abercrombie proposed to move some of the important surviving buildings which 'interfere with the proposal' to foundations on new sites (a technique later occasionally employed by Nicolai Ceausescu in re-planning Bucharest), noting that this could be done for 35% of the cost of demolition and rebuilding. But this did not happen, of course. The (gutted and partly demolished) Guildhall, designed in the 1870s by the local

architects Norman & Hine but with E.W. Godwin as consultant, was, in the event, partly retained, but buildings by Foulston which had survived the war were destroyed (the Assembly Rooms complex had been demolished almost immediately after being gutted by incendiary bombs). These included his Athenaeum, which Pevsner noted was 'gutted but repairable', and the intact St Catherine's Church (demolished in 1958). This 'civic vandalism' no doubt reflected a conventional prejudice against stuccoed Regency architecture, but *The Plan for Plymouth* had praised Foulston's work and recommended the retention of his Crescent – which, mercifully, was done.

The re-planning of the city centre was, at least, largely carried out with the best of motives. What now seems inexcusable was the post-war treatment of the Barbican area, which had not been so badly bombed. 'Old Plymouth, miraculously escaped from destruction, is treated quite differently from the modern Centre,' explained Paton Watson and Abercrombie. They wrote that it should be 'carefully renovated and reconditioned, but without archaeological faking', but in fact recommended replacing some streets by open spaces and re-aligning other old street lines while leaving the ruined Charles Church isolated beyond a new road.

The resulting loss of more ancient buildings was not new: the demolition of 16th- and 17th-century houses for slum clearance in the 1920s had led to the establishment of the Old Plymouth Society, and it was out of this society that the Barbican Association emerged in 1957 to fight further unnecessary and ill-considered demolitions. The *Shell Guide to Devon*, published in 1955, noted that 'In Notte Street, New Street and Looe Street can still be seen the richly fashioned Elizabethan houses of these merchants who supervised the lading of their vessels in Sutton Pool: houses as finely wrought as the

▲ Ker Street in Devonport photographed by Herbert Felton in 1957. The group of civic buildings by Foulston had survived the Blitz but the terraces leading up to it were demolished in the 1960s.

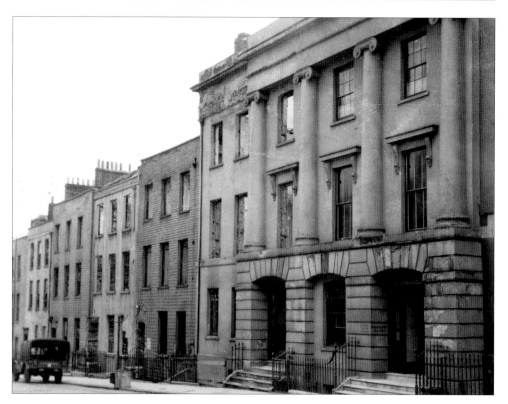

▲ Small slate-hung Regency houses in the naval base at Mount Wise in Devonport which were destroyed in the Second World War.

▶ The buildings on the south side of Ker Street, photographed in 1943, which were also cleared in the 1960s, leaving the surviving core of Foulston's civic development isolated and pathetic.

poops of their vessels', but no such houses can be found in (widened) Notte Street today.[145] Revisiting in 1967, Ian Nairn was shocked to find the demolition of historic buildings continuing: 'Those in Notte Street have already gone, of course, and the area now looks like the result of a sneak raid by a German Rip Van Winkle who had gone to sleep for a quarter of a century'.

Devonport is, perhaps, the most depressing part of Plymouth today, and it is now

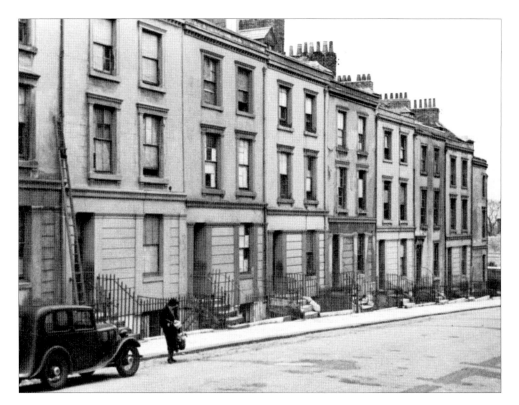

Foulston's terraced houses on the north side of Ker Street, Devonport, photographed by C.J. Palmer in 1942; after long neglect, they were gratuitously demolished rather than restored in the 1960s.

PLYMOUTH

169

hard to imagine how dignified and handsome it once was. As Bridget Cherry notes, 'Much that survived the war has been demolished, and the replacements are of the drabbest kind'. Foulston's remarkable group of civic buildings in Ker Street largely survives after decades of neglect (the Hindoo school disappeared in the 1920s) but the surrounding terraces – still standing in the 1950s – have been quite unnecessarily destroyed. Plymouth, today, could have been celebrated for its Regency architecture, like Cheltenham or Hove, but, thanks to the philistinism and stupidity of those who have governed it as much as to the Luftwaffe, there is little left. And it has certainly not been replaced by anything better or more interesting.

The authors of *A Plan for Plymouth* wrote of recapturing 'the wonderful continuity of the street scene obtained by Nash and Wood the Younger, as in Old Regent Street and Bath, but in the modern idiom'. They might also have mentioned Foulston, and recommended the retention of more of his buildings. But nothing of the urban character of Georgian and Regency towns was created in the rebuilt city centre. What, after so much wartime suffering, was achieved was a new city centre which was so inadequate, so lacking in proper urban density and so mediocre in its architecture that the 1950s buildings are now being replaced. What remains of the historic Barbican is now thriving and is, needless to say, the most interesting and characterful part of the whole city. Even so, modern Plymouth is a tragedy, and it is impossible not to grieve for the messy, imperfect but fascinating and elegant city that stood between the Hamoaze and the Cattewater before the Second World War.

18: PORTSMOUTH

As a Mediaeval foundation and England's principal naval base since the reign of Charles II, the home of Nelson's *Victory* and other historic ships, with its ancient fortifications and the wide green-sward of Southsea facing the English Channel, Portsmouth ought to be an architecturally distinguished and attractive town. It isn't. Although there are still naval structures of unique interest and importance and some remarkable churches surviving, the town itself is depressing. For this, the Luftwaffe is partly to blame because, as a major military establishment, Portsmouth was very badly bombed and suffered dreadfully. But the post-war rebuilding has been dreadful too, with far too little restored and the replacement buildings mediocre and unimaginative. David Lloyd, in the *Buildings of England* volume for *Hampshire*, wrote that 'Portsmouth in 1965 is, as a whole, muddled and visually squalid; it still has the chance to make itself something very different, and much better, before the end of the c20'.[146] That chance was missed. Forty years on, despite the redevelopment of the area between Old Portsmouth and the Harbour, with the gratuitous Spinnaker Tower, it remains visually squalid. To look at pre-war photographs of the High Street and see the same street today is desperately sad – and infuriating.

St Thomas's Church, Portsmouth Cathedral since 1927, has been much altered and extended over the centuries, but its oldest parts date from the 12th century. The Royal Garrison Church is also in essence Mediaeval. Fortifications survive from the reign of Henry VIII, notably Southsea Castle, and much remains from the 17th century when Portsmouth became the country's principal naval establishment. Remarkable naval buildings survive in the Dockyard from the 18th and 19th century, but these are not really part of the town as they stand in what is still a restricted area. Old Portsmouth was the centre of life and interest, and its glory was the High Street. The houses in this long, gently curving street were mostly rebuilt or refronted in the later 18th and early 19th century, so that a visitor could remark at the beginning of Victoria's reign that 'We were surprised at the splendour of the shops in High Street, as well as the extent and beauty of the street itself.'[147] Here was the Theatre Royal and the Guildhall with its Greek

◀◀ The gutted shell of St Paul's, Southsea, in 1941; the church of 1820-22 by Francis Goodwin had cast-iron tracery in the windows.

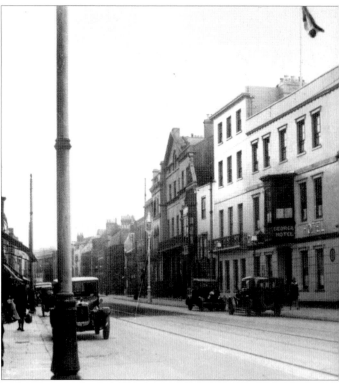

▲ The bombed-out ruin of the Greek Revival former Guildhall, lately the Museum & Art Gallery, which stood opposite St Thomas's Cathedral in the High Street photographed in 1943. Along with other damaged but reparable buildings in Old Portsmouth, it was subsequently demolished.

▶▶ The High Street looking north-east in the 1930s with the George Hotel – where Nelson stayed before Trafalgar. These buildings did not survive the war.

Doric portico; here were Georgian coaching inns and hotels, above all the George, where Nelson stayed before his last voyage which ended at Trafalgar.

By the later 19th century, however, the centre of gravity of the town was beginning to shift northwards because of the advent of the railway, and it was close to the station that a new and much bigger Guildhall, still Classical in style, was built in 1886-90. Portsmouth greatly expanded in the 19th century, with the growth of Landport to the north-east of the new Guildhall and of Southsea to the south-east, facing the sea across the Common, which became the most desirable part of the town in which to live and thrived as a watering place. To serve the much increased population, many new churches were built although few, unfortunately, were of much architectural distinction.

The 20th century was less kind to what was now a city. A huge power station was begun just north of Old Portsmouth in the 1930s, and was made even bigger and more dominant after the war. The 1937 *Shell Guide* considered that 'There is not much to go to Portsmouth for except to see what ships happen to be in the greatest naval harbour in the world, or to call to mind dead heroes.'[148] Then came the Blitz. The greatest naval harbour was naturally a target for German bombers, but the whole town was, inevitably, badly hit. The bombing started on 10 January 1941 and there were 37 raids in all over the next two months. More devastating attacks came in April. Casualties were high and mass absenteeism was reported among the population, with looting and vandalism reaching 'alarming proportions' and the police being unable to exercise control. Architectural casualties were also many: the Guildhall was gutted, as was the Garrison Church; the beautiful unaltered Georgian church of St John in Portsea was destroyed, as was the 18th-century Unitarian Chapel in the High Street. Churches all over the town were damaged or destroyed. As with other blitzed cities, an ambitious Plan for rebuilding had of course been prepared – by F.A.C. Maunder, the Deputy City Architect, in 1943 – which envisaged a new civic centre around the Guildhall, but this was abandoned five years later when it became clear that the cost of reconstruction would fall on the ratepayers.

The High Street and the surrounding old streets in Old Portsmouth were worst hit.

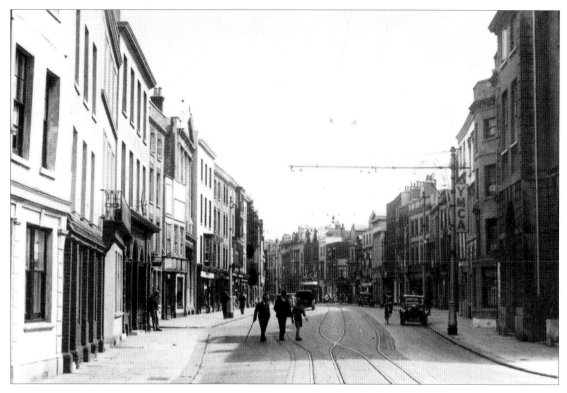

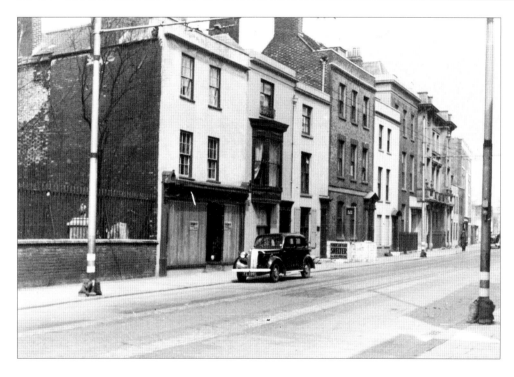

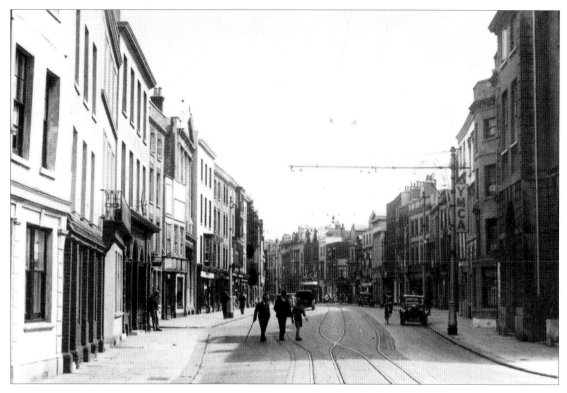 The High Street in the 1930s looking south-west. Few of the elegant stucco-fronted buildings which lined the street would survive the Second World War.

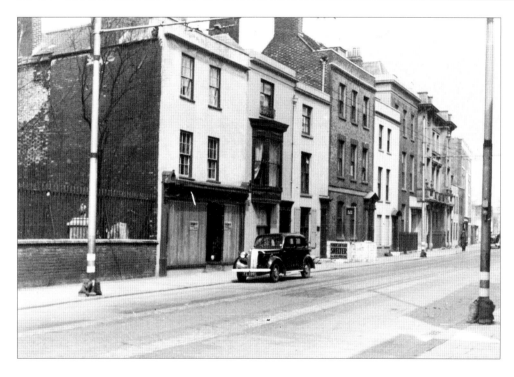 Buildings in the High Street in 1941; few would survive subsequent neglect and re-planning.

The George Inn went and the old Guildhall, by now the Museum & Art Gallery, was badly damaged, and many Georgian houses destroyed. But it is what followed that now seems unforgivable. Faced with such devastation, the authorities could either have repaired and restored badly damaged buildings of architectural quality and filled the gaps with good new buildings, or they could have decided completely to rebuild and re-plan the city. They chose to do neither.

Buildings which could have been restored were bulldozed, and the High Street was merely rebuilt with new blocks of flats of inexcusable dreariness and mediocrity filling

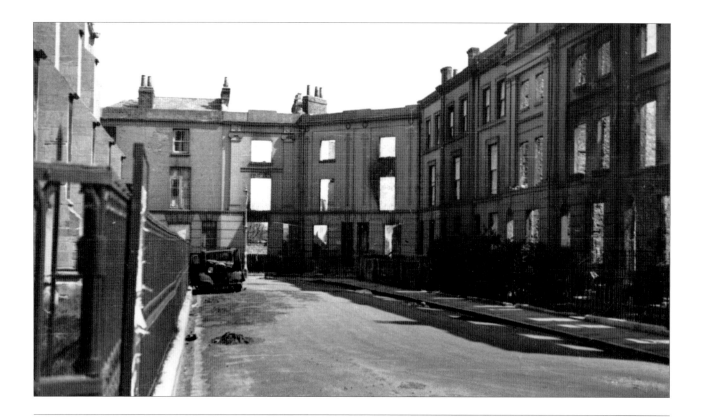

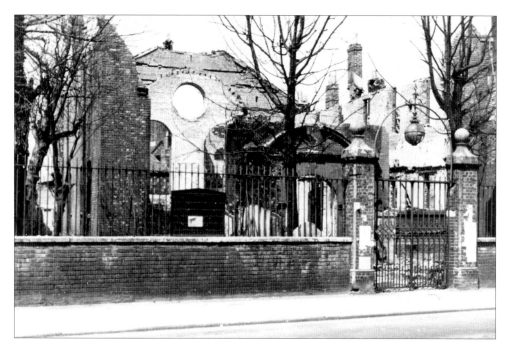

▲ The ruins of early
19th-century stucco-
fronted houses in St Paul's
Square which surrounded
Goodwin's Gothic church
in Southsea 1941. All
would be cleared away
soon afterwards.

▶ The gutted shell of
the early 18th-century
Unitarian Chapel on the
north side of the High
Street in 1941.

the many gaps. What had been a bustling commercial street now became a largely resi-
dential area, and one from which most character had been drained. Where the old
Georgian buildings had elegantly fronted the street, the new brick blocks were stupidly
set back, with trivial and pointless open spaces in front. As well as elegance, urbanity was
expunged. Well might Lloyd complain that the High Street 'is now a wretched hotch-
potch of buildings that are neither modern nor even decently copyist but just unpleas-
antly nondescript'.

There has been one cheering development, however (apart from the recent comple-
tion of the Cathedral). St Agatha's Church was an Anglo-Catholic mission church

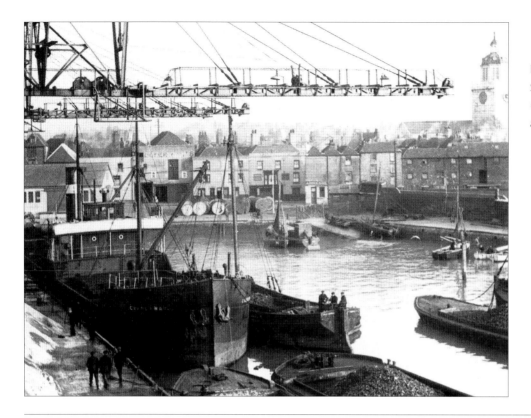

◀ The Camber in *c.* 1910 looking east towards St Thomas's Church (before it was enlarged as a cathedral).

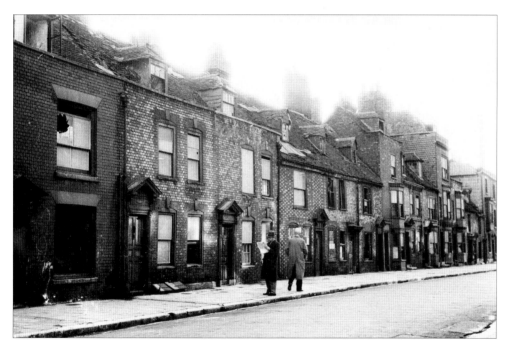

◀ Houses in King Street near the High Street in *c.* 1941; all have since disappeared.

built in the 1890s in a poor district of Landport and remarkable for its Arts & Crafts decoration. It closed in the 1950s after its parish had been wiped out by bombing and clearance, and was threatened with demolition. Instead, it became a naval store, but was threatened again by a new dual carriageway skirting an area that was being developed as a new shopping centre. Local opposition resulted in a public inquiry and, in the end, the road was diverted. And the building survived. Today, St Agatha's has been restored and brought back into use for worship, while the neighbouring and unpopular Tricorn shopping centre, a Brutalist structure of raw concrete, has now been demolished. It is a great pity that a similar story cannot be told for Old Portsmouth.

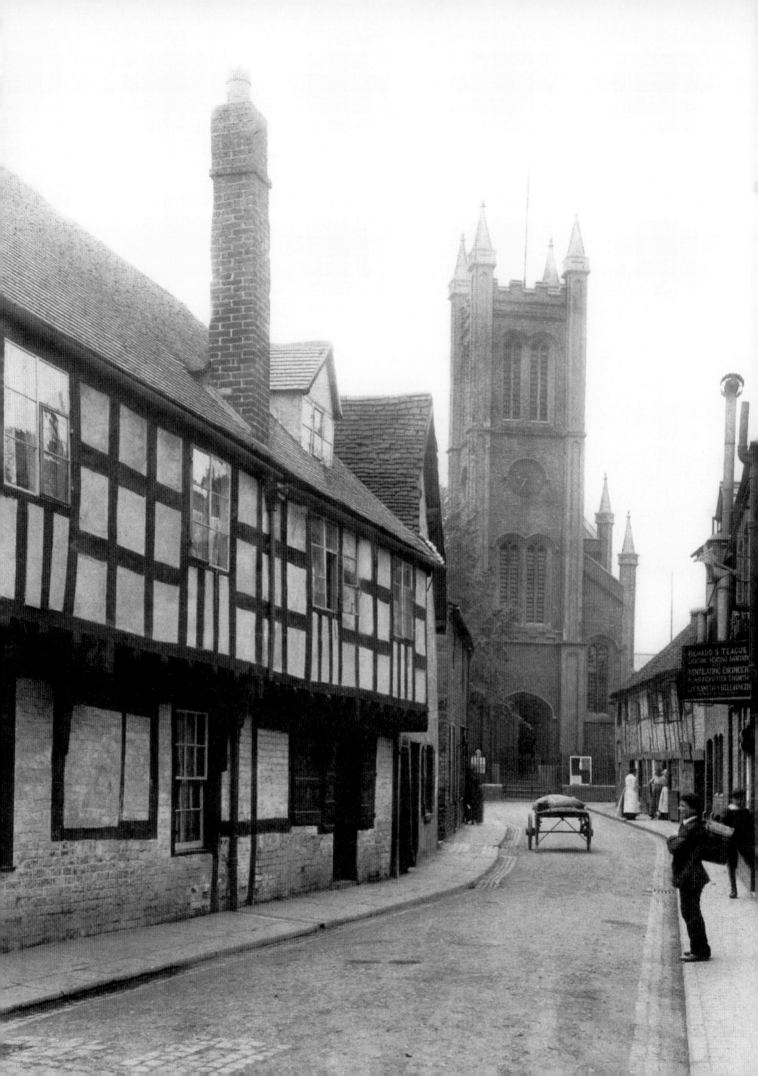

20: WORCESTER

Many seeing Worcester for the first time assume that it was badly bombed in the Second World War – the victim of a Baedeker Raid, perhaps – because there is so much post-war rebuilding so close to the mediaeval cathedral and elsewhere in the centre of this ancient city. But although Worcester had industry as well as a wealth of old timber houses, the city was not deliberately attacked from the air – the single raid seems to have been a mistake by German bombers looking for Birmingham or Coventry. As with the nearby cathedral city of Gloucester, the damage done to the historic fabric of Worcester was entirely self-inflicted. As James Lees-Milne put it in 1964, 'Worcester was repeatedly sacked by Romans, Danes, Saxons, Welsh and Roundheads. Though it escaped German bombing in the last War, so much of the old city has been cleared away for car-parks and commercial development of the sort to be found in all post-war industrial towns, that the visitor may have the impression there has been yet another invasion'.[149]

Worcester, sited on the east bank of the river Severn, is one of the oldest settlements in England, with a history stretching back at least two thousand years. It was an important religious centre in Mediaeval times, as the Cathedral and several churches testify. But four of the city's churches as well as many handsome brick houses date from the 18th century, when the Royal Worcester Porcelain Works was established. The 'Faithful City' was active and prosperous, and, in addition to the porcelain industry, there was carpet and glove making as well as cider, vinegar and (Worcester) sauce manufacture. Further industries arrived in the 19th century, particularly in the Shrub Hill area. No wonder, therefore, as Tudor Edwards wrote in 1949, 'Worcester has a vigorous daily life, an activity in business and industry, which is lacking in those dreamier cathedral-towns lauded by admirers of "ye olde"'.[150] In consequence, many early structures like the Mediaeval Deanery had been replaced, provoking Sir Gilbert Scott – who helped restore the cathedral – to remark in 1873 that, 'Worcester enjoys an unenviable notoriety for the destruction of its antiquities'.[151]

But much of the past survived into the mid-20th century, as Lees-Milne recalled: 'Worcester used to be a jumble of timbered Tudor houses and cottages and of Georgian

◀◀ St Peter's Street in 1906, looking south-west to the church of St Peter the Great, rebuilt in 1837. The church was demolished in 1976 and all the buildings in the street were cleared when Sidbury was widened into a main traffic artery.

▲ The Old Deanery in Lich Street in 1907. The whole of this street would be swept away in the 1960s to make way for a shopping centre.

▶▶ The ancient Lych Gate in Lich Street which once led to the Cathedral precinct in 1906. It would be destroyed to make way for the insultingly eponymous Lych Gate development.

mansions and small houses. This gave it a unique and irreplaceable character which distinguished it from its rival Cathedral cities of Gloucester and Hereford'. That character was rapidly destroyed in the second half of the century, although damage had been done earlier in response to the usual desire for modernity and to accommodate the motorist. It now seems incredible that the magnificent early 18th-century Guildhall could ever have been threatened (it was saved by public outcry) or that the long-neglected 15th-century timber house known as Greyfriars in Friar Street, 'one of the finest timber-framed buildings in the county' and also owned by the Corporation, was proposed for demolition in 1943 (but saved by the Worcester Archaeological Society). 'The face of Worcester is indeed already changing,' wrote Tudor Edwards immediately after the war, 'slowly but surely and inevitably. The waterfront warehouses are peeling and there are gaps like missing teeth. Urban development threatens to complete a process begun by the "blitz"'.

Although it had not been bombed, Worcester still had to have its own rebuilding plan for the future, and in 1944 one was commissioned from the architects Anthony Minoprio and Hugh Spencely. Published in 1947, almost inevitably this assumed that much of the city would have to be rebuilt. It proposed road-widenings, a ring road to the east outside the line of the old city walls, land-use zoning and a new quarter with civic buildings. 'Like so many other cities,' concluded the authors, 'Worcester suffers from the impact of an ever-increasing volume of traffic upon roads designed for the movement of men and animals'.[152] There was one novel and sympathetic idea in the Plan, however, which was to remove College Street, the new road made in 1794 to connect with the Severn Bridge, which cut through the north-east precinct of the Cathedral. To replace it, there were to be new blocks of buildings corresponding to the plan of those formerly on the site while through-traffic was to be directed further north.

Although the immensely destructive city walls ring road was eventually partly

carried out in the 1970s, this interesting proposal was ignored by Worcester Corporation. Instead, the city decided to widen College Street as well as the ancient street called Sidbury to the south-east to take more traffic to the Severn Bridge. The result is that the Cathedral is now separated from the High Street and Friar Street by what Nikolaus Pevsner described as 'that ferocious traffic route'. Never, surely, in all *The Buildings of England*, did Pevsner express himself so angrily about the treatment of an historic town as he did in the Worcestershire volume, published in 1968. As far as he was concerned, despite the industry, 'C20 Worcester was a cathedral town first and foremost, and that makes it totally incomprehensible that the Council should have permitted the act of self-mutilation which is the driving of the busiest fast-traffic road through in a place a few yards from the cathedral. The crime is the planners', not the architects', and the planners would of course have been powerless without the consent of the City Council'.[153]

To add further insult to injury, the surroundings of the Cathedral across the new roundabout were ruined by the redevelopment of the south-eastern end of the High Street. Here, where there were mostly Georgian and early 19th-century brick facades, the extensive Lych Gate development along with the Giffard Hotel rose between 1963 and 1969. This required the removal of the unique cathedral lych-gate as well as of Lich Street itself, once the main route from London to Mid-Wales, with its timber-framed buildings. Further east, as a recent commentator has complained, 'The mediaeval character of Friar Street and the start of Sidbury was destroyed by the building of what is possibly the ugliest car park in the country'.[154] 'It is not easy to be fair to it', wrote Pevsner, when confronted by the duty of describing these structures. 'But one should not forget that this development in this place is hara-kiri by the city, not murder by the architects' (who were Shingler, Risdon Associates and Russell, Hodgson & Leigh).

But this was not all. A few years earlier, Lees-Milne recorded that, 'The area east of High Street consists (or until the last decade consisted) of narrow streets of mediaeval, Tudor and Stuart houses, very many in half-timber with gables and overhangs, and some even with exterior galleries. No English city was so rich in houses of these early

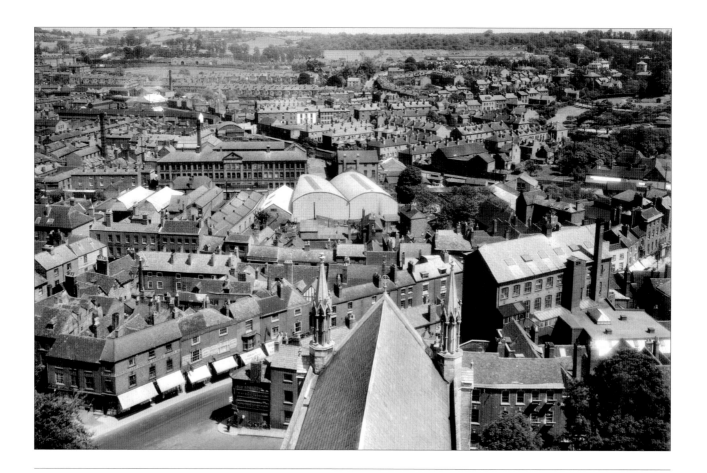

periods. What the war did not do, peace, prosperity, and lack of appreciation are doing instead. The remaining houses in Sidbury and the Shambles are due for demolition'. And today they have gone, with the Shambles left as an uninteresting 20th-century shopping street. Only in Friar Street does a little of the old character of Worcester survive.

These dreadful developments, which today seem as inadequate as they are mediocre, provoked public protest and correspondence in *The Times*. Yet the official city guide could later claim that, 'The fears voiced by many, including architects of national reputation, that the development would dominate the cathedral appear now to have little substance'.[155] Nevertheless, in response to this criticism, the City Council declared the historic core of the city a conservation area in 1969 and, after 1972, operated a long-running conservation Town Scheme, while further work on the relief road was halted. But it is doubtful if the councillors had really changed their spots. In 1977, the Council proposed the demolition of the remarkable but long endangered Countess of Huntingdon's Chapel in Deansway to enable yet another shopping development. It was saved, however, by the opposition of the Worcester Civic Society and was subsequently converted into a concert hall, although it is now engulfed by the Crowngate Shopping Centre.

'It is remarkable', wrote a visiting journalist in 1973, 'how Worcester – more than any other historic county town – has obliterated its past to make way for engines of prosperity'.[156] The trouble was that by doing so the city undermined its appeal as a tourist destination while signally failing to create anything of contemporary merit or interest. A recent study of post-war planning in the city has concluded that 'Worcester clearly remains a "tourist-historic city" for its heritage and form, but by default rather than conscious planning decision in the immediate post-war period: in sharp contrast to the replica vernacularisation of cities such as Nuremberg'[157] – and Nuremberg, of

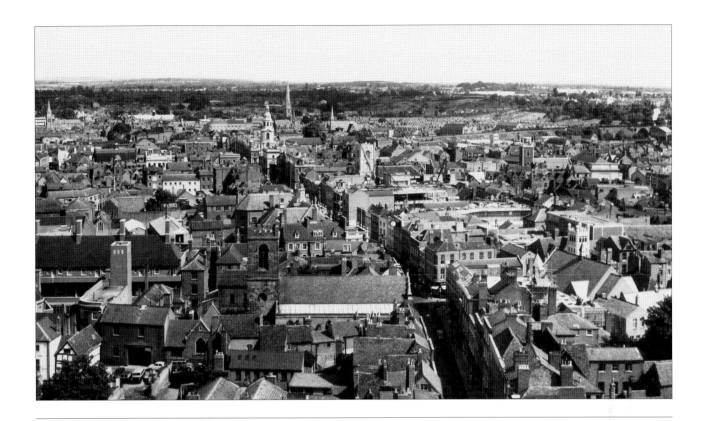

Looking north from the tower of the Cathedral in *c.* 1960. All the Georgian buildings lining the south-east side of the High Street, seen bottom-right in the foreground, would soon be destroyed to make way for the Lych Gate shopping centre.

Sidbury Bridge over the Worcester & Birmingham Canal when Sidbury was being widened into a dual carriageway in the 1960s, requiring the demolition of all buildings along its south-west side.

course, unlike Worcester, was very badly damaged in the Second World War. The depressing story of Worcester in the 20th century merely confirms that – as with so many other British cities – if we now regret the unnecessary loss of so much that was historic, beautiful, enjoyable and vital, there is really no one else to blame. Enemy action may have been responsible for much terrible destruction elsewhere, but probably not as much as our own road engineers and planners. The real villains were here at home, comfortably ensconced in town halls and borough engineers' offices. And the real heroes were the individuals and local societies who tried to resist them.

REFERENCES

[N.B., sources are cited only when first referred to in the text]

1 John A. Brodie in *The Royal Institute of British Architects Town Planning Conference, London, 10-15 October 1910, Transactions* (London, 1911).

2 *Traffic in Towns: a study of the long term problems of traffic in urban areas, reports of the steering group and working group appointed by the Minister of Transport* (London, 1963).

3 Thomas Sharp, *Town and Countryside: some aspects of urban and rural development* (Oxford & London, 1932).

4 John W. Simpson, 'Preface' in RIBA *Town Planning Conference, op. cit.*

5 G. Baldwin Brown, 'Town Planning and the preservation of ancient features' in RIBA *Town Planning Conference, op. cit.*

6 John Summerson, 'Farewell Brunswick Square', B.B.C. radio broadcast 4 January 1938.

7 Walter Gropius, *The New Architecture and the Bauhaus* (London, 1935).

8 *New architecture. An Exhibition of the elements of modern architecture organized by the mars (Modern Architectural Research) group, New Burlington Galleries January 11-29 1938.*

9 Le Corbusier, *Aircraft: The New Vision* (London & New York, 1935).

10 Quoted in Sven Lindqvist, *A History of Bombing* (London, 2001).

11 W.G. Hoskins, *Two thousand years in Exeter* (Exeter, 1960).

12 Nick Tiratsoo, Junichi Hasegawa, Tony Mason & Takao Matsumura, *Urban Reconstruction in Britain and Japan 1945-1955. Dreams, Plans and Realities* (Luton, 2002).

13 Julian Huxley, 'Foreword' in Flora Stephenson & Phoebe Pool, *A Plan for Town and Country* (London, 1944).

14 Alison Ravetz, *Remaking Cities* (London, 1980).

15 Osbert Lancaster, *Drayneflete Revealed* (London, 1949).

16 Wayland Kennet, *Preservation* (London, 1972).

17 Maxwell Fry, 'The New Britain must be Planned' in *Picture Post*, 4 January, 1941.

18 Lionel Esher, *A Broken Wave: the rebuilding of Britain 1940-1980* (London, 1981).

19 Junichi Hasegawa, *Replanning the blitzed city centre: A comparative study of Bristol, Coventry and Southampton 1941-1950* (Buckingham & Philadelphia, 1992).

20 Oliver Marriott, *The Property Boom* (London, 1967).

21 Amery & Dan Cruickshank, *The Rape of Britain* (London, 1975).

22 John Betjeman, 'Foreword' in Amery & Cruickshank, *op. cit.*

23 Keith Waterhouse, *Daily Mirror*, 12 June 1975.

24 John Summerson, *Georgian London* (London, 1988).

25 Ian Nairn, *Britain's Changing Towns* (London, 1967), p.16.

26 Tudor Edwards, *Warwickshire* (London & New York, 1950).

27 Asa Briggs, *Victorian Cities* (London, 1963).

28 J.B. Priestley, *English Journey* (London, 1934).

29 quoted in Andy Foster, *Pevsner Architectural Guides: Birmingham* (New Haven & London, 2005).

30 Paul S. Cadbury, *Birmingham – Fifty Years On* (Birmingham, 1952).

31 *The Victorian Society Annual 1968-9.*

32 Nikolaus Pevsner, *The Buildings of England: Yorkshire The West Riding* (Harmondsworth 1959).

33 John Ruskin, *The Crown of Wild Olive* (1866).

34 quoted in Ian Beesley & David James, *Victorian Bradford: The Living Past* (Halifax 1987).

35 S.G. Wardley, 'Town Improvement and Development' in *The Surveyor & Municipal & County Engineer*, 30 January 1948.

36 quoted in *Telegraph & Argus, Bye Bye Broadway: A Pictorial History of Bradford City Centre* (Derby 2005).

37 Christopher Hammond, *The Good, the Bad and the Ugly: An Architectural Walk through Bradford City Centre and Little Germany* (Bradford 2006).

38 *Bye Bye Broadway.*

39 Hammond, *op. cit.*

40 John Summerson, 'Bristol', in Eileen Molony, ed., *Portraits of Towns* (London, 1952).

41 Nikolaus Pevsner, *The Buildings of England: North Somerset and Bristol* (Harmondsworth, 1958).

42 quoted in Andrew Foyle, *Pevsner Architectural Guides: Bristol* (New Haven & London, 2004).

43 quoted in Juliet Gardiner, *Wartime Britain 1939-1945* (London, 2004).

44 John Betjeman, 'Preface' in Reece Winstone, *Bristol To-day* (Bristol, 1958).

45 quoted in Junichi Hasegawa, *Replanning the blitzed city centre: A comparative study of Bristol, Coventry and Southampton 1941-1950* (Buckingham & Philadelphia, 1992).

46 quoted in Hasegawa, *op. cit.*

47 Foyle, *op. cit.*

48 Gordon Priest & Pamela Cobb, eds, *The Fight for Bristol: Planning and the growth of public protest* (Bristol, 1980).

49 quoted in Charles Whiting, *The Three-Star Blitz: The Baedeker Raids and the start of Total War 1942-1943* (London, 1987).

50 J.M. Richards & John Summerson, *The Bombed Buildings of Britain*, 2nd ed. (London, 1947).

51 Pennethorne Hughes, *A Shell Guide to Kent* (London, 1969).

52 quoted in Richard Morrice, 'Anthony Swaine and Conservation in East Kent' in Elain Harwood & Alan Powers, eds, *The Heroic Period of Conservation: Twentieth Century Architecture 7* (2004).

53 *The Architects' Journal* for 24 April 1952, quoted in Morrice, *op. cit.*

54 John Newman, *The Buildings of England: North East and East Kent* (Harmondsworth, 1969).

55 W.G. Hoskins, *About Britain No.5: Chilterns to Black Country* (London, 1951).

56 John Summerson, 'Town Buildings' in James Lees-Milne, ed., *The National Trust: A Record of Fifty Years' Achievement* (London 1945).

57 quoted in David McGrory, *Around Coventry in old photographs* (Stroud 1991).

58 quoted in Nick Tiratsoo et al., *Urban Reconstruction in Britain and Japan 1945-1955: Dreams, Plans and Realities* (Luton 2002).

59 quoted in Robert Gill, 'From the Black Prince to the Silver Prince: Relocating Mediaeval Coventry' in Elain Harwood & Alan Powers eds, *Twentieth Century Architecture 7: The Heroic Period of Conservation* (2004).

60 quoted in Gill, *op. cit.*

61 J.M. Richards & John Summerson, *The Bombed Buildings of Britain* (London 1947).

62 quoted in David Kynaston, *Austerity Britain 1945-51* (London 2007).

63 Nikolaus Pevsner & Alexandra Wedgwood, *The Buildings of England: Warwickshire* (Harmondsworth 1966).

64 quoted in Kynaston, *op. cit.*

65 Thomas Morer, quoted in David M. Walker, *Architects and Architecture in Dundee 1770-1914* (Dundee, 1955).

66 Charles McKean & David Walker, *Dundee: An Illustrated Architectural Guide* 2nd ed. (Edinburgh, 1993).

67 G.S. Fraser, *Vision of Scotland* (London, 1948).

68 Charles McKean & David Walker, *Dundee: An Illustrated Introduction* (Edinburgh, 1984).

69 quoted in Ann Simpson, 'James Pryde 1866-1941' in *James Pryde* (Edinburgh, 1992).

70 Patrick Abercrombie & Derek Plumstead, *A Civic Survey & Plan for the City & Royal Burgh of Edinburgh* (Edinburgh & London, 1949).

71 Ian G. Lindsay, *Georgian Edinburgh* (Edinburgh & London, 1948).

72 Alastair Rowan, 'Thoughts on the Early Years of the Scottish Georgian Society' in *Architectural Heritage XVII: The Journal of the Architectural Heritage Society of Scotland* (2006).

73 *The Scotsman*, 21 February 1930, quoted in Gavin Stamp, 'Hitchcock, Summerson and Glasgow' in Frank Salmon, ed., *Summerson and Hitchcock: Centenary Essays on Architectural Historiography* (New Haven & London, 2006).

74 quoted in *The Victorian Society Annual Report 1965-66.*

75 quoted in Miles Glendinning, 'The "Grand Plan": Robert Matthew and the Triumph of Conservation in Scotland' in *Architectural Heritage XVI* (2005).

76 A.J. Youngson, *The Making of Classical Edinburgh 1750-1840* (Edinburgh, 1966).

77 quoted in Thomas Sharp, *Exeter Phoenix: A Plan for Rebuilding* (London 1946).

78 Anne Treneer, 'Exeter' in Molony, *op cit.*

79 W.G. Hoskins, *Two thousand years in Exeter* (Exeter 1960).

80 quoted in Whiting, *The Three-Star Blitz, op. cit.*

81 Nikolaus Pevsner, *The Buildings of England: South Devon* (Harmondsworth 1952).

82 Ann Jellicoe & Roger Mayne, *A Shell Guide to Devon* (London 1975).

83 Bridget Cherry & Nikolaus Pevsner, *The Buildings of England: Devon* (London 1989).

84 *The Architects' Journal*, 6 May 1964.

85 Francis Worsdall, *The City that disappeared: Glasgow's demolished architecture* (Glasgow, 1981).

86 J.M. Reid, *Glasgow* (London, 1956).

87 *Glasgow Herald*, 8 May 1964, quoted in Gavin Stamp, *Alexander 'Greek' Thomson* (London, 1999).

88 Andor Gomme & David Walker, *Architecture of Glasgow* (London, 1968).

89 Henry-Russell Hitchcock, 'Early Cast Iron Facades' in *The Architectural Review*, February 1951.

90 Nikolaus Pevsner, *The Buildings of England: Yorkshire: York and the East Riding* (Harmondsworth, 1972).

91 *A Plan for the City and County of Kingston upon Hull. Prepared for the City Council by Edwin Lutyens and Patrick Abercrombie* (London & Hull, 1945).

92 Amery & Cruickshank, *op. cit.*

93 Ivan & Elisabeth Hall, *Georgian Hull* (York, 1978/79).

94 Ian N. Goldthorpe & Margaret Sumner, *Architecture of the Victorian era of Kingston upon Hull: being a study of the principal buildings erected in Hull 1830-1914* (Beverley, 2005)

95 John Betjeman, 'Leeds – a City of Contrasts' in the *Architectural Review*, ?? 1933, reprinted in *First and Last Loves* (London, 1952).

96 John Betjeman, 'Preface' in Derek Linstrum, *Historic Architecture of Leeds* (Newcastle-upon-Tyne, 1969).

97 Nikolaus Pevsner, *The Buildings of England: Yorkshire The West Riding* (Harmondsworth, 1959).

98 *City of Liverpool Official Handbook* (Liverpool, 1907).

99 Nikolaus Pevsner, *The Buildings of England: South Lancashire* (Harmondsworth, 1969).

100 quoted in Gardiner, *op. cit.*

101 *Liverpool Daily Post*, 5 July 1946.

102 Richard Pollard, Nikolaus Pevsner & Joseph Sharples, *The Buildings of England: Lancashire: Liverpool and the South-West* (New Haven & London, 2006).

103 J.F. Smith, Gordon Hemm & A. Ernest Shennan, *Liverpool: Past – Present – Future* (Liverpool, 1948).

104 Quentin Hughes, *Seaport: Architecture & Townscape in Liverpool* (London, 1964).

105 C.H. Reilly, *Some Liverpool Streets and Buildings in 1921* (Liverpool, 1921).

106 James Bone, *The London Perambulator* (London, 1925).

107 E. Beresford Chancellor, *The Private Palaces of London, Past and Present* (London, 1908).

108 A. Trystan Edwards, *Good and Bad Manners in Architecture* (London, 1924).

109 *The Times*, 16 July 1924.

110 Harold P. Clunn, *The Face of London: The record of a century's changes and development* (London, 1932).

111 Douglas Goldring, *Pot Luck in England* (London, 1936).

112 Douglas Goldring, 'The Georgian Group' in the *Architectural Review*, August 1937.

113 Robert Byron, *How we celebrate the Coronation* (London, 1937).

114 James Lees-Milne, *Another Self* (London, 1970).

115 Cecil Stewart, *The Stones of Manchester* (London, 1956).

116 Ian Beesley & Peter de Figueiredo, *Victorian Manchester and Salford* (Halifax, 1988).

117 Nikolaus Pevsner, *The Buildings of England: Lancashire I, The Industrial and Commercial South* (Harmondsworth, 1969).

118 quoted in Beesley & de Figueiredo, *op. cit.*

119 Nairn, *op. cit.*

120 Thomas Sharp, *Northumberland: A Shell Guide* (London, 1954).

121 Nikolaus Pevsner, *The Buildings of England: Northumberland* (Harmondsworth, 1957).

122 Nairn, *op. cit.*

123 Thomas Sharp, *A Shell Guide: Northumberland* (London, 1969).

124 John Grundy, Grace McCombie, Peter Ryder, Humphrey Welfare & Nikolaus Pevsner, *Northumberland* (London, 1992)

125 W.R.S. Forsyth, 'Foreword' in *City Planning: Newcastle upon Tyne* (London, n.d.)

126 Lyall Wilkes & Gordon Dodds, *Tyneside Classical: The Newcastle of Grainger, Dobson & Clayton* (London, 1964).

127 Arnold Kent & Andrew Stephenson, *Norwich Inheritance* (Norwich n.d.).

128 J.B. Priestley, *English Journey* (London 1934).

129 Nikolaus Pevsner, *The Buildings of England: North-East Norfolk and Norwich* (Harmondsworth 1962).

130 C.H. James & S. Rowland Pierce, *City of Norwich Plan* (Norwich 1945).

131 George Swain, *Norwich under fire: A camera record* (Norwich n.d.).

132 Quoted in Whiting, *The Three Star Blitz, op. cit.*

183

133 Norman R. Tillett, 'Foreword' in James & Pierce, *op. cit.*

134 H.C. Rowley, 'Reservations on Report by City Engineer' in James & Pierce, *op. cit.*

135 Wilhelmine Harrod & the Rev. C.L.S. Linnell, *Shell Guide to Norfolk* (London 1957).

136 Nikolaus Pevsner & Bill Wilson, *The Buildings of England – Norfolk I: Norwich and North-East* (London 1997).

137 Chris Robinson, 'Plymouth's Historic Barbican' in *Twentieth Century Architecture 7: The Heroic Period of Conservation* (2004).

138 Nikolaus Pevsner, *The Buildings of England: South Devon* (Harmondsworth, 1952).

139 Howard Colvin, *A Biographical Dictionary of British Architects 1600-1840*, 3rd edition (New Haven & London, 1995).

140 John Betjeman, *Devon: Shell Guide* (London, n.d.(1935)).

141 J. Paton Watson & Patrick Abercrombie, *A Plan for Plymouth: The Report prepared for the City Council . . .* (Plymouth, 1943).

142 Charles Whiting, *Britain Under Fire: The Bombing of Britain's Cities 1940-1945* (London, 1986).

143 Viscount Astor, 'Foreword' in Abercrombie & Watson, *op. cit.*

144 Bridget Cherry & Nikolaus Pevsner, *Devon* (London, 1989).

145 Brian Watson, *Devon: A Shell Guide* (London, 1955).

146 Nikolaus Pevsner & David Lloyd, *The Buildings of England: Hampshire and the Isle of Wight* (Harmondsworth, 1967).

147 Quoted in John Webb, *An Early Victorian Street: The High Street, Old Portsmouth* (Portsmouth, 1977).

148 John Rayner, *Hampshire: Shell Guide* (London, 1937).

149 James Lees-Milne, *Worcestershire: A Shell Guide* (London 1964).

150 Tudor Edwards, *Vision of England: Worcestershire* (London 1949).

151 quoted in Richard K. Morris & Ken Hoverd, *The Buildings of Worcester* (Stroud 1994).

152 'Outline Plan for Worcester' in the *Architect & Building News* for 3 October 1947.

153 Nikolaus Pevsner, *The Buildings of England: Worcestershire* (Harmondsworth 1968).

154 Morris & Hoverd, *op. cit.*

155 quoted in Morris & Hoverd, *op. cit.*

156 Jane Morton, 'Worcester: a county town on the defensive' in *New Society* for 1 February 1973.

157 J. Vilagrasa & P.J. Larkham, 'Post-war redevelopment and conservation in Britain: Ideal and reality in the historic core of Worcester' in *Planning Perspectives* 10 (1995).

ACKNOWLEDGEMENTS

I am grateful to Graham Coster and Phoebe Clapham at Aurum Press for suggesting the idea of this photographic study, enabling me to combine my enthusiasm for historic photographs with an investigation into the (usually lamentable) changes which British cities saw in the last century. It is cheering that certain of them, like Coventry, Dundee and Norwich, boast a fine archive of images, but a majority of the photographs here come from the National Monuments Record and the National Monuments Record of Scotland, and as regards the former, I am greatly indebted to Ian Leith for guiding me through the collection at Swindon. My selection and description of the 19 cities is based on my own knowledge of them, but I benefited from the advice of Christopher Hammond with Bradford, Robert Gill with Coventry, Ian Gow with Edinburgh, Joseph Sharples with Liverpool and Paul Binski and my brother Gerard Stamp with Norwich. As regards Bristol, my mother long ago told me what a scandal it was that while the bombed heart of her native city was not rebuilt after the Second World War, a largely undamaged area (where her relatives had worked) was rebuilt instead. Such was planning.

BIBLIOGRAPHY

In my descriptions of the cities, much use has been made of the *Buildings of England* (and *of Scotland*) volumes founded by Sir Nikolaus Pevsner and of the more recent *Pevsner Architectural Guides*. I have also referred to several of the *Shell Guides* to counties by many authors, begun by Sir John Betjeman and to some of the *Vision of England* series of the 1940s edited by Clough and Amabel Williams-Ellis. There are extensive quotes from two perceptive 20th-century travellers around Britain: J.B. Priestley, who published his *English Journey* in 1934, and Ian Nairn, whose articles for the BBC, with postscripts, were published as *Britain's*

Changing Towns in 1967. Invaluable articles by Robert Gill, Richard Morrice and Chris Robinson on, respectively, Coventry, Canterbury and Plymouth, were published in *Twentieth Century Architecture 7* on *The Heroic Period of Conservation* (2004). For the ordeal of Britain's cities during the Second World War, I depended on Juliet Gardiner's *Wartime Britain 1939-1945* (London, 2004) and the two books by Charles Whiting, *Britain Under Fire: The Bombing of Britain's Cities 1940-1945* (London, 1986) and *The Three-Star Blitz: The Baedeker Raids and the start of Total War 1942-1943* (London, 1987), as well as on *The Bombed Buildings of Britain* by J.M. Richards and John Summerson (London, 1942 & 1947). For the wartime rebuilding plans and their realisation, the authorities are Junichi Hasegawa, *Replanning the blitzed city centre: A comparative study of Bristol, Coventry and Southampton 1941-1950* (Buckingham & Philadelphia, 1992).and Nick Tiratsoo, Junichi Hasegawa, Tony Mason & Takao Matsumura, *Urban Reconstruction in Britain and Japan 1945-1955. Dreams, Plans and Realities* (Luton, 2002). For what has happened since the Second World War, there is Oliver Marriott's study of *The Property Boom* (London, 1967 & 1989), the necessarily polemical *The Rape of Britain* by Colin Amery & Dan Cruickshank (London, 1975), Lionel Esher's *A Broken Wave: the rebuilding of Britain 1940-1980* (London, 1981) and *The Rise of Heritage in Modern Britain* edited by Michael Hunter (Stroud, 1996), amongst other sources, many of which are given in the references. Finally, for the story of photographing endangered or damaged buildings and places, there is *50 Years of the National Buildings Record* with an introduction by Sir John Summerson (London, 1991).

Britain's Lost Cities only scratches the surface of a vast subject, but I hope it may lead readers to the encouraging wealth of published photographic histories of towns and cities that now exists, among which Reece Winstone's pioneering compilations on Bristol and Hermione Hobhouse's *Lost London* (London, 1971) deserve mention.

Passages from *English Journey* by J.B. Priestley are reprinted by permission of William Heinemann Ltd.

PICTURE CREDITS

English Heritage, National Monuments Record: ii, vi, 2, 11, 12, 14 (top), 16 (top), 19, 20, 23, 24, 25, 36, 37, 38, 41, 42, 43, 44, 74, 75, 77, 80, 94, 96 (bottom), 99, 100, 102, 103 (bottom), 104, 105, 109 (top), 110 (bottom), 111, 113, 114, 118, 119, 120, 121, 122, 125 (bottom), 127 (bottom), 128, 130, 131, 133, 134, 136, 138, 140, 144, 145, 146, 147, 150, 152, 158, 160, 161, 163 (top), 164, 165, 166, 167, 168 (bottom), 169, 170, 172, 173, 174, 175, 179.
Courtesy of the Royal Commission on the Ancient and Historical Monuments of Scotland, Crown Copyright © RCAHMS: 5 (with permission from The New Club), 54 (RAF Air Photographs Collection), 57 (bottom), 64, 66, 67 (© National Archives of Scotland), 68, 69, 70, 82, 84, 85, 86 (© Frank Wordsall), 88, 89, 90, 91, 92.
Birmingham Central Library: 14 (bottom), 16 (bottom).
Country Life Picture Library: 17, 71, 116.
Reece Winstone Archive: 26, 27, 28, 30, 31 (bottom), 32, 33, 34, 35.
The Francis Frith Collection: 31 (top), 40 (top), 46, 76, 85 (bottom), 98, 162 (top), 176, 177, 178, 180 (top).
Canterbury Cathedral Archives, by permission of Anthony Swaine: 40 (bottom).
Coventry Libraries and Information Service: 47, 48, 49, 50, 51, 52.
www.photopolis.org: 56, 57 (top), 58, 59, 60, 61.
RIBA: 62, 86 (top), 117, 132, 162-3 (bottom).
Devon Record Office: 72.
D.W. Wrightson: 87.
Archives and Special Collections, Mitchell Library: 91 (top), 92 (top).
Memory Lane Gallery: 96 (top), 97.
Leeds Library and Information Service: 103 (top).
Liverpool Record Office: 106, 108, 109 (bottom), 110 (top), 112.
London Metropolitan Archives: 124, 125 (top), 129.
Getty Images: 126 (top).
Newcastle Libraries and Information Service: 143.
Norfolk County Council Library and Information Service: 148, 151, 153, 154, 155, 156-7.
Worcester News: 181 (bottom).

INDEX